3D ART ESSENTIALS

To Volodya, who insisted.

3D ART ESSENTIALS

The Fundamentals of 3D Modeling, Texturing, and Animation

AMI CHOPINE

Routledge
Taylor & Francis Group

LONDON AND NEW YORK

First published 2011
by Focal Press

Published 2019 by Routledge
2 Park Square, Milton Park, Abingdon, Oxon OX14 4RN
52 Vanderbilt Avenue, New York, NY 10017

Routledge is an imprint of the Taylor & Francis Group, an informa business

Notices

Practitioners and researchers must always rely on their own experience and knowledge in evaluating and using any information, methods, compounds, or experiments described herein. In using such information or methods they should be mindful of their own safety and the safety of others, including parties for whom they have a professional responsibility.

To the fullest extent of the law, neither the Publisher nor the authors, contributors, or editors, assume any liability for any injury and/or damage to persons or property as a matter of products liability, negligence or otherwise, or from any use or operation of any methods, products, instructions, or ideas contained in the material herein.

British Library Cataloguing in Publication Data
Chopine, Ami.
 3D art essentials : the fundamentals of 3D modeling, texturing, and animation.
 1.Computer animation.
 I. Title
 II. Three D art essentials
 006.6'93-dc22

Library of Congress Control Number : 2010942642

ISBN 13: 978-0-240-81471-1 (pbk)

CONTENTS

Chapter 20 Making a Career out of 3D

Acknowledgments

First and foremost, I'd like to thank my family, who put up with me while I wrote this book. Is that a cliché? Yes. Is it a real part of being a writer, spouse, parent, and child? Yes. They're loving and, importantly, they're a humorous bunch of people and I'm grateful their lot was cast with mine. In particular, my husband Vladimir helped me out with a few of the illustrations. He is a much better visual artist than I am.

Paul Champion was my technical editor with this book. I'd worked with him before and trusted him to help me get things right where my street-learned skills, so to speak, gave me some misunderstandings and gaps. He proved himself, and then some.

I'm grateful to Chris Simpson, who helped steer me into getting this project started, and to Anais Wheeler, who cheerfully saw it through to the prolonged end. And to all the other great editors and crew who have worked hard to make it look good on paper, whether of trees or electronic.

Thanks to the staff at my children's school, American Preparatory Academy, who kindly allowed me to take up some of their space while writing, thus saving me an extra commute. Lastly, I'd like to acknowledge my poor dog Mitzi, who didn't get to go on as many runs as she is used to.

How To Use This Book

This book was written to give beginning 3D artists a map through the art and how to get involved in the 3D industry. You can use this book by reading all the way through it cover to cover with or without doing the tutorials, by picking and choosing chapters based on gaps you want to fill, or as a quick reference to a concept you remembered last week but not this minute. You don't even need to own software yet for this book to be useful to you. In fact, it may be a help as you decide which application will best fit what kind of 3D art you want to do.

If you are at all familiar with tutorials for 3D or other types of art or activities, you'll know that they often give very detailed, step-by-step instructions on which exact thing to click or select. This is not possible with *3D Art Essentials* because it's software agnostic. The best way to go through these tutorials is to have your application's documentation next to you to help you complete each step. The tutorials are designed to give you some practice with important concepts. If you can finish every tutorial in this book, you're well on your way to enjoying the art and creating whatever is in your imagination.

As well as learning from this book, use it as a guide for studying each topic more in depth. Go through each chapter and then spend a couple of weeks on the topic which that chapter covers, to learn and practice the concepts more in depth. You'll probably find some topics more interesting than others. That's okay. The field is too wide for there not to be specialists.

With just a few weeks of study, you can already be creating interesting models. With a few years of experience, you can animate characters or creatures that are nearly indistinguishable from life.

No matter your age or background, and no matter your goals, the art is in you.

Enjoy.

A HISTORY OF COMPUTER GRAPHICS AND SPECIAL EFFECTS

When we watch a movie like *Avatar*, we are seeing the results of nearly 200 years of dreamers. It started in the nineteenth century, with Charles Babbage. He grew up among wonderful new inventions, including machines to transport people and goods faster than ever before, and ones that achieved precision in manufacturing previously impossible. He imagined a machine that could be made to do complicated mathematics (Figure 1.1). His analytical engine was unfortunately never funded and many of his modern ideas wouldn't be matched for almost 100 years.

The earliest computers were mechanical adding machines. Later, electronic computers were used in World War II in the USA to help crack communication codes, create artillery tables, and help with the mathematics needed to develop the atomic bomb. They weren't practical for anyone other than government or large research institutions. First of all, they were huge, taking up the entire floor of an office building. They were expensive and broke down a lot. This was because they used vacuum tubes instead of our modern transistors. Shaped like a long light bulb, these were large, fragile, and hot.

These computers had no screens or interactivity. Every equation had to be programmed in which was achieved by changing the circuitry of the computer at switchboards. Variables were input using a punch card reader, and the answer was received in the same way, with a punch card (Figure 1.2).

Before any graphics could be done on computers, there had to be a display. The first was another military invention, the Whirl-whind, which used an oscilloscope to show an airplane's location and a light pen to get more information about them.

In 1963 at MIT Ivan Sutherland created *SKETCHPAD* as part of his doctoral thesis. He is known as the father of computer graphics for good reasons. A person could draw shapes, both

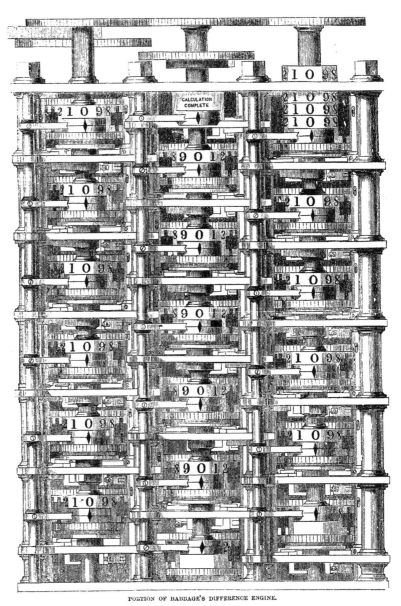

PORTION OF BABBAGE'S DIFFERENCE ENGINE.

Figure 1.1 A drawing of part of Babbage's analytical machine.

two- and three-dimensional (2D and 3D), with *SKETCHPAD*, using the light pen on the screen. This was the first time a user could truly interact with the computer program other than by running a bunch of punch card instructions through. The TX-2 system that Sutherland used to run his program was based on the

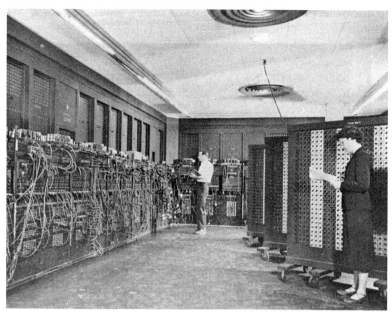

Figure 1.2 The ENIAC.

Whirlwind, but used transistors instead of vacuum tubes. This shrunk computers to a decent-sized room and made them far less likely to break down. Sutherland had to rig the TX-2 especially for his program, and then restore it to the way it was when he finished. *SKETCHPAD* couldn't run on any other machine (Figure 1.3).

This was one of the difficulties that had to be overcome before computer graphics (a term coined by another pioneer, William

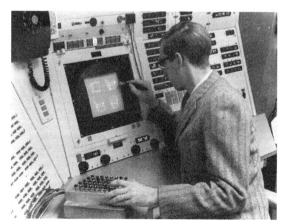

Figure 1.3 Ivan Sutherland running *SKETCHPAD* on a TX-2.

Fetter, when he used a computer to create ergonomic designs) could become a common reality. Early computers had no operating system or programming language as we understand them today, let alone "reusable programs" that one could purchase. If you bought a computer in the early 1960s, you would have to program it with switches before you could do anything on it. To make them commercially viable, strong and successful efforts developed computers to a point where they were useful upon turning them on, and easily programmed using a programming language that could be input with a keyboard. Still, they were so expensive that many organizations rented computer time rather than owned computers, and computer access was precious indeed at the universities. It was not uncommon to be scheduled in the middle of the night to work on the computer.

Still, this didn't stop people from creating and playing computer games, which was pretty much an act of clandestine love during the 1960s. No one got paid. Copies were passed around in a programmer's underground of sorts, often in the form of booklets printed with the code. If someone wanted to play a game, they would have to type in all the code.

Which game was the first computer game is up for grabs, but one of the earliest interactive ones was called *Spacewar!* (Figure 1.4). Created by Steve "Slug" Russell, Martin "Shag" Graetz, and Wayne Witaenem in 1962, it took about 200 man-hours to code. People spread copies around so that nearly every

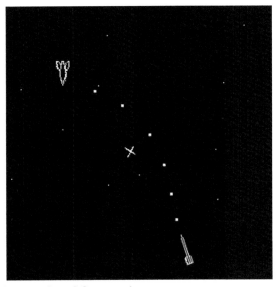

Figure 1.4 A screenshot of *Spacewar!*

owner of a DEC PDP-1 (a commercial version of MIT's TX-2) had one. People had to rig their own controls for the game to play it. Of course, before long a copy fell into the hands of Digital Equipment Corporation, who ended up using it to test PDP computers in the factory and shipping a copy with each system sold. Computer programmers who loved *Spacewar!* ported it to other computer systems and several arcade versions were released in the 1970s.

The graphics of both *SKETCHPAD* and *Spacewar!* were simple white-line drawings on cathode ray tube (CRT) screens. 3D objects, made up of polygons, could only be viewed as wire-frames. You could see through them, to the back as easily as their front. This, and many other difficulties still had to be resolved to be able to make realistic pictures using computers. Several institutions chipped away at the problems, but the University of Utah had a sledgehammer of a program in 1973 with a $5 million a year grant from the Advanced Research Projects Agency of the US Department of Defense (ARPA).

ARPA's interest in computer graphics lay in the ability to create simulations. This would be an inexpensive and safe way to train soldiers and airplane pilots. Simulation technologies are now a major aspect of training pilots, allowing them to practice dealing with potentially fatal situations. This has led directly to a reduction in airplane crashes. Other graphics of the time were devoted to computer-assisted design (CAD), scientific visualizations, and medical imaging.

Miniaturization and other advances at this level of financing led to packing more and more computing power into single supercomputers. These monoliths of circuitry were still so costly to build and maintain that only well-funded institutions had them. The University of Utah was able to afford these assets because of the ARPA grant.

Sutherland, who had been working at ARPA, was recruited to Utah's program by its head, long-time friend Dale Evans. There, researchers in the program created an algorithm that would hide surfaces, improving on the wireframe and giving it a solid appearance. At Utah and in other places, shaders had been invented to shade the colors of surfaces based on how the light hit them. These were big improvements, but objects still did not look like they had natural lighting. Bui Tuong Phong noted that direct lighting on objects created highlights, and developed the Phong shader algorithm to simulate these. As he worked on this problem, which was to be his doctoral thesis, he learned that he had leukemia. Though a terminal diagnosis, he kept on and received his PhD in 1975 before passing away. Phong shading

produced great results, but was quite slow to render. Another Utah graduate student, Jim Blinn, used Phong's work to figure out a faster way. Both Phong and Blinn shaders are in common use today in most 3D applications.

Other important advances to come out of the University of Utah included texture mapping, shadows, antialiasing, facial animation, and many more. The famous Utah teapot (Figure 1.5) was first modeled by Martin Newell. Its primitive is still found today in 3D applications, because the simple round shape with the elements of the spout and handle make it ideal for testing lighting and maps.

Among the other big Utah names was graduate student Ed Catmull. Catmull had long wanted to go into animation, but found out he couldn't really draw well. But he did know mathematics, so he studied physics and computer science at the University of Utah and after a short stint in the military, returned for graduate school. After he gained his PhD in 1974, he was recruited to the Computer Graphics Laboratory (CGL) in New York. The efforts of his team there led to further advancements in animation and texturing, and attracted the attention of George Lucas, the visionary behind *Star Wars*.

Lucas had become interested in using computer graphics, and set about creating a computer graphics division within his special effects production house, Industrial Light and Magic (ILM). He recruited Catmull and others from CGL to form this department, where they created the first fully computer-generated animation that would appear in a feature film: the Genesis Effect simulation sequence from *Star Trek II: The Wrath of Kahn* was released in 1982. Some of the advances seen in the animation were particle effects and motion blur.

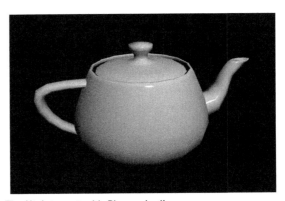

Figure 1.5 The Utah teapot with Phong shading.

That same year, Disney's *Tron* came out. Disney had used the services of three computer graphics companies to create *Tron*. But the innovative animation and compositing of live footage with it could not prop up the storyline. *Tron* tanked at the box offices.

Seeing this, and noting how expensive computer graphics were (the power alone for the supercomputers needed at the time could be in the hundreds of dollars per day), Lucas decided to drop the computer graphics division. Still passionate about being able to create animations with computers, Catmull kept the department together and began to look for someone who could finance them. Steve Jobs, founder of Apple Computers, took on sponsorship, and that led to the birth of Pixar Animation Studios.

Though animated computer graphics were thriving in areas such as advertising and opening credits for television shows, *Tron*'s failure frightened most producers away from using computer graphics in movies. One exception was *The Last Starfighter*, produced through the turmoil of those years and released in 1985. Unlike any other movie that was set in space before then, no physical models were used for the spaceships. They were 3D rendered models. In this production, using computers saved time and ended up saving money compared to the traditional techniques. Critics gave *The Last Starfighter* above-average reviews, and it succeeded at the box office, leading to a revival of interest of filmmakers in using computer graphics for movies. One of the first milestones from this era was *The Abyss*, which in 1989 had the first convincing 3D graphics creature in the form of a pseudopod with a face on it. Terminator II pushed it further with a whole human model that moved naturally. By the time of *Jurassic Park* (1993) and *Walking with Dinosaurs* (1999), the state of the art had progressed to having fully realized computer-generated dinosaurs interacting with their environment.

That same year, *Babylon 5* brought 3D graphics technology to television serials, coping with the lower budget and rapid production cycles. This had become possible because of advances in both computers and software, and some sleight of hand. In the first couple of seasons, they were unable to render the spacecraft the entire way around, because of the memory load. *Babylon 5* computer graphics would be produced using networks of personal computers (PCs) to render. With this jump in technology, computer graphics had become less expensive than many traditional special effects. This continued to spread through all aspects of the feature film industry. Computer-generated 3D graphics were brought to cartoons as well. *Reboot* was the first of these 3D cartoons to air, in 1994. Production on it started in 1988

and it was purposely set as a world within a computer mainframe because at the time, they could only create blocky looking models.

In 1995, Pixar came to maturity as a film production company with the release of *Toy Story*. Equipment and experience allowed them to make much smoother models, but they still animated mostly inorganic surfaces with the toys. Creating realistic organic surfaces still had many challenges to overcome including complex surfaces, the changing shape of those surfaces when a character or creature moves, hair, and the translucency of skin. *Jurassic Park* had overcome some of these problems simply by the sparseness of the actual computer graphics: only a total of six minutes was computer generated and in none of that were the dinosaurs ever seen really close up.

In 2001, *Final Fantasy: The Spirits Within* attempted to create such a fully realized human CGI character that they would use her as a star in later films. Though most of the capabilities were there, both movement and problems with realistic skin contributed to the uncanny valley, a place where characters are almost human but not quite, making the audience uncomfortable. Much of this continues to be a problem of animation: getting the character to move right. One of the developments to help with this has been motion capture technology.

Several movies use motion capture to bring realistic movement into their characters. The best examples are usually not fully human, such as Gollum in *Lord of the Rings: The Two Towers* (2002) and Davy Jones in *Pirates of the Caribbean: Dead Man's Chest* (2006), but technology is improving. Of special concern has been the subtle facial expressions that give us our humanity because of our ability to decode emotion on the human face from even tiny movements. A big improvement in this ability was seen in *The Curious Case of Benjamin Button* (2008).

One of the biggest movies of 2009 was *Avatar*, in which the main characters were entirely computer generated either some or all of the time and which used sophisticated motion capture techniques. Once again, these characters were not completely human but were entirely convincing.

Not only did *Avatar* feature incredible characters; most of its environment was computer generated as well, allowing incredible effects such as glowing plants and floating mountains to increase the power of the natural setting. Using computer graphics to create set extensions or even entire sets is becoming a more common practice. Another example is the completely artificial environment of *Tron: Legacy*, in 2010. With hardware and software advances, including digital cameras and editing

software, much of the technology has become more efficient and less expensive to use than traditional methods of on-location shooting. It is becoming more common to film in front of green screens even for those films that are not special effects focused.

Much of the programming that created the first computer-generated effects seen in movies was completed in-house. Even with the off-the-shelf software for creating 3D animations that is available today, studios, artists, and researchers often need to add capabilities through other programs they develop. Many of the advances in software are due to software companies working with studios to give them what they need or acquiring plugins that studios have created. These leading-edge technologies are finding their way more and more quickly into the personal computers of 3D art enthusiasts and students, who can now create their own computed-generated artwork from home.

From Institutions to Homes

Two developments had to occur before users could create 3D computer graphics at home. One was the development of hardware, and the second was the development of software.

The first computers to make it into the home were actually console games. More sophisticated than their house-sized predecessors, these were made small and portable by using hardwired programming in the form of cartridges. The first console, the Magnavox Odyssey, had 28 games. As far as graphics are concerned, it could only produce white lines and dots. Game backgrounds took the form of plastic overlays that were placed on the television screen. The first commercial release of Odyssey was in 1972, about the same time as Evans, Sutherland, and their graduate students at Utah were pioneering 3D graphics.

Through several industry stumbles, game consoles continued to evolve and thrive in the home market. At the same time, business computers were also improving, with a push to bring these minicomputers into the home. These home/game computers of the early 1980s were aimed at making both parents and kids happy: you could play games or run educational software or even program in the BASIC language on them. They connected to televisions, but now the graphics were more exciting, with up to 256 colors from Atari 400 and 800 models (early 1980s), although the images were still very pixelated because of the low resolutions used.

Gaming capabilities would continue to push personal and home computing technology forward, but art was also a part of

this development. Even the early computers such as the Atari 400/800, Apple II, and Commodore 64 had drawing programs, as did the IBM PCs. For better graphics, not only was color necessary, but so were higher resolutions and the ability to perform complicated graphics calculations quickly.

In 1986, Eric Graham created a 3D animation on his Amiga computer, writing a ray-tracing renderer in the process. *The Juggler* featured a man made up of spheres, juggling three reflective spheres. It was 24 frames long and looped so it could play continuously. It even included a little sound when a sphere was caught. Up until this time, people believed that a mainframe computer was required to do any kind of ray tracing. He showed it to Commodore, who believed he had written it on a mainframe until he sent the source code so they could run it themselves on an Amiga. They immediately purchased rights to use it in their promotional material and ran an article about it in their magazine. It generated so much interest that they asked Graham to turn his home-made program into something more complete that could be sold commercially. Thus was born Sculpt3D in 1987, the first 3D graphics software that could be run on a home computer. It had many features common in today's applications, including primitive 3D shapes, more than one view of the object, a camera (called the Observer), and lights (Figure 1.6). 3D models were made of triangles, of which only a few hundred could be handled by the computer. For long rendering tasks, a cardboard stop sign was provided with the software that read, "Caution: Raytrace in progress".

Amiga computers cost around $3000, meaning that only those with a special interest in computers were likely to invest. It was

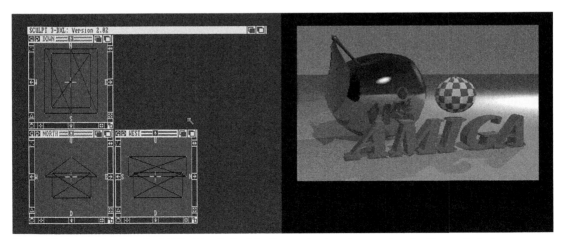

Figure 1.6 Screenshot from David Watts' website, http://www.classicamiga.com (used with permission).

the 1990s before the average person could afford a machine powerful enough to create their own 3D graphics at home. At that point, most commercial programs they were likely to encounter were still in the thousands of dollars, generally used by those who did freelance work. However, computer programmers have a tendency to code for the pure joy of it and share their work. All of the algorithms needed to create 3D programs were public knowledge, and several people programmed freeware to pass around. POV-Ray is a prominent example of these early open-source 3D applications, and is still in existence today.

This trend for free programs continued to go strong. Blender started as an in-house application, was briefly released for free online and sold for commercial use, and then became completely free and open source in 2002 through the Blender Foundation. It is currently the most powerful of all the free 3D toolsets available.

For a few years, only very expensive programs or free programs were available, both of them with interfaces that tended to have steep learning curves. But starting in the early 2000s, with computers common in middle-class households, a new class of 3D software began to be released, with simple interfaces and prices comparable to the purchase of a couple of games. Communities grew up around this new gratifying pastime, supporting other artists.

With this upswing of use, a new kind of commodity came into being: 3D models and other assets, including entire scenes. Modeling is a skill that not all artists enjoy. Many hobbyists just wanted to arrange and pose models in scenes. They could go to websites such as Turbosquid, Daz Productions, Renderosity, and Cornuciopia3D, which provided a market for the communities and activities such as contests. Because of their ability to make money through the sale of content, much of the software that used to cost a few hundred dollars is now free. Part of this content has been tutorials, many of which are free themselves. Many professional artists of today have been mentored in the online communities through these tutorials and personal feedback by professionals.

Modelers are also starting to have another outlet. The advent of 3D printers has allowed the distribution of their creations in physical form.

Because of the increase in computer and console games, and the need for effects and visualization in advertisement as well as television and film, demand for 3D artists and the tools they use has risen. This has led to a lowering of prices for professional-level software, so that now it is within the range of the serious hobbyist. Hardware is also continuing to grow in power as well as

shrink in size and price. For those with a computer and internet access, it is an art form now more easily available than paints and canvas or clay.

3D art on computers has come a long way from being available only to those who could hard code machines. These days, children as young as five are playing with it and older people who could barely draw stick figures can bring to life the beauty that has been in their imagination. Solo artists have already been able to create short animations on their own. Perhaps in the near future, individuals may be able to make entire movies all by themselves.

2

GETTING STARTED
AND GETTING FINISHED

All of us have probably had the experience of being able to form a lump of clay or mud or maybe some wet sand into some kind of animal, vehicle, or object. The feel of the substance as we squeezed it through our fingers and molded it into our sculpture was sometimes even more fun than having the finished project.

Creating 3D graphics can be much the same. Now it will not be your hands, but your brain doing the molding. Your medium is lines and shapes and angles, color, and light. You are no longer bound by the laws of gravity or physics. Any form you can imagine, you can create.

You do have to gain some technical skills for it. But you've done that before, when you learned how to read and use your hands, computer, or cell phone. You'll notice that a lot more is said about your own habits than what hardware or software you use. That's because it is possible to create great-looking images on older computers, using what some consider lesser software. It's been done for several decades. But it is not possible without your effort.

Good Hardware

In order to do graphics, you will need a good computer. Because things change so quickly, it's not practical to give a list of specifications for you to look for. But that isn't hard to find. Check out the specifications of current versions of the main 3D packages (see Chapter 19). Pay attention to the ones you're considering using; then try to go a step or two better. It may be a bit more expensive up front, but this will get you a computer that can last you a while. If you're going to college, you will probably want a computer that can last you all three or four years. And that is a long time in this business.

Putting together a computer can be the cheapest way to do this, if you have the ability or very kind friends. But you can also

have a custom computer assembled elsewhere and shipped to you. Or of course you can get one preconfigured for graphics work off the shelf. But it's not just what's under the hood or on the screen that's important to your work. Graphics work needs a good mouse; a number pad is often useful and so is a tablet. If you must get a laptop, you will need to have a docking station. You will want to be getting your hands on a keyboard and especially a mouse before you buy, if at all possible. Hand shapes and input styles are different for every person. I love my ergonomic keyboard and prefer a small, three-button mouse. My husband hates ergonomic keyboards, and his mouse has lots of buttons on it.

Do make sure you have a good chair that you will be comfortable sitting in for hours. And make sure your screen is at a good viewing level. Nothing stops creativity like an aching back.

Useful peripherals include a scanner and a decent digital camera for textures and inspiration photos. If you're doing animation, you may also want a video camera. Digital cameras often have video capability as well, though you must make sure you have both the battery power and the memory if you intend to use it that way often. Some animators use a webcam to record their facial animation.

Good Software

There are more 3D applications out there than you can shake a stick at. To see a small gathering of the most prominent packages, check out Chapter 19. Choosing which one may feel overwhelming. Luckily, just like cars, you can test drive them before you invest a lot of money. If you are feeling very frustrated with a piece of software, try another one out. Just like the mouse and keyboard, the way we wrap our brain around things is intuitive and very individual. An interface that can be absolutely perfect for your friend may drive you nuts. Some of the software is very specialized, too. It is a good idea to go through this whole book before you settle on the software you will be using. After that, you will have a better feel for what it is that you really want to do in 3D.

Your First Look

The first thing you will notice is the working space. It may be a single large view with a gridded plane that you appear to be

looking at from a corner perspective. This is the perspective or camera view. You will be able to move the camera to any angle.

You may have four views instead. One of those will be a perspective or camera view. The others will be orthogonal views such as top, front, and side. There is no perspective in orthogonal views. Each object you see in the view maintains its size relative to the other objects and distance from camera. Getting rid of perspective and working in the orthogonal views helps to maintain proportions while modeling. You'll be able to move the camera in and out, from side to side, and up and down, but not change the direction it is pointed in.

Most mainstream 3D packages enable you to customize your views, so that you can choose how many you want, their layout, and what they are showing. Some views can show other kinds of information like a list of objects in the scene or a texture editor.

Another element of the workspace is coordinate axes: X, Y, and Z. X typically goes in a horizontal direction, Y is vertical, and Z is depth. This is how to measure the placement of each part of the model, leading also to its size. Usually you will have a representation in the corner of each view, showing how those axes are oriented. Or there may be a kind of navigation system in the upper right corner, showing you where you are pointed.

Characteristics or attributes about what you're working with may be shown by default on the right side. The top and left will be devoted to tools and commands. For those packages dealing with animation, there is typically a timeline below the views.

Because there are so many things a mouse can do, you will need to select a tool before being able to use the mouse to accomplish the task. You may have to press a command, control, function, or the alt key while using your mouse to move the camera. In some applications you can right click on your mouse to open up menus with options that depend on what you are doing with the cursor at the time.

The views you will be looking at are simple depictions of your scene that can be drawn or rendered by the computer quickly in order to let you work interactively with the models. The actual image is achieved by a more thorough render. You will want to see better previews occasionally, and can do this by having the computer render your scene. By default, your software will be set to render at preview or draft quality. You will have to change the settings to improve that. Chapter 16 has more details on those settings. As you read through this book, you will find out more about how every choice you make can affect your final rendering.

Good Habits

There are a few habits to start now that will make things easier and better for you while working as well as give you better results when you finish. Making a plan, keeping things organized, and understanding what will affect your final render are all part of good workflow. Some of these habits are critical for working with teams of animators and artists. Others are important no matter what.

Referencing

Stop and smell the roses. This isn't just a way to chill out; it is part of the artist's process. Always take time to look around you and really see things. Look up at the sky, look down at the ground. Let your gaze trace the horizon and get lost in watching a tree sway in the wind. After a short while creating, you won't have to force yourself to do this. For instance, as you are modeling an old county courthouse, you'll find your eye drawn to bits of architecture here and there.

Take the time to record your observations. Carry around a small sketchbook. Don't worry if you think you can't draw. This is for you, not for public display. Even a simple drawing and/or a few words will bring back to mind the view that inspired it. You can also keep a pocket digital camera (perhaps your cell phone) with you for the same purpose.

As you begin a project, study what it is you will be modeling or animating. Make reference photographs and sketches. Be especially observant of anatomy, and unless you can draw muscle and skeletal structure accurately, use photographs or anatomy books. There are several books aimed at artists for this purpose. Keep all your references labeled and organized in a folder or, better still, tape them onto the wall next to you. Pull all of these into a one- or two-page drawing that will be your concept art. If you have more than one character or setting, you may have several pieces of concept art.

If you are creating an animation, you need to create a storyboard. A storyboard is important not just to help with the flow of action, but also to evaluate what it is you need to do. How many shots do you need to make? How many 3D scenes (or settings) will you need? What does each scene need in terms of models, texturing, lighting, and effects? Keep this storyboard up to look at, and then make a list of everything. Associate the right concept art and reference photos with each item on the list.

Naming Conventions

Before you have even cracked open the 3D tools, you've already got a lot of assets. As you start creating, this will grow exponentially. You keep track of these all using a naming convention. Name everything clearly and keep those naming conventions through the whole project. As objects are created that are part of other objects, you will add their nomenclature to the name. For instance, you may have a main object called Train. A wheel on the train may be called TrainWheelFrontRight. This makes it very clear what it is. You need to set that naming convention early on. If you are working with a team, it may have already been set for you.

Naming conventions and asset management can be complicated for even small projects. An object may have to be modeled, detailed, rigged, textured, and perhaps clothed. Each of these tasks may be assigned to a different person. They will need to know that what they are working with is the right thing. For large projects with multiple team members, asset and workflow management software is available.

Back down to the solo artist's reality, naming is still very important. The application will by default name the primitives and bits of your object something like sphere01. If you have a lot of these in your object list, you'll have a hard time knowing which one to select when you want to work with it. Also, you may forget what you were doing before you had to leave the computer for a couple of days. So make it a habit that you name everything you create that shows up on the list.

Save Often

It is a fact of life that 3D applications crash once in a while. You need to save your work often. Some applications have an auto-save and it is a good idea to turn it on. Unless it is done in the background, this could mean some waiting while the file is being written. That does get frustrating, but not more frustrating than losing the work you just did over the past hour. Set it to a reasonable time interval. With or without that option, you will want to save every time you do something spectacular, every time you are going to start a lot of editing or do something that will change things, every time you get up, every time the phone rings, and every time you see a black cat walk by. If it occurs to you to save in the middle of something, then do it. Intuition and all that. And I'm not kidding. Your subconscious brain may pick up on a pattern as to when your application crashes before you do. So

trust yourself. If you are doing saves before edits, it is a good idea to keep a copy of your scene from before you started changing things.

Pace Yourself

As you first make up your plan, schedule how long you should spend on each part of the project. This will help you as you work with a deadline to not take up too much time fiddling with some tiny detail, or messing around. When doing this, make sure you plan on finishing before your deadline, so when the inevitable problem does show up, you're not up against a wall. While you are a beginner, your goal is to learn your craft. It is said that it takes 10,000 hours of working on a skill to become a master at it. To break this down, that is a bit more than nineteen hours a week for ten years. You can certainly get a job and do well before then, but to really excel you need to put in the hours. This means that you should plan a number of hours every day if you are going to improve. If your goal is professional, industry-level work, these hours are not negotiable.

Even if you are a hobbyist and your quest is geared more toward enjoyment, you will enjoy your art more once you have taken the time to grasp the basics in both theory and working with the application. This doesn't take 10,000 hours, but it does take more than a weekend, or even a month of weekends.

Get Feedback

To help you improve, look for others to offer critique. Ask them to tell you what is wrong with your image. After all, you can't fix a thing if you don't know what to fix. You can find these critiques from fellow artists, usually online at a computer graphics forum. Sometimes it can be difficult to get constructive criticism, as the purpose of people in communities is to encourage each other. Make it clear that you're asking for a critique, and not a "thumbs up". If you are worried about something, ask specifically, though you may want to wait and find out first if anyone sees it as a problem before you mention your concern or frustration. Through schools, there are the teachers, but there can sometimes be industry professionals who will to act as mentors and give critiques to developing artists.

This feedback will not stop once you've gotten a job. In fact, it will be much more to the point. Looking for criticism can assure you're meeting standards, and is also a good way of getting unstuck from some problems. And some of it won't be about what

is wrong, but what needs to fit the client's needs the most. In all cases, when receiving instruction, advice, or a client request make sure you write it down immediately to avoid forgetting it, especially on a job. Not only will this record it for future reference, but the act of physically recording the words can make it stick in your mind better.

POLYGONS: HOW 2D BECOMES 3D

As a kid, one of my favorite movies was *Tron*. Once the hacker was sucked into computer world, it had the most amazing graphics ever. Gone were the blocky and flat pixel sprites of the home video games I'd played. This movie had cool polygon characters and objects that were fully three dimensional. I had never seen anything like it. We were looking at the future.

The very first graphics program, *SKETCHPAD*, used polygonal modeling. This is the oldest method of creating a computer-generated 3D model. And it's also the easiest for many people to grasp when just beginning to create in computer-generated 3D environments. Though there is a lot more refinement because of advances in both processing power and the math used, the computer graphics you see on any screen today are still polygons. Even if other methods of modeling are used, models are usually converted to polygons to make images out of them.

Understanding Polygons

When you first opened up your 3D application, it might be that one of the first things you did was to create a polygon primitive. These are instant 3D objects. If you have any art background at all you know you can do a lot with them. There are several types of primitives: cube, sphere, cylinder, etc. Starting with one of those, say a cube, let's break it down into its parts. The cube is made up of six square sides. Each square is made up of lines, and there are also four corners. Going from understanding these grade-school basics to being familiar with computer-generated models made from polygons is mostly just a trip through a glossary.

The square sides of the cube are polygons. The inside area of a polygon is generally called the face, though some applications call it a polygon. The lines which bound that face are called edges. When talking about the corners of the polygons, we're more concerned about the points which make up those corners than

the angles. Those points are called vertices, or in the singular, vertex. So: face, edge, vertex. These are the basic building blocks of polygons.

To dig a little deeper, let's break these 3D models down into their dimensions. A vertex has no length, width, or height. Zero dimensions. A line has one dimension: length. A polygon has two dimensions: width and length. And a cube has all three: length, width, and height (Figure 3.1).

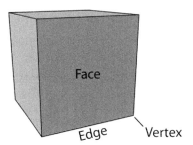

Figure 3.1 A cube.

Polygons don't have to be just squares. They can be made up of any number of edges and vertices (and there is always the same number of vertices as edges), three at least. You need three to make a face, because that makes a triangle. Now triangles, because they are so simple, are easy for the computer to deal with. This makes them ideal for game engines, since they need to render all those 3D models to the screen as you are trying to get your knight to whack a goblin while healing a friend at the same time (Figure 3.2).

Even a four-sided polygon is unlikely to be a square. Their edges can be all different lengths. Four-sided polygons are called quads, short for quadrangle. Quads are another important

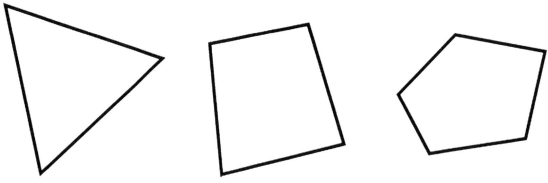

Figure 3.2 A triangle, a quad, and an n-gon.

polygon in modeling. They stack together in a neat, orderly grid and require only one diagonal edge to break them up into simple triangles. For these reasons, and a few others you'll learn about later, a lot of modelers prefer to use only quads when modeling.

And then there are the ostracized n-gons. Any polygon with more than four edges is an n-gon. They are more complicated for the computer to work with and less easy to tile neatly.

One last thing to know about polygons is whether they are planar or non-planar.

Imagine building some polygons out of Tinkertoys, with the sticks making up the edges and the connectors being the vertices. So you've got a triangle, a couple of quads and some n-gons lying on the floor. With any of your creations that have four or more sides, you can bend up a corner so that part of them is lying on the floor and part of them isn't. But if you lift any corner of a triangle off the floor, the entire shape comes up.

Think of your floor as a plane (Figure 3.3). In mathematics, planes have no curves. They can go on and on forever straight in each direction. The triangle can only be on one plane. Existing on only one plane is called being planar. Quads and n-gons can be, and ideally are, only planar. But you can bend up a corner and they can become non-planar. Now, not all applications can work with non-planar polygons. If a polygon is non-planar, it can and will sometimes automatically, be broken down into the simpler and more digestible triangles.

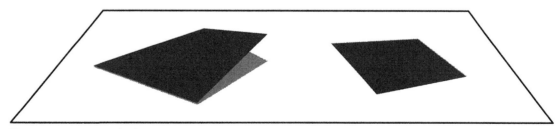

Figure 3.3 Non-planar (left) and planar (right) polygons.

Polygon Meshes

Going back to the cube, notice that edges share vertices, and faces share edges and vertices. They are all connected together. Whenever you have a group of polygons like this that form a model, it's called a polygon mesh. The Master Control

Program from *Tron* was a polygon mesh, and so was Gollum from *Lord of the Rings*. They can be as simple or complex as you like, having only one polygon or billions. The only limit, really, is your system's ability to handle the number of polygons you throw at it.

The cube is an example of a closed polygon mesh. This means that all of the edges are being shared by other faces. There is no hole to get inside the polygon mesh. Now think of a mesh of four quads all stuck together in a plane. That would be an open polygon mesh. Each of the edges that are at the outside of an open mesh are generally called boundary or border edges. A good example of an open polygon mesh would be the leaves of plants you see in many games (Figure 3.4). Close inspection of most in game plants will reveal that the leaves have no volume, but are a handful of polygons in a mesh that is shaped and curved like the leaf.

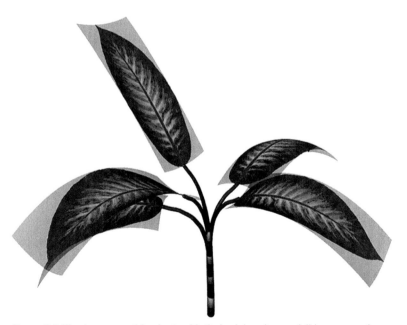

Figure 3.4 The leaves on this plant, with their alpha planes visible, are good examples of commonly seen open meshes.

Starting Your Model

Once upon a time, modeling with polygons was a time-consuming and meticulous process. The position of each vertex

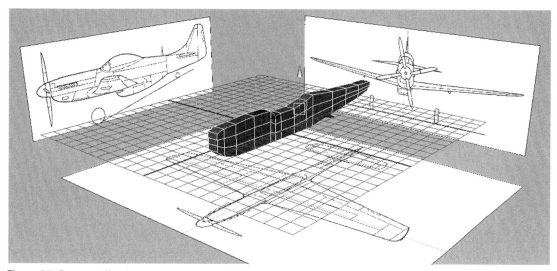

Figure 3.5 Box modeling in progress.

had to be manually drawn in, or even programmed in. These days, things are quite a bit simpler. You can start with polygons or entire primitives, but even drawing in a vertex (if you want) is a lot easier.

There are two popular styles of polygon modeling: box modeling (Figure 3.5) and extrusion (sometimes called edge) modeling.

Box modeling is so named because it starts with a box (a cube primitive). Then the artist scales the object, moves (translates) vertices and edges, and adds more faces by adding edges, so that they create the 3D shape the artist wants. You can think of box modeling as sculpting. One advantage is that it tends to make neat grids and is ideal for subdivision modeling (see Chapter 5).

Extrusion modeling can start with an edge or polygon. Then the artist extrudes (see Extruding, page 29) new polygons from that, building the 3D form around its boundary edges (Figure 3.6). This is the type of modeling often preferred by artists who draw a lot and are familiar with contour drawing. A typical starting point is adding edges around a profile drawing of the object being modeled. Once an entire contour is completed, polygons are extruded so that the polygons bound the edge of the silhouette. Some artists start with a polygon and build the ring of polygons around the profile. Another ring of polygons might be formed around the profile from a different

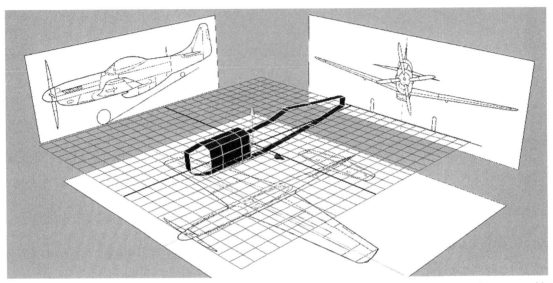

Figure 3.6 Extrusion modeling in progress. The first face which was created when the contour was drawn out with vertices. It was then deleted after the polygons were extruded and another ring of polygons was started.

side of the object. Then more polygons are extruded from these edges until they meet each other in a mesh that fully depicts the object.

Notice in Figures 3.5 and 3.6 that there are pictures being traced. Both types of modeling often use two or more ortho gonal drawings or photographs imported into the application and then fixed so that the artist can trace them. An orthogonal drawing is a depiction of a character or object without perspective. Think of blueprints. These drawings are usually set up as planes in the front view, side view, and top view of your application (Figure 3.7). When using orthogonal drawings, you need to take care that they each have the same aspect ratio and are set up so the edges of each drawing match each other where they would meet.

Another method common to box and extrusion modeling is mirroring. Instead of modeling each side of the object, only one side is modeled. Then its mirror is duplicated and merged into the mesh. Some applications allow you to see the mirror image as you model. This saves a lot of time and ensures a symmetrical model.

3D modeling on the computer is very much an art form and like any artist you will develop your own way of doing things. It's a good idea to do a couple of projects using both box and

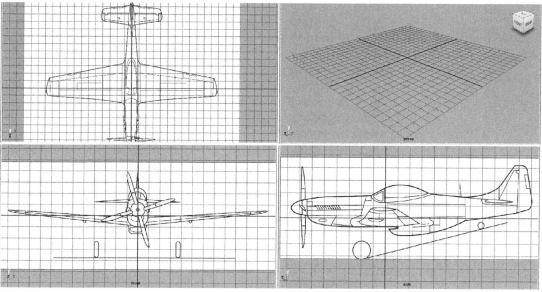

Figure 3.7 Three orthogonal drawings are set up in the top, front, and side views, and as they would be for use in modeling in an application.

extrusion modeling and see what you're most comfortable with. Many modelers use both, choosing the method depending on the circumstance. Within those two large classifications of modeling there are lots of ways of adding bulk and detail to your model. Building your personal set of 3D modeling skills takes lots of time and practice.

Viewing the Object

Let's take a step back and talk about what you're actually seeing on the screen. 3D applications differ in a lot of ways, but are also very similar since they are using the same math and are aimed at human operators.

Chances are, that primitive cube you've got floating in the virtual 3D space (perhaps seen in four views) on your screen is a wireframe view. A wireframe view shows you all the edges that make it up. They are transparent, so you can see through them. That's good for being able to see the back part of the model at the same time as the front. But it can be confusing, especially when there is a mess of other objects in the scene. So other applications start with an object that is shaded. This means that the object is colored and there is simple lighting so

that you can easily pick out which side is which. It appears solid so that you can't see behind it. You can also have a combination of shaded and wireframe. This lets you easily see the edges and vertices while remaining dense, or just a little transparent.

There are a few different other views of the object you could choose. One is to have only the silhouette of the object; this is good when you have several things in the scene and you want to see how they occlude each other without any other details getting in the way. Another possibility is to have your object textured. A textured object has the desired image or pattern applied to it so you get an approximation of what it will look like when you render the geometry. This is better for when you're finishing a project and want to perfect some details.

Editing the Mesh

To begin, you need to be able to select individual components of your mesh, including edges, vertices, and faces. If you started with a primitive, in some applications you will assign the select task to your cursor, and then tell it what component you want to select. At that point you could draw a rectangle (though you may have to specify that type of selection) around a group, or click on just one part at a time. You can also choose the option to select things such as a ring of edges which form a continuous line around your mesh. This is quicker than choosing one edge at a time and useful for moving a whole edge loop.

Once you have something in your virtual grasp, you can move it around or scale it in several ways to form the desired shape. For an example, try selecting a face (or polygon) and pulling it out. You can see how it affects all the polygons around it, changing the shape of your mesh. Now try this with an edge and a vertex. In general, vertices that are not part of the selection do not move. The rest of the model retains its integrity while you create a sharp and steep change of the geometry attached to the changed selection. However, some applications allow you to control how strongly the vertices and polygons surrounding the selected part are affected. When you have polygons from far away feel the effect of changing a face's position; then the change will create a smoother, less steep slope. The mesh behaves like soft clay, and so this is typically called soft selection (Figure 3.8).

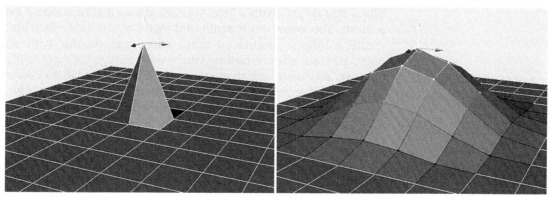

Figure 3.8 An example of regular selection (left) and soft selection of a vertex (right).

Extruding

Extruding is a little different than just pulling and reshaping. It's a way to add more polygons to a mesh. You can select either an edge or a polygon face (Figure 3.9). When you pull it out, the polygons that shared edges with it will remain the same, but more polygons are automatically created which connect the neighboring polygons to the polygon face you are pulling out.

Figure 3.9 Extruding faces and edges.

When you do this with a face, you are often creating a bump on a mesh. You could do it again and again to the same face and create a longer, multifaced tube. When you do this with an edge, you are simply pulling out a new polygon. Once again, you can do this more than once on that same edge to create a path of polygons, a method that extrusion modelers use a lot. Having extruded a portion, you can then manipulate it like any other part of your mesh. This is an essential tool for adding detail.

Controlling Edges and Edge Loops

You may find as you're adding detail that you need more polygons in general to work with. You can get these by adding edges in strategic places. Be careful as you're adding edges, as this also adds vertices and can make a quad into an n-gon, even if it appears rectangular. Some applications let you add or subtract a ring of edges that loops around the mesh or a section of the mesh, as in Figure 3.10. These are called edge loops. Adding an edge loop quickly inserts vertices and edges all around the model. Subtracting edges in a similar way is useful if you need to simplify, have artifacts from modeling, or are preparing your mesh to be added to another mesh. Edge loops are important to

Figure 3.10 An edge loop.

the overall structure of your model, especially with regard to animating it. You will learn more about edge loops in Chapter 5.

Subdividing and Simplifying

Both adding and subtracting edges can be done across the entire mesh. Adding edges increases the number of vertices as well as polygons. This is called subdividing, and is explained in more detail in Chapter 5. The basic thing to remember is that the more polygons you have, the smoother a curved surface will appear. You can simply subdivide your mesh, or you can subdivide and smooth (Figure 3.11). You can move subdivided edges before you smooth. Smoothing averages out the vertices, so that it has fewer sharp angles. Automatic subdividing in many applications means both the process of increasing the number of polygons by adding edges in between each edge across the entire mesh and then of smoothing.

Likewise, you can decrease the number of polygons in your model by reducing or simplifying the model. To simplify just a small area, you can select individual edges and delete anything unnecessary.

Combining Meshes

It is often easier to sculpt different parts separately before combining them into a single mesh. This is also a great way to

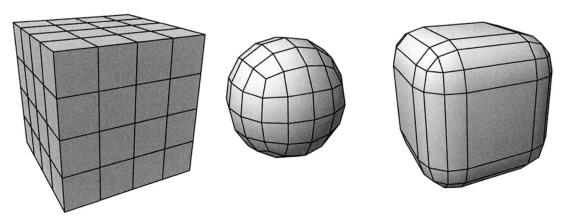

Figure 3.11 A cube. The cube subdivided, subdivided and smoothed, and chamfered. Notice that a similar number of edges was added to the chamfered cube, but they were moved so that the basic cube shape remains, but the corners are beveled.

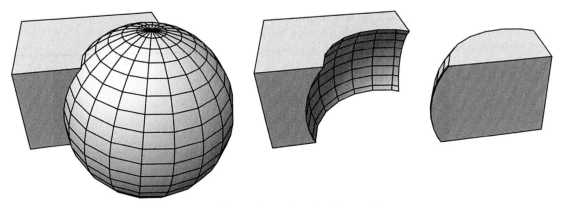

Figure 3.12 Boolean operations, from left to right: union, subtraction, intersection.

build a library of assets for future projects. There are several ways to combine polygon meshes, each with its own advantages.

One of the simplest to perform is a Boolean operation. Here, you will place your completed meshes together in the 3D space and select the Boolean operation you want. There are three that are typically used: adding (or union), subtracting, and intersection (Figure 3.12). When you add two meshes together, they simply combine to make one mesh. In this kind of combining, the surfaces that are buried into each other still exist. This means that any overlapping polygons still exist, which adds to the complexity of the mesh. When you subtract, you will select the mesh you want to keep first, then the mesh, then choose the Boolean: subtract operation. This will cause the second mesh to "disappear", removing with it the section of the mesh that overlapped the first mesh. When using the intersect or union operation, only the overlapping areas of both meshes will still appear. Boolean operations are good tools to create more complex models from primitives and can be used on Nurbs, subdivision surfaces, or any kind of 3D model. However, the computer does all of the calculations. This can result in a somewhat messy mesh that requires cleaning up, including deleting faces that may appear on the inside of your model and deleting, adding, or adjusting edges, vertices, and faces to get back to a neater grid-like geometry.

Another way to combine two meshes is to weld them (Figure 3.13). Here, you will specify vertices on the border edges from two different meshes. When you weld them together, those vertices and the edges they make up will combine into one. You could also bridge two border edges. Here, a new edge will be drawn between the selected vertices,

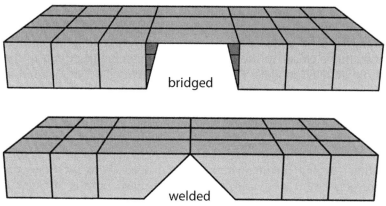

bridged

welded

Figure 3.13 Bridged and welded edges. Notice with the bridged object that new polygons were created to connect the edges. You can add as many divisions as you want to these new polygons.

so that new bridging polygons are created between the border edges of the two meshes. This bridge has the advantage that you can further subdivide it if needed. Both of these operations can be automated if you have selected two entire border edges, and have them properly aligned and with the same number of vertices.

Polygon Count

The polygon count is an important aspect of a mesh. The larger the polygon count, (Figure 3.14) the more detail it will have. But it will also take more processing power to manipulate the mesh. This translates into time: the more polygons you have, the longer it will take to render. With the right equipment, none of this may be an issue. However, if you are modeling for games, you

Figure 3.14 Polygon meshes with different polygon counts. Notice that the amount of detail and the smoothness of curves increase as the number of polygons increases.

may very well have limits. In fact, some games have the same model with different levels of detail. Those models farther away from the camera do not need as many polygons to look good. As they move closer to the camera, the game changes them to the more detailed models. This controls the overall polygon count of the animated scene that the computer must render in real time. No matter the goal or resources, it's a good idea always to keep an eye on how many polygons you are using.

As you're modeling, start with a rough sculpture; then slowly add detail only where needed. Quickly adding edges and polygons when you are unsure whether you'll need them increases the polygon count and also makes your mesh editing trickier. A well-done model has fewer polygons in places of low detail and increases mesh density only where needed. It is usually easier to add polygons than to remove them.

There is more than one way to calculate polygon counts. Sometimes, those that you actually see drawn are those counted. Other times, polygon count has more to do with the vertices. And in other cases, the polygon count is the number of triangles making up the model. Even if you've used quads or n-gons, extra edges will be added into the calculation to split them into simpler but more numerous triangles to come up with a polygon count. Many applications make it easy to keep track of polygons, sometimes showing a count on the interface or with a simple click.

Normals

In computer graphics, polygons have a back face and a front face. When a primitive is created, this is easy enough to define: the side of the faces that you can see are the front faces. You can also think of this as the direction that the polygon is pointed in. This is called the normal. Another way to visualize it is to imagine a line that points straight out, or perpendicular to your polygon. It makes your mesh look like a pincushion (Figure 3.15).

Normals are important to calculate how virtual light interacts with the model, as well as several other rendering calculations. Keep track of the directions your polygon faces are pointing in. Normals on a mesh should all be facing the same way. You may find that with some automatic operations such as filling in holes in a mesh, polygons can be created that face in different directions to those near them. In those cases, you will have to fix these before you can move forward with the model.

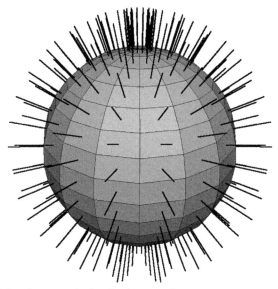

Figure 3.15 A polygon mesh showing its normals.

UV Coordinates

On any type of model you create, you will need to have a way to measure locations on its surface. This is done using UV coordinates. U is measured across one direction and V is perpendicular to that. These locations will allow you to map a 2D image onto your 3D object, giving it a texture.

Aesthetics and Compatibility

There are several things to consider about the look of your model. As mentioned before, many artists prefer to use only quads. Even if you're modeling for a game, triangles can create sharp angles when there is a lot of detail or curves. Quads tend to reduce this effect. It is easy enough to split them into triangles once you have finished modeling. Polygon modeling is the first step to creating a subdivision surface model. Because the polygons are subdivided automatically, having a mesh that is already a neat grid of quads will make a smoother subdivided model and make animation easier since deforming will be more predictable.

You should also avoid having polygons that are very different in size next to each other. When these are smoothed out using

subdividing, or deformed when the model is posed, you may get bumps or ripples. Having more or fewer than four edges originating from a single vertex (such instances are called poles) can cause pinching in a subdivided model. Another common snag in modeling is polygons that are unusually shaped, like T-shaped polygons, or convex — a polygon where some of the lines are drawn inward, toward the inside of the face. Some of these strangely shaped polygons may not even be valid in the application you are using.

When you are just getting started, it's a good idea to follow these conventions. However, with a little experimentation, you may find that the properly used triangle, n-gon, or pole can give you just the surface you need on your model.

Valid Geometry

As you can imagine, there could be several possibilities where your application will not allow certain geometries. Different programs differ in what they can and cannot work with so by keeping in mind the typical rules, you can create a polygon mesh that is easy to export for further development or to sell. Below is a list of things to look out for.

- Every vertex must be a part of at least one polygon, as should every edge. You will often get stray vertices when an edge has been deleted. Watch out for these.
- Any vertex can only be used once in the same polygon.
- All edges in a polygon must be connected to each other.
- Only two polygons can share an edge.
- A polygon may not cross itself.
- Some programs do not support convex polygons.
- Do not have a vertex that is the only connection point for two parts of a model (think of a vertex being shared by two cones meeting at their points).
- Avoid edges on top of edges and faces on top of faces.
- Be careful of any holes you leave in a mesh: areas that may appear to be a polygon, but which are simply border edges.
- Valid meshes have all the normals pointing in the same direction.

Lots of these things may occur when you're using automatic operations. Be sure to inspect your mesh for them. Many applications have special scripts to pick out bad polygons or polygon meshes. Using these right after important steps in your modeling can help insure that your mesh will be clean and usable.

Tutorial 1
Simple Polygon Robot

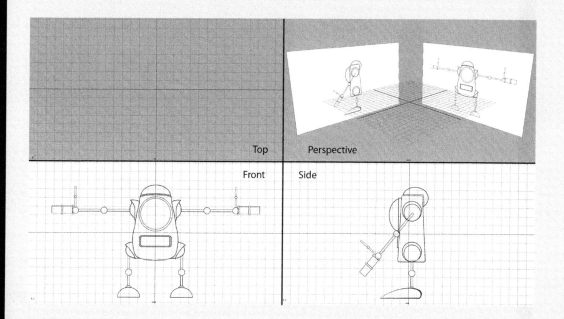

Step 1

Download RobotFront.jpg and RobotSide.jpg from the book's website, www.3dartessentials.com. Start a project in your application and place the pictures as image planes in your front and side orthogonal views. Make sure they are centered and all parts are vertically aligned, except for the arms, which have been put at different angles in both pictures. The grid can be very helpful for this. If you want to keep the image planes in your perspective view, you can move it back along the orthogonal view's axis by enough units to put it behind the perspective view's grid.

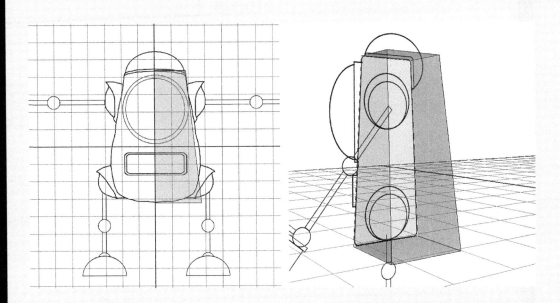

Step 2

There are two ways to start this. With extrusion (edge) modeling, you will start on the side view. Draw a polygon tracing the main body, using only four vertices. Don't worry that it doesn't match the beveled corners exactly. That will come later. Put your vertices a bit outside the bevels, as smoothing will pull surfaces inward. Select the polygon's face and extrude it in the front view. It will be starting from the center. Pull it to the farthest edge of the main body.

With box modeling, you will create a cube, with one face on the side view plane. Then, still in the side view, select the vertices at the corners and move them in to match.

Do not include the big round top or its border in your cube. Name the shape Body.

Now, no matter how you started you will need to go to the front view and move those corners to match. Select the two vertices on the top at the outside edge and move them into that corner of the main body. It helps to select by bounding with a rectangle to get all of those vertices on the corner. Moving multiple vertices can help to keep things in line. Usually there is also a way to single select more than one by using the keyboard as you select each one with a mouse.

Delete the face that is on the side view plane — the one that is down the center of the robot image in the front view. If you extruded, it's the one you originally drew.

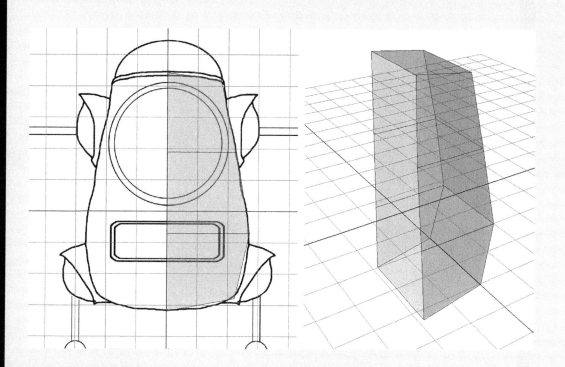

Step 3

You will want to add more details to make the main body match the drawing more closely. To do this, you will add edges to the box. You can often easily add more edges that go all the way around the model. Insert an edge loop toward the bottom, and one near the middle of the eye. This will make three subdivisions along the width and across the height. Now select vertices and move them into place. Try to select as large a group of vertices as possible to move at once; then start moving smaller groups to tweak.

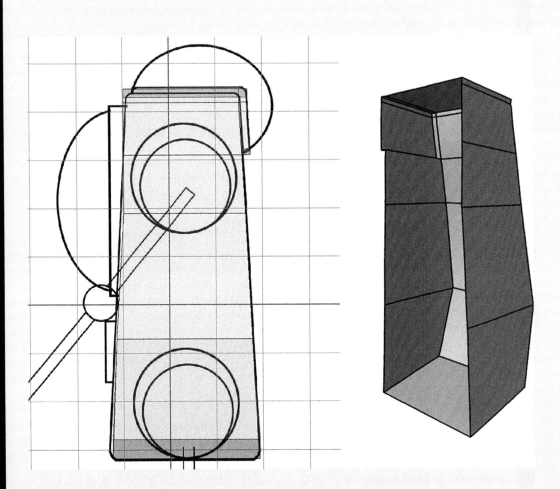

Step 4

To create a sharper corner for more interest on the top of the head, you'll need another edge loop. Going from the side view, add an edge loop at the place where the border for the brain case starts in the back. Extrude the face that's on the top up just a bit to make the border on top, and then extrude the back face for the border and the new skinny face that was made with the top extrusion, once again just a little. With this done, you'll probably have new faces on the open center by all the newly extruded faces. Make sure you delete these.

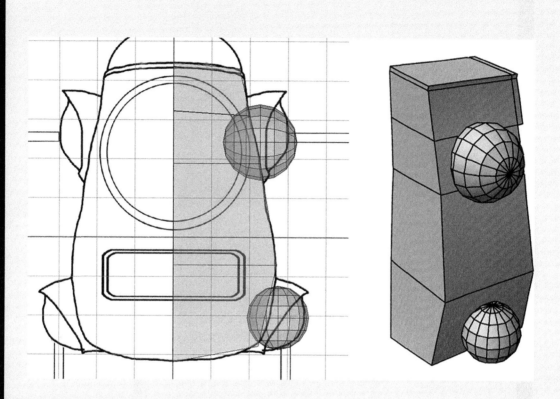

Step 5

Create a polygon primitive sphere in the side view. You will want the height axis to be along the axis that the arm will go, so that the "longitude lines" go in that direction. Size it and place it to match the sphere on the right shoulder. Name the sphere Shoulder. For the hip joint, copy the shoulder sphere and place it at the hip. Rotate it 90 degrees so that its height axis points along the leg. Size it so that it is a bit smaller. Name it Hip.

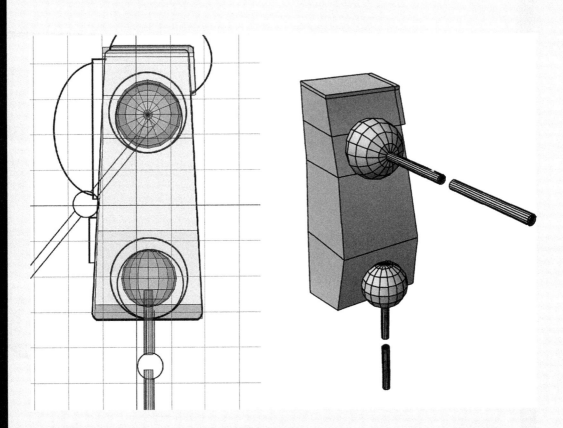

Step 6

Starting on the side view, create a cylinder primitive. Size it and place it so it matches the upper arm limb and is in the middle of the shoulder sphere. Copy the cylinder, and place it on the forearm. Copy again, this time rotating and moving it to the thigh. Resize it to match. Notice that the hip joint as a ball joint would be awkward because of the angle of the thigh. Resize and move the hip joint. It may not match the picture exactly, but that's okay. It happens sometimes, especially if your image plane is just a sketch. It's more important that the model be more structurally sound for later rigging. Now copy the thigh cylinder, then move that copy down to become the lower leg. Make sure you name all of the cylinders: UpperArm, LowerArm, UpperLeg, LowerLeg.

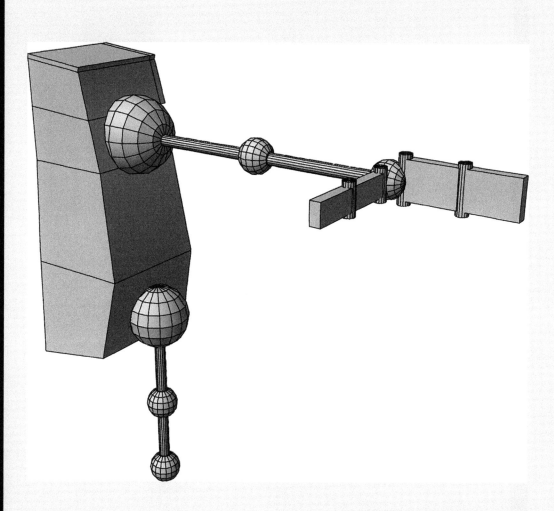

Step 7

Now create a sphere for the elbow, make copies, and place them at the wrist, knee, and ankle. Remember to keep their axes aligned along the arm and leg the same way the shoulder and hip spheres are. Name them accordingly. To create the hand clamp start by making cube primitives, sizing them, and placing them as per the picture, keeping a gap for the hinge joints. The thumb clamp should be a bit narrower than the palm clamp. To make hinges, create little cylinders and place them at the base of the palm clamp and thumb clamp, then between the finger and hand clamp and the thumb and second thumb clamp. Name each shape.

Step 8

Now, just to work with and see in future tutorials, you are going to mirror the main body. Select Body. Because of the way you created the shape with the image planes, along the center of the front plane, Body should already be in place. This is also the reason for deleting the face and having the shape open. There will be some options for mirroring the geometry. Make sure you choose the right axis or else it will mirror in a direction you don't want. Also, select the option to have the vertices merge. Otherwise, it may merge borders while still keeping those edges and you will find extra vertices and edges down the middle.

NURBS: THE SPLINY TRUTH

In the earlier days of computer graphics, it simply wasn't possible for processors to handle huge numbers of polygons. Practical models made with polygons had angles and looked artificial. Modelers wanted a way to get nice-looking curves, originally to make more organic-looking models. Pixar, in particular, experimented successfully with the use of NURBS in its production of the first fully computer-animated movie, *Toy Story*.

NURBS (non-uniform rational Bezier splines) are specialized curves. They can be cross-hatched together to make a grid of curvy lines, which is called a NURBS surface. In today's fast computing world, they are not used at all for organic models, but are a great way to model things such as cars and toaster ovens. You've probably noticed their effect in the design of these real-life things.

Just like polygons, there are as many ways of dealing with curves and NURBS as there are applications out there. Not only could names be different, but the apparent way of building or showing the curves may be different. But if you understand a few key points, you will find it pretty easy to deal with them in whichever application you choose.

From Straight to Curvy

It's easy enough for you to draw a curvy line, but how do you get the computer to calculate one? You add new properties to it. The more intricate the curve is, the more tools you need to control it. We will start with simple and grow from there.

Straight lines have endpoints. These points have only their position which defines the beginning and end of the line. For a simple curve, you can turn these endpoints into control points or control vertices. The control points of a cardinal curve have another property: variable slope. Now you can turn them, much like a steering wheel. The slope, or slant of the line changes. But it doesn't affect the whole line, as if it were a stick swinging around on its end. Instead, it acts more like a stiff rope, with the effect of

3D Art Essentials

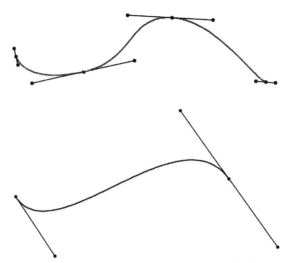

Figure 4.1 On the bottom is a cardinal curve. Above it is a Bezier curve.

the variable slope getting smaller the farther away from the control point it gets. This kind of a curve is called a cardinal curve (Figure 4.1).

For a more complex curve, you can add more points in the middle to control it. This makes it a Bezier curve (Figure 4.1), which can have any number of control points. This brings up an important property that you will work with: the degree of a curve. The degree is equal to the number of control points on a curve minus one. Another way to think of it is the number of spans between the control points. A curve with four control points is a third degree curve and has three spans. The higher the degree of the curve, the more complicated the mathematics. And while computers aren't going to mess up the math, they will take longer to calculate it. One solution is to create several Bezier curves and connect them together. But this has its own problems. Instead, one can use another type of curve called a Bezier spline or B-spline.

The term spline comes from the tools draftsmen used before computers were available (Figure 4.2). Flexible pieces of wood, plastic, or rubber tubing would be held in place by carefully placed lead weights. The strip of material would curve around the weights in the smoothest way possible. The draftsman traced a line along the strip, gaining exactly the curve they needed for the ship, automobile, or any other object they were designing. Once this process was described in mathematics, it could easily be simulated on computers.

Figure 4.2 A spline such as those used by draftsmen before computers.

The most noticeable difference between a Bezier curve and a B-spline for the artist is that the control points are not on the curve itself, with the exception of the beginning and end points. They are connected to each other by lines, creating a controlling polyline often called a hull.

Here, the degree of the curve comes into play again. A spline is made up of several equations that define a series of curves. That is why it makes a better solution than connecting several Bezier curves together. These curves all have the same degree, and it is the degree of those curves that controls the shape of the resulting spline (Figure 4.3). The degree no longer shows the number of control points. Instead, it gives a clue to how close the curves of the spline will be to the control points. In general, the larger the degree, the closer the curve of the spline will be to the polyline. Some applications refer to a curve or spline's order rather than its degree. The order of a curve is its degree + 1.

Another controlling aspect of splines is the knots. The knots are the numbers that show the extent of influence a control point has on a span of the spline. Knowing the degree or order of the curve and understanding how knots work can help you to grasp the behavior of the curve you're creating. You will probably have access to these numbers.

Figure 4.3 Third, fifth, and seventh degree B-splines.

One more important controlling characteristic of B-splines is the weights associated with each control point. Weights basically indicate how much a control point affects each span of the curve. A simple B-spline is one where all the weights are the same, so the control points each affect the curve with the same intensity or uniformity. Thus, it is uniform and non-rational. When the weight values of control points are different, this is called a non-uniform rational Bezier spline, or NURBS (Figure 4.4).

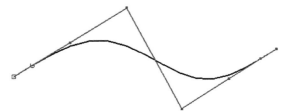

Figure 4.4 A NURBS curve.

Creating and Modifying Curves

To make a curve, you can add a curve that is already drawn and then edit it, draw it freehand, or draw in the control points by yourself. This last method is perhaps the best way to get a feel for how curves work. The control points may appear to be part of the curve itself, or may be the control vectors of the hull or polyline.

You will see the curve grow and change shape naturally as you add each control point. Often, the endpoint of the curve is attached to the cursor while creating, allowing you to see what the shape of the curve will be before you click to create a control point.

To change the slope of a curve, you have control handles on each of the control points. The handles are always tangential to the curve. This means that at the control point, where the handles connect to the curve, they have exactly the same slope, or go in exactly the same direction as the curve. As mentioned before, they act like steering handles. Turn a handle in one direction and it pulls the slope of the curve in that direction. The displayed length of the control handle may affect its influence too. You can also move the control points of the curve to change its shape.

In order to refine your curve, or give you the ability to add more detail to it, you will have to insert a point. Usually this is accomplished by selecting an insert task, and then clicking on the curve or polyline where you want it. Sometimes, this will be called insert knot. Inserting a knot is not exactly inserting a control point or vector; however, the number of knots is equal to the degree of the curve plus the number of control points. Therefore, unless you change the degree of the curve, inserting a knot effectively inserts a control point. Even if you directly add a control point, a knot will automatically be added.

NURBS Surfaces

NURBS surfaces act very much like NURBS curves. To create a surface, you can start with just one curve, sweeping it. As it is swept across, several curves will be created as part of a grid of curves. Rather than all going in a straight direction, it is possible to sweep the curve across another curve or to have multiple curves criss-crossing each other. You will control your surface using a hull. Instead of a single controlling polyline, the hull is a gridded surface. This is the network of control vectors connected to each other by the polylines of the curves that make up the surface. All control points on a surface are intersections of two curves (Figure 4.5).

As with polygon meshes, you can measure a NURBS surface using UV coordinates. In fact, it is a little easier, as the grid makes such mapping automatic. The curves are only added in the U and V directions, more or less perpendicular to each other. So you will get quads making up your surface. Even if it appears that there are

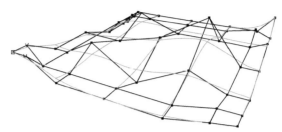

Figure 4.5 A NURBS surface (in gray) with its control hull (in black), control vectors, and the U and V directions.

triangles, as is often the case with something like a NURBS sphere, closer inspection of the curves and control points (opening them up at the top of the sphere) will reveal a four-sided face (Figure 4.6).

Adding detail to a NURBS surface can become very involved. You cannot simply insert a single point on the surface or hull. You must add at least one curve. And if the position where you want to add a point has no curve at all going through it, you will need to add two curves. Using a single surface to model something like a face, which has wide areas with little detail and other areas with lots of detail, can become complicated.

One solution to this is to create a model out of more than one NURBS surface. When doing this, each surface is called a patch or a NURBS patch. Creating with patches works very well, but it requires some planning. At the edge where you join the patches, the seam, you must have the same number of points to join patches together (Figure 4.7).

Figure 4.6 In this sphere, the endpoints of the curves have been pulled out to reveal that the segments do not end in triangles, but are still four sided at the poles.

Figure 4.7 Connecting NURBS patches together.

Creating and Modifying NURBS Surfaces

Many of the techniques used in polygon mesh creation can also be applied to NURBS. For instance, extruding works very similarly. You select a shape or a curve and pull it out. The object is duplicated, and as you pull the two copies apart, they remain connected around their entire border by what appear to be straight lines. They are straight, but because the lines have all the properties of curves it is possible to move control points to add curvature to them. This will create a fully enclosed surface or mesh.

Extruding does not have to happen along a line. It can be swept along a curve, or in the case of revolve, it is drawn around a central axis creating a circular model with the contours of the original shape. Revolve is a tool that can also be used for polygon shapes.

Lofting is another creation tool. Here, two different shapes are connected along their border by lines at each control point. As with joining edges of NURBS surfaces or polygon mesh, you need to ensure that there is the same number of control points. You must also make sure that the positioning is correct, so that you do not get unwanted twisting.

Advantages and Disadvantages of NURBS

NURBS curves have several advantages when it comes to modeling. Once you get the hang of manipulating them, they are easy to shape. Because of the standard math used to describe NURBS, it is possible to use them across multiple applications. And being a true curve, rather than a collection of straight edges, NURBS can offer smoother surfaces with a smaller footprint in your memory storage and faster processing. At one point, NURBS

modeling was a welcome leap forward in 3D computer modeling technology and was very popular in the 1980s and 1990s.

However, they have the disadvantage of being difficult with things like sharp corners. Whole surfaces do not deform well, making it hard to animate organic creatures. Patched surfaces split or kink when deforming. In addition, NURBS surfaces are usually converted to polygon meshes for rendering, since render engines calculate light against faces, not curves. As a result, the direct and/or exclusive use of NURBS for modeling is now falling out of favor. Still, a well-rounded animator should at least grasp the basics. Knowing the behavior of NURBS curves and surfaces will give you a running head start to understanding the next big thing: subdivision surfaces.

Tutorial 2
NURBS on Robot

Step 1

Open up the project with the robot you started in Chapter 3: Tutorial 1. To make its feet, draw a curve tracing the top of the robot's foot in the side view. Make sure you specify the axis that would be at the bottom of the 2D foot shape. You may have to move your curve object's local axis there. Then apply a revolve operation, setting it to only 180 degrees, to make the curve of the foot. You will notice that the robot has a very pointy toe. Select all the control vertices of the tip and scale and move them to make it a more rounded shape. Try scaling with all axes and then with each one to see the behavior. You may want to even out the back of the foot as well. The bottom of the foot will be open. Close the open surface, so that the foot is fully formed, rather than being like an upside-down bowl. The original curve you used to revolve and create the foot may not be part of the object. Make sure you delete it.

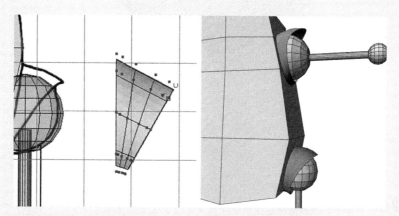

Step 2

For the shoulder and hip guards, start at the hip in the side view. There are two circles there, an inner and outer. Create those two circles. In the front view, they will probably be on the Y axis. Move them out to work with them and then move the smaller one further to the right. Still on the front view, rotate the smaller circle about 15 degrees so that it tips away from the other circle. Move it so its lower edge is a bit below the larger circle's edge. Select both circles and loft them, including three spans in the new curves which will be drawn. Place the hip guard over the hip joint and use the control vertices to stylize it. Copy and move it to the shoulder, then stylize that one. Delete the circles that you originally lofted with.

Step 3

Create a NURBS sphere and place it where the eye is. You will need to flatten it along the Z axis, on the side view. This is just to give you an idea of what a NURBS sphere looks like. Make another sphere for the brain case. Place it and resize it approximately. Then use the control vertices to make curves matching the image plane drawing of the brain case.

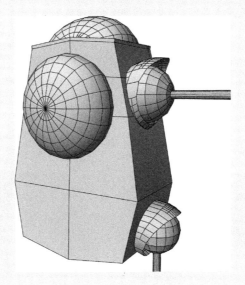

Step 4

For the purposes of creating the entire robot, all surfaces will need to be polygonal. Select each NURBS surface, the foot, the hip guard, shoulder guard, and the eye. Choose the convert NURBS to polygons tool. Make sure that it will be converted into quads rather than triangles at this point. There will be quite a few settings that you can play around with. Try them out to see what happens, using the undo button if they don't work well for you, until you get the best result. Because of the curves, not all the polygons will be the same size on the feet and joint guards. The more polygons you use, the closer to the curves your mesh will be.

SUBDIVISION SURFACES: THE MARRIAGE OF POLYGONS AND NURBS

As the drawbacks of NURBS became apparent when they were put to the test in feature film production (Pixar only used NURBS for their first feature-length film, *Toy Story*), experts turned back to modeling with polygons. By the mid 1990s, computers were magnitudes faster. Rather than using mainframes, racks of computers were connected together in huge networks. Technology had caught up with the need. But how could the artist manage so many polygons?

The solution turned out to be subdivision surfaces. This trick was developed in the late 1970s by two teams. Ed Catmull, founder of Pixar, was a member of one of those teams. After trying out subdivision surfaces in the Pixar short *Geri's Game*, they were used to make *A Bug's Life*. Subdivision surfaces are the most common type of modeling done today.

Subdivision surfaces are made up of polygons. But controlling them is very similar to controlling NURBS. You start by modeling a polygon mesh, then subdividing it one or more times so that the number of polygons is multiplied and the model becomes more rounded and smoother. The original polygon mesh becomes a control cage, acting much like the hull of a NURBS surface.

Subdividing

Let's say you've made a square-shaped pizza, and you want to cut it up into four equal parts. You can see immediately how to do it. Cut down the middle in one direction, and cut down the middle in the other direction. You've just subdivided your pizza into four squares. In modeling terms where there was one face, there are now four faces. Cut down the middle of each square again — you'll be making four cuts — and you'll have

sixteen squares or slices of pizza, just the right amount to get a party going.

Think of the pizza as a flat quad polygon. Cutting down the middle of the pizza added two vertices in the middle of edges that were opposite each other and cut an edge between them. Another way you could do this is to cut a piece from the middle of the edge to the middle of the quad. That turns out to be the best way, since you can also use this method to subdivide a triangle or an n-gon (Figure 5.1).

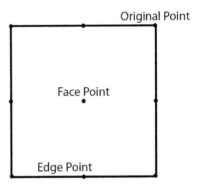

Figure 5.1 The parts of a polygon used when subdividing.

Once the faces have been subdivided, they need to be smoothed. So, back to those original four corners, which are called the original points. An average is taken using the center of the quad and the new edges' vertices. This new point becomes the new corner vertex. The edges are now drawn from those new middle edge vertices to the new vertex.

What about when we kick it up a dimension, and work with a cube instead of a square? The six faces of the cube become twenty-four. The same smoothing operation takes place, but now the original points are using all the edge points and the average of the face points of faces connected to them to get their new position. In the case of the cube, the average of the three face points connected to an original point turns out to be the middle of the cube. But this kind of average works well for more complex models too. This first subdivision step makes a rough sphere. If we do a second subdivision step, it looks even more like a sphere, and so on. Some applications will have a smoothing operation. This works similarly, but is not pure subdividing. For instance, a smoothed cube will have its corners rounded out, but will retain the cube shape. A subdivided cube will become like a sphere.

What I've just described is Catmull–Clark subdividing (Figure 5.2). This is the most efficient method that gives a good

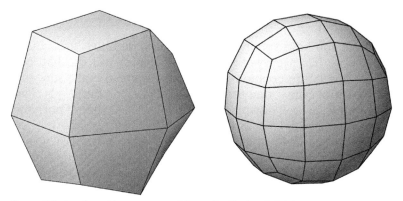

Figure 5.2 A cube with two steps of Catmull–Clark subdivision.

enough result to be usable. It is pretty much the only one that is used in any application you're likely to work with.

Other Subdivision Methods

Two other types of subdivision methods are also worth mentioning (Figure 5.3). Doo–Sabine creates a new face at each original point and the edges connecting to those points. You can think of it as "cutting" each corner out to replace it with a face. It has the characteristic that every new vertex will always have four edges connected to it. After several iterations of this type of subdivision, a cube tends to remain a cube. However, all corners become beveled and applying a UV mapped texture can be tricky, as the original edges are now faces. The other is loop subdivision, which splits each triangle face into four triangles by connecting middle edge points, then averages out the vertices to smooth it. This method is very useful when only triangles can be used in modeling.

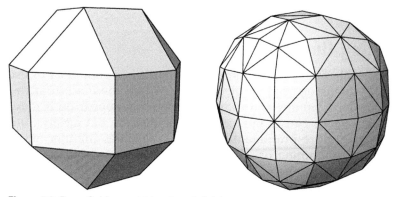

Figure 5.3 Doo–Sabine and triangle subdivision.

Topology

Once you have subdivided a mesh several times, it begins to look more like a curved surface. But before you do that, and during the entire creation process, you want to make sure that your control cage — that first, undivided polygon mesh — is clean and simple, as well organized as possible. The layout of polygons across your mesh is its topology.

Imagine a sheet of rubber. You can stretch it, twist it, and deform it in countless ways without ripping or cutting into it. Topology studies how the sheet is changed when you deform it without ripping or cutting it. Likewise with polygon meshes (Figure 5.4).

When you subdivide a mesh with good topology, you will be able to predict the smoothed outcome better. It will be easier to rig and pose with more accurate deformations. It is also important for applying texture to your model. Understanding topology is essential to creating good models.

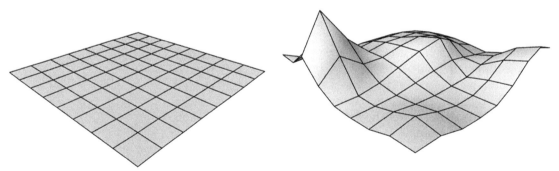

Figure 5.4 Both of these meshes have the same number of polygons. Notice how deformed the mesh can get, and how the placement of each vertex affects the edges and polygons.

Using Quads

In Chapter 3 it was mentioned that it is a good idea to use only quads on your polygon mesh. Where there are triangles or n-gons, bumps and other artifacts may appear on a mesh (Figure 5.5). Theses bumps do not appear on flat meshes, but become more prominent as a mesh becomes rounder either during smoothing or when deforming a mesh as it is posed. While it might even be that the bump is desirable and adds a detail you want, care must still be taken. For instance, the behavior of a bump occurring because of an n-gon may

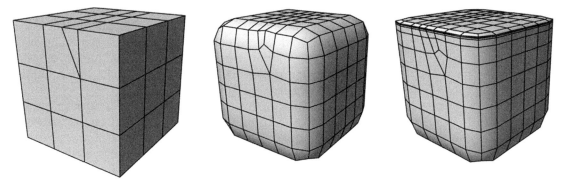

Figure 5.5 In this image, the triangle on the corner results in a bump when the shape is subdivided and smoothed. If you add some edges to bevel the corner, the bump is reduced and the corner is made sharper.

not flow with the rest of the model as it deforms. It also reduces cross-platform compatibility, since 3D applications deal with n-gons differently. This is one of those cases where you should stick with the rule until you are familiar enough through repetition to know exactly what happens when you break the rule. Experience will teach you how quads and n-gons behave and you can learn to use them to your advantage.

It's not really that quads are tamed and triangles or n-gons are wild. What is mostly going on is the difference between the size of polygons neighboring each other, or rather the changes in the space between vertices. This may cause a ripple in the mesh as it is rounded. This also applies to areas of high density near areas of low density.

The steeper the curves, the more prominent the distortions can become. One way to overcome this is to use extra edge lines running parallel to sharp corners or curves in your mesh. These edge lines should be perpendicular to the edge lines that are being bent. This shortens quads and brings them each to a more similar length, minimizing bumps that may occur along the beveled edge because of differences in quad density or size. As a general tip and not just a problem solver, the closer you put these extra edge lines together, the sharper you can make a turn.

Poles

Poles are vertices that have more or fewer than four polygon faces attached to them. Like triangles and n-gons, poles may

cause the mesh to deform in a way that you don't want when you pose the model. Though you can minimize their occurrence, poles are unavoidable when you are modeling anything with detail, most like human faces. There are two common types of poles that appear as you shape your model: the E(5) pole and the N(3) pole (Figure 5.6).

An E(5) pole happens when you extrude a surface, at the vertices that you extrude from. Take a simple quad mesh and extrude one of the quads. At a vertex at the base of the extrusion, where once there was a single polygon face and two edges, there are now two faces and three edges. This makes five edges coming off the vertex: an E(5) pole. N(3) poles also appear during extrusions. At the top of the extrusion, a vertex of the original quad that once had four faces connecting to it now only has three faces and three edges.

Sometimes, poles are not very useful. Modelers often hide them in places where they cannot be seen and not much movement will take place, such as in an ear. But poles can also be used as important tools to manage the deformation of the mesh by controlling the flow of edge loops.

Figure 5.6 An E(5) pole and an N(3) pole.

Edge Loops

An edge loop is a continuous line of polygon edges that comes back around the mesh to connect with itself and form a complete loop (Figure 5.7). This makes a loop of edges. These edges must all have vertices with only four edges going off them. Otherwise, the path stops.

The placement of edge loops is very important to how models deform. This is where understanding anatomy becomes important. Especially in faces (Figure 5.8), edge loops flow with the placement and direction of muscles so that when the model is deformed for animation, the deformation looks natural. For instance, when someone smiles, the corners of the mouth pull up, the cheek bulges, and the eyes crinkle. Good topology with edge loops will make this happen automatically. It is good practice to use a reference photograph (or a drawing if the artist is really good and gets accurate anatomy down), and draw out where the edge loops should go before you start modeling. Faces are unique not just on the surface, but also in their musculature. When someone smiles, it may be wide or the corners may pull up particularly high with narrow cheek bulges. Because of this, there is no one edge loop standard that can be used for every face model.

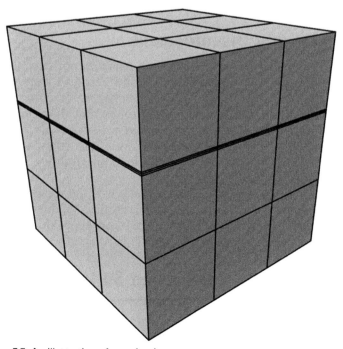

Figure 5.7 An illustration of an edge loop.

Figure 5.8 A photograph of a face with edge loops drawn on, and an illustration of the same face modeled with subdivision surfaces.

Enlightening Disagreement

Some experienced subdivision modelers do not strive to use edge loops and only quads in their models. Instead, they simply go with the flow of adding edges and polygons. They have seen how all the quirks behave so many times that they can often predict what will happen to the mesh in any situation. One thing you see is that even if there are not continuous edge loops, the flow of the edges still matches the lines of structure and the muscles of living creatures.

Other modelers sculpt a mesh freely with no quads at first, since it allows for a faster and more creative building process, then refine the details later to quads and edge loops. A few applications are even geared for this kind of creation.

Modeling with Subdivision Surfaces

Subdivision modeling starts out just like polygonal modeling. You can use box modeling or extrusion modeling, or a combination of both. As always, start with the largest aspects first, and then progress to the smallest features. Adding polygons to your

model in the early stages so there is a lot of polygons before there is a lot of detail will make modeling like trying to work with chewing gum rather than clay. Working with extra polygons will slow down your software, and it will also make every other task more complex and time consuming. The goal is initially to model each of the features with the lowest number of polygons possible, for the simplest control cage you can have.

As mentioned before, the control cage acts much like the hull of a NURBS surface. Some applications have one simple subdivision surface smoothing operation, and all editing occurs on the original polygon mesh. Other applications give you the power to have several subdivision steps and preview each of them, allowing you to move back and forth between the control cage and the higher polygon count steps to view and edit. As you view higher subdivided steps, you may find that the smoothed details do not look exactly as you would like. But do not edit the subdivided mesh yet. Always try to fix the problem first with the control cage, and then move on to each higher subdivision step to tweak your model to perfection. Lots of editing at the highest subdivision step might look perfect when smoothed, but can result in a control cage with vertices and faces crossing over each other. This not only makes the control cage unintuitive to work with and unattractive, but also causes problems with UV mapping and rigging. Both of those use the control points of the control cage.

Try to subdivide the least number of times, using the lowest possible subdivided step to get your result. This is important to optimize rendering speeds. There comes a point where more polygons do not add to the smoothness of the model. It is better to have too few polygons than too many (Figure 5.9).

Figure 5.9 The same model with 88 polygons, 1344 polygons, and 5376 polygons (from left to right).

Subdivision surface modeling is very useful for game modeling, when you may need the same model to have different polygon counts to optimize in game rendering speeds. Models farther away should have lower polygon counts than models close up.

Organic Modeling

Creating characters that come alive on screen is the primary reason that modeling with subdivision surfaces was developed. You've already gained an idea of it in the discussion on edge loops. Good organic modeling starts with good references, including not only concept art and orthogonal drawings, but also a basic understanding of underlying anatomy. Even if the model is not of a natural creature, one can still extrapolate anatomy from existing animals. With several copies of your sketches, try drawing lines where the muscles are, and use these to guide your placement of polygons or edge loops. Many modelers have been known to have multiple poses of subjects so they can study the changes as their subjects move. This is especially helpful with facial expressions, but is excellent practice for any movement your model is likely to make.

Tutorial 3
Subdivided Robot

Step 1

Start with the robot as finished in Chapter 4: Tutorial 2. Though we've been looking at the whole body of the robot, it will be more useful to have to only work on one side and have the symmetry automatically added. Cut off the mirrored geometry, so that now you only have the side of the main body that you first created. Cleaning up is an important part of modeling. Make sure you have no extra hidden vertices and borders. Merging the vertices can be a good way of taking care of doubled up borders. It is possible to work with a mirrored instance, in which the other side does exactly what you're doing on the original side. For the purposes of clear illustration, this tutorial will only show one side. In addition, all of the other parts have been hidden.

Turn the main body mesh of the robot into a mesh cage (a subdivision proxy) for a subdivision surface. Choose two subdivision steps or levels. Once you've made the subdivisions, take a bit of time to look at the subdivided surface of the robot and how the edges of the mesh cage have influenced the smoothed out surface.

Step 2

Add two more edge loops: one between the bottom and the next edge loop up, and the other in between, about in the middle of the eye. Adjust vertices to match the edge of the robot in the image plane. You may be able to toggle proxy display so you don't see the subdivision surfaces. If you can, this will make things easier.

Step 3

To create a border that outlines the eye, you will need to move some vertices. The vertical edge, which is the second one in, crosses through the outside of the eye. Grab the two vertices in that edge that are just inside the eye. If you're looking in the front view and draw around them to select them, you will also grab the vertices in the back of the robot, which you don't want. In this case it is easier to select them one by one, adding to the selection group. Move those two vertices toward the outside to match the shape of the eye. On the same edge, the next vertex up makes a corner outside the eye. Move that inward and a little down to match the image. On the bottom of the eye is a horizontal edges that crosses through. Move each one of the three inside vertices on the edge to match up with the eye.

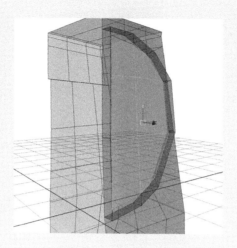

Step 4

Select each face in the eye. As you're selecting make sure you don't select any extra faces. Extrude, pulling the face forward in the side view to make an edge. Extrude again, scaling smaller to match the inner eye border. Fix any vertices. Select the main faces in the eye again, and extrude inward, even a little farther than the original surface. Extrude one more time, scaling larger to create a hidden lip.

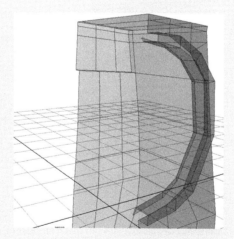

Step 5

To create an eye hole, delete the faces that are selected. During the extrusions, you will have made several faces that border the inside middle, where there should be no faces at all for later mirroring. Carefully delete each of these faces. Then check for extra vertices and clean those up.

Step 6

Move the vertices to match the mouth shape, as you did with the eye. Keep mouth borders straight. You should have only two faces on the mouth. Extrude three times: forward, inward to the border, and backward. The faces you have selected will remain as part of the model, but you will have to delete some edge faces and vertices that border the middle, as you did with the eye.

Step 7

If you have the view of the subdivided mesh turned off, turn it on now. As you look at the subdivided mesh, you'll notice that the mouth is pretty rounded at the corners. To correct this, insert an edge loop just inside of the outer vertical border of the mouth. If you leave the edge loop as it is, you will have creases in your robot's face, because of the skinny polygons next to the wider ones. Except at the mouth, where you want the crease, move the vertices of the new edge both to make a smoother circle in the eye and to make the narrow strip of polygons wider, more like their neighbors. See the illustration for Step 8 for an idea of how to do this.

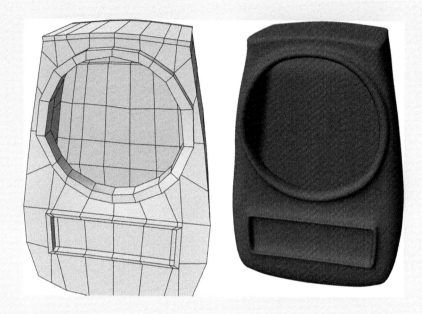

Step 8

Mirror the geometry and make sure the model is clean, with no extra edges or vertices lying around.

6

DEFORMING: IT'S A GOOD THING

When Gollum had his split personality conversation on the big screen, I forgot that he was an animation. I empathized with Gollum not just because of the context of his character, but because I could see the emotion on his face. It was so good, in fact, that hard-of-hearing people could lip read. Such facial expressions had never before been possible. Weta Digital, the team responsible for the *Lord of the Rings* digital effects, achieved these realistic expressions using tools to deform the mesh.

Deformation is an important tool for modeling. It's a great way to mold your object in a way that would be difficult polygon by polygon, such as bending a pipe, twisting a rope, or changing the proportions of a nose. In animation, not only can you make facial expressions such as opening a mouth wide for the dentist's drill, but it's also useful for simpler things like a wilting flower or a bouncing ball which flattens when it hits the ground.

You've probably already deformed an object. Moving a vertex, an edge, or a face is the most basic kind of deforming. All the tools to deform are essentially just ways to move large numbers of vertices in specific ways to change the shape of a model. Like other things, these could be called different things in other applications. This is because all modeling has evolved within each application, with each team implementing its use differently and coming up with their own name. Rather than being called a deformer, a deforming tool might be called a modifier. The principles remain the same, however.

Sculpting and Special Selections

A sculptor with a lump of clay will push and pull on it to mold it into the desired shape. This is a very intuitive way of deforming a mesh, and many applications have tools to do this. Soft selection is something you've already met, when surrounding vertices are influenced by the movement of one or more vertices. Another common tool you will find, and one that is the basis of some

3D Art Essentials

modeling programs, is the use of brushes. There are several different tasks they can do, such as smooth, inflate, and pinch, and they come in different shapes and sizes.

You can also save a selection of vertices in a specialized group, sometimes called a cluster. Cluster deformers have their own controls. When you grab the control or handle and scale, move, or rotate it, all the vertices of the cluster will be affected.

Morph Targets

Using these sculpting techniques, you can create several key forms of your model, and then use tools that allow you to morph your mesh between several forms you've created. This is an efficient way of animating things such as different facial expressions. You duplicate the mesh and then reshape the copy as desired. The reshaped copy then becomes a morph target (also called a blend shape and other things). A slider control will be created to move between the base shape and the morph target so that you can control how much the original shape deforms into the target (Figure 6.1). Deformers work really well for this reshaping because they don't change the number of vertices. When blending shapes between meshes, it's important that each one has the same number of vertices. During the animation sequence, the application will move the vertices from the original mesh to their new place in the target mesh. You can have as many targets as you want, allowing you to morph between lots of different forms of the same mesh.

Figure 6.1 The percentage indicates how much the morph target is influencing the base shape.

When the vertices move to change shape, they will move in a straight line. For some things, this may not work well — for instance, a blinking eye. If the eyelid goes straight down as it shuts, it will go through (intersect) the eyeball: not exactly a natural occurrence. If you were to use this morphing method, you would need more than one target to make the eyelid blink. Morphing tends to work well for simple movements. More complex movements may require other methods for the best results.

Lattices and Curves

Lattices and curves are similar to the control hull or mesh of NURBS and subdivision surfaces, except that they offer more abilities in deforming a mesh. A vertex on a lattice or a deforming curve affects a number of vertices on the model. Think of having lots of hands at one time being able to push or pull on your model.

Curve deformers (Figure 6.2) are simple ways to bend the model or a part of it into the curve you want. Create a curve and assign it to the desired portion of the mesh. Moving this curve will then move the mesh. This is an easy way to create a control for things like raising an eyebrow or wagging a dog's tail.

A lattice works just like a curve except that it is a whole surface. You may have a set of prebuilt lattices or you can build one to fit your needs. Like the curve, the shape of the lattice affects the shape of the model. Lattices usually have a base shape that they can easily revert to. A great advantage of this is being able to evenly deform your mesh across certain areas, and repeat this same deformation

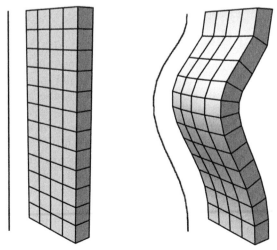

Figure 6.2 This model has a curve deformer next to it. As the curve is bent, the model bends with it.

with subtle differences without having to fiddle around on the mesh itself. You can even add a lattice to another lattice. This is good for flexing a muscle or changing proportions, but a little too general for things such as facial expressions.

One nice use of lattices is to move models through them to animate the models (Figure 6.3). A good example of this is passing a snake through a tube lattice that has the wavy shape of the snake's path. This illustrates another advantage: your model will have a default shape that it retains once the lattice is removed if you desire. This makes lattices and curves very useful for the kind of deformations you need in animation.

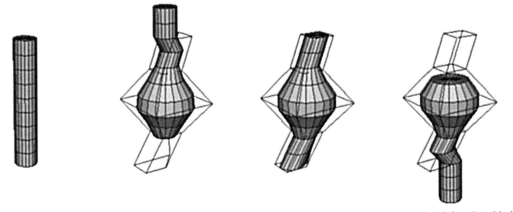

Figure 6.3 Here is a cylinder that is being moved through a lattice. Notice how the lattice makes it bend and bulge.

Controlling the Influence

What if you did not want to evenly deform your model? When you are pulling up the cheeks of a face model to create a smile, you don't want all of that area to deform by the same amount. That would just pull out a big gob of cheek. Instead, there is a lot of pull right around the mouth and some slight bulging at the cheek. Some applications give you the ability to weight the influence on control points. You can also control how many vertices each lattice point controls. With this weighted method, you may even be able to use a single point as a handle. This is another good solution for eyelid animation. By placing a pivot at the corners of the eye, and then weighting the influence along the curvature of the lid, more in the middle and less at the edges, you can pull the eyelid down in such a way that it does not intersect the eyeball (Figure 6.4).

Figure 6.4 Before the vertices of the eyelid were given weighted influence, the lid tended to intersect the eye. In the middle image with the gradient, the white represents those vertices most influenced by the handle.

Specialized Deformers

Say you want to model a screw. How are you going to get the threads on it? Well, certainly you could carefully sculpt them in there. But what if you could just twist the surface? Many applications have deformers with which you can do just that. There are various specialized deformers that let you shape your mesh in very specific ways to get common shapes and effects. The ways that these deformer controls act and the kinds of attributes you can give them differ across applications but they all have one thing in common: they change the positions of vertices. Some of the actions you can perform with these kinds of deformers are bend, flare, twist, flex (a bulge on the inside of a bend, simulating how muscles work), bulge (a uniform growing around the whole circumference), warp, narrow, etc. (Figure 6.5).

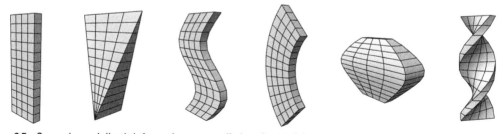

Figure 6.5 Several specialized deformations as applied to the model at the far left.

Soft Bodies

How would you control the movement of the cloth sail on a pirate ship? What about animating hair as your character does a backflip and it brushes against the floor and her clothes? Cloth and hair are good examples of flexible objects that react to forces such as wind, gravity, and the movement of the person wearing

them. There is more than one way to achieve these complex animated deformations, but a popular one is the use of soft bodies (Figure 6.6). When you make your model a soft body, you copy the vertices in the mesh and replace the copied vertices with particles. Particles are virtual points that react to simulated forces or even collisions with other objects. This makes them great for hair, which might collide with clothing or the model itself during movement. The particles in soft bodies are connected together in a mesh just like the model. They can control the surface of your model in the same way that a lattice does, except their movement is dynamic. That means that their animation is controlled by the application applying the simulated forces to them that you have specified. This doesn't just free you from trying to accomplish that task. Because the simulations are based on physics, the animation is generally more realistic than a manual animation, provided you set things up properly.

You could theoretically just copy and convert your model to a soft body, but then it would be very difficult to control with little advantage in movement. The rule of thumb when creating soft body deformers is to keep them as simple as possible. Low-polygon meshes are often used for soft body deformers

Figure 6.6 The flag in this image is a soft body cloth. Gravity affects the flag in both pictures, and a wind force has been applied to the one on the right.

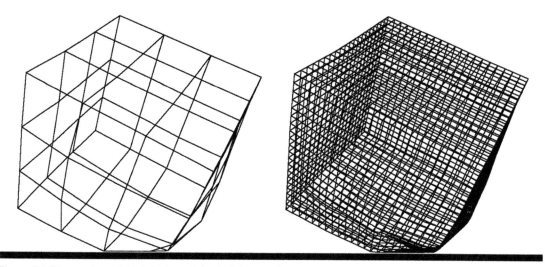

Figure 6.7 The mesh on the left is the soft body deformer. On the right is the model.

(Figure 6.7). The more particles you have, the more calculations the computer must make, which equals higher render times for animated sequences or worse: altogether stalling your computer to a complete stop. You can cache the animation of the model provided by the soft bodies, so that these calculations do not have to be done again.

What if you have something that is flexible upon impact, but would retain its shape? Let's use a cardboard box as an example. If hit with a wooden sword, the box must crinkle and indent, and will mostly stay that way, though there will be a bit of springing back to the original shape. You can control if and when your soft body is active or inactive.

Constraints

Though these particles are connected to each other in a mesh that should more or less retain its shape, it is not uncommon for there to be too much movement. For instance, if you were simulating the movement of a Slinky toy, you might find that it pinches, bulges and, at the ends, flares out. You can assign certain kinds of constraints to it so that it retains its cylindrical shape while snaking downstairs. This is a fairly rigid type of restraint, keeping all of the vertices across a certain axis in exactly the same place relative to each other. Another kind, often called springs, allows for more flexibility but still keeps the movement of the particles in check. A good example of this is a candle flame. You

need the tip to move all around in space, but it is not good if the vertices on the tip move away from each other, so you use a spring constraint to hold these together. There are quite a few parameters you can control in each kind of constraint, allowing you to create models that react in different ways to their environment.

Skeletons and Muscles

Many animals have skeletons, whether endoskeletons like ours or exoskeletons like a grasshopper's. You can give your model a skeleton as well. The skeletons of 3D models are always endoskeletons, but they work differently than our organic ones. Like ours, they are stiff, jointed objects. But unlike real skeletons, skeleton rigs (see more in Chapter 7) in models are the movers (Figure 6.8). Each point on the mesh surface is attached to the skeleton rig. When the rig moves, the points move. You can set how strongly each point is affected by each joint. The muscles are just simulations. They are special deformer lattices, being moved by the skeleton, and in turn deforming the model. This is to make organic movement more realistic.

Figure 6.8 A skeleton of joints and bones applied to a 3D model. When the joints are rotated, they cause the model to bend at that place.

Rigid Bodies

There are also surfaces that you will not want to be deformed during dynamic animations. In those cases, you will want to make the surface a rigid body. Rigid bodies are great for things such as robots, cars, and wooden swords. Imagine, for instance, a fort of those cardboard boxes being attacked with the swords. The swords would be made rigid, while the boxes are the soft bodies which deform when the swords hit them. When a model composed of rigid bodies is moved, the parts will move relative to the other parts, but the shape will remain the same. This makes them an excellent solution to having something hard that is combined with something soft, such as a chest plate on a Roman soldier. The chest plate must move with the chest but you should not be seeing muscular movement on the plate. However, in a very detailed animation you might want to see how the leather and/or skin rubs under the hard plate armor.

Order

Every time you add a deformer, modifier, or some other kind of attribute to your object it will be listed with your object. It may be called an object history, a list of input operations, a stack, etc. You may see it as a graph. You will be able to access this and in many cases change the order of the deformations or other actions applied to your object. The order in which any of your modifications are applied is important. Each one will act differently depending on the order in which you apply them (Figure 6.9). If they are in the wrong order, this may give unpredictable results for your animation.

bend > twist twist > bend

Figure 6.9 The same two deformations were put onto this cylinder: first X and Y and then Y and X.

Tutorial 4
Smiling Robot

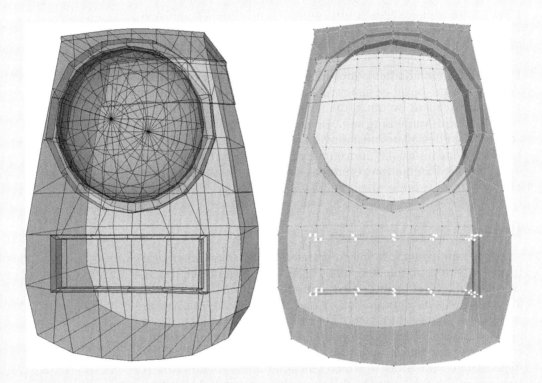

Step 1

To begin, select the robot body and duplicate it. Move it to the side. On the copy, select all the vertices that make up the mouth. Once you have these selected, make them into a cluster with a control. If that is not possible, you will want to save them as a selection set.

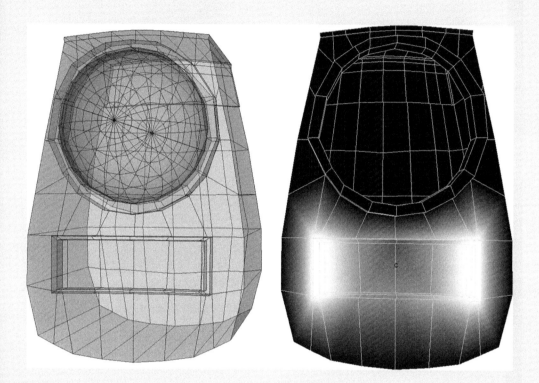

Step 2

You can make clusters so they influence some vertices in the group more than others. In other words, the vertices have weights on them which determine how much the cluster will influence them. With the mesh selected and the cluster specified (if necessary), use a weight painting tool to reduce the influence that the cluster has on the vertices in the middle of the mouth. There should be no influence right in the middle, and increasing influence until it is total at the two edges of the mouth. In the illustration showing this, black is no influence and white is full influence. If it is not possible in the application to create a cluster and paint the weights on it, use soft selection, which approximates this.

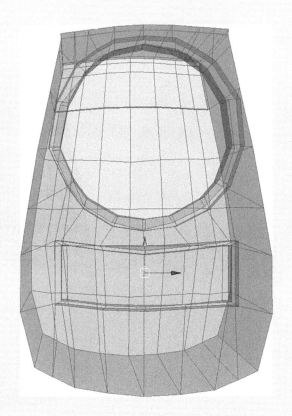

Step 3

Use the cluster handle to move the vertices up. Now you've got a robot smile. Select your smiling robot mesh and the first base mesh; then use the tool to create a morph target. In the options of the tool before you complete the creation, name the morph target Smile. Open up the window that contains the slider for the morph target, then move the slider so the base has the same expression as the smiling robot. As you move the slider, you'll see how the morph works.

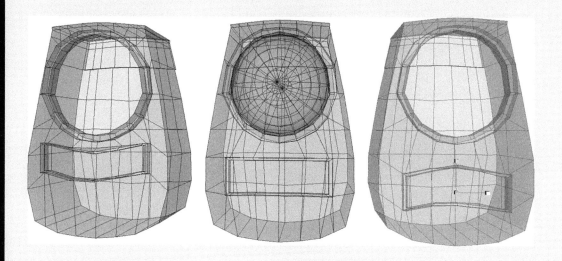

Step 4

Make a copy of both the smiling robot and its accompanying cluster. Pull the cluster downward so that the robot has a frown. Select this second copy and the base robot mesh, and create a morph target with the name Frown. Now in your morph target control view, you'll have two sliders: Smile and Frown. You can have them both influencing the base target at the same time, and the expression will be neither a smile nor a frown, nor the original shape. You can use these controls to make a variety of mouth expressions.

RIGGING

One of the things that makes Iron Man cool is that as his superhero self, he looks like a robot, but we know that underneath that technology is a human who is responsible for every movement it makes. Though there was a real suit, in the movie most of Iron Man's action was computer generated. So it wasn't a human moving it. It was a rig.

There are several kinds of rigs. The most common one is made up of a skeleton of joints, like what was used for Iron Man, or any other object that has poseable limbs. But what about things like facial animation? You can have a rig made up of lattice deformers, or of blend shapes. A rig for an organic computer-generated character will need the muscle deformers as well. To complete your rig, you will need controls to move the skeletons, deformers, and blend shapes. These controls should be designed properly, both for ease of use and to help the action be realistic.

Since a rig is part of what allows you to bring your model to life, it is a good idea to build a rig before your model is fully detailed. This allows testing.

Parent and Child

A fundamental part of rigging is working with hierarchies, or what parts of your model are controlling other parts. In a hierarchy the controlling object is called a parent, and the object being controlled is called a child. In a display of the hierarchy, a parent is above a child. Also a child of an object can be the parent of a different object.

For a real-world example of a hierarchy, let's start with your arm. Hold it straight out and try moving it at your shoulder. Your elbow, wrist, and hand follow it. But if you move it just at your elbow, the shoulder does not have to move but the forearm and everything below it does. Your upper arm is the parent of the forearm, which is the parent of the hand, which is the parent of the fingers, etc. (Figure 7.1). In terms of hierarchy, the forearm is lower in a hierarchy than the upper arm, or downstream from the upper arm.

Figure 7.1 Here, the shoulder is the parent of the elbow, while the elbow (child of the shoulder) is the parent of the wrist. The parent—child hierarchy would cascade down through each knuckle.

But objects don't have to be connected. Animating a simulation of a star system is much easier when hierarchies are used. Using a sphere as the central star, or sun of the system, you would set it as the parent for other spheres, the planets. As this star moves, orbiting around the center of the galaxy, all the planets go with it. They have their own movement, but it is always an orbit around that star. They are the child objects of the star. Orbiting around some of the planets would be moons. A planet with a moon would be the parent of that moon. You could even have space stations orbiting a moon, in which case they would be the child of the moon. Objects in hierarchies do not have to be meshes or surfaces, but can be other things such as lights. When the sun goes down in the sky, it can cause a light source to turn on.

This hierarchy will be represented in your object list so that you can easily see the relationships of different objects to each other (Figure 7.2). The parent at the top of the hierarchy is called

Figure 7.2 The star in this system is the parent of the planet, which is the parent of the moon.

the root or base of the hierarchy. As you can see, even without rigging this can be very useful. For instance, you can parent the body of a cart to its axel and in turn parent that axel to the wheel. But when you have a complicated rig such as a skeleton, hierarchies are indispensable to managing all the joints.

Bones and Joints

In 3D animation, joints are so basic that working with them is pretty much the same in every application. Select the joint tool (whatever it is called) and click in the scene. A joint will be created where you click. Joints, or more accurately joint deformers, are places where your model can be bent or rotated. If you click again while your joint tool is still on, a bone and another joint will be created. This joint will be the child of the first joint. This automatic parenting is one of the beauties of using rigs. The bone is a visual connector between joints and also indicates which joint is the parent and which is the child. The base of the pyramid shaped bone is at the parent joint, and it points to the child (Figure 7.3).

Figure 7.3 Three joints connected together. Notice that the bone is in the shape of a long pyramid. Its base is at the parent joint and it points to the child joint, giving an indication of hierarchy.

Skeletons

You can create more than one child joint coming off another joint. It is this branching off that allows you to create the complex hierarchy of joints that you typically need for complicated models such as robots, people, and creatures. It can also quickly get confusing unless you organize things properly.

First of all, you'll want to name your joints. It's best to name them logically, according to their place in the anatomy; for instance, leftAnkle or rightPinky1. Be aware of what is parented to what. When a skeleton rig is fully closed up in the object list, only the root joint is visible, usually something in the neck or hip area, depending on construction. When you expand that joint object, you will see all of its child joints.

There is no reason for you to have to add in every single joint. You can duplicate chains of joints where they are the same on the body: fingers, two arms, two legs. You can mirror, rotate, and transform them as you copy them too. You will want to make sure you have a good placement of joints, and, once there, bind the pose so you can always get your model back to a good position (Figure 7.4).

Figure 7.4 In this skeleton, the bones are merely connectors between the joints, which are the movers.

Creating a Skeleton Rig

Getting good placements of joints on your rig requires a working knowledge of the anatomy of your creature, whether real or fantastic. If you are building a human character, you can

refer to yourself or a friend to study how humans move. For instance, if you rotate your wrist, you can see that your elbow joint does not rotate. Another joint between the elbow and the wrist is required to accomplish this movement.

Once you have everything set up the way you want, you want to create the bind pose. This pose is a starting position that you can easily go back to, with each joint rotation and transformation set to zero. You must take into consideration what bind pose you want to use even before you start rigging. For humanoid characters, a very typical bind pose is called the T pose. This is a person standing up with arms outstretched, looking like a small T (Figure 7.5). The reasoning behind this is that it is easier to not have any parts of the model overlapping. It is also easier to skin (see Skinning, page 94). If the arms are straight down and you are trying to bind the skin to the joints, then you may accidently bind the hip or leg to the arm joints. Another important reason is that all of the joints and deformers that move your model are only approximations. The farther away from the first pose they get, the more deformation there is, and the more unwanted pinching, wrinkling, and bulging you'll get. A T pose, for arms, is halfway between any positions the arm might make. However, arms straight up is a much less common

Figure 7.5 T pose and Y pose.

position than arms down. Also, for the arms to be straight out, the shoulders must be modeled as all bunched up. Therefore many modelers are adopting a position called the Y pose, where the arms are out at only 45 degree angles (Figure 7.5). This puts the shoulders in a more natural starting position, while maintaining the distance between arms and legs needed for skinning and staying within a mid-range pose to reduce distortion when you pose. Going even farther along these lines, some modelers let other joints like the elbows and knees be bent just a little bit in a more relaxed and ordinary pose. As you can see, we aren't just talking about rigging here. Modeling your character with good form is essential to good animation.

When creating the joints of a limb, you will want them to be properly aligned. This is especially true with the rotating joints such as the one between the elbow and wrist. If this is not straight, the arm will appear to be broken. Most applications allow you to snap to the grid, making it easier to achieve a straight line when creating joints. Once you've done this, you can move first the parent joint of your line to its place, then adjust the other joints so that each one is where it belongs (Figure 7.6).

Another important alignment consideration is the orientation of the joints' rotation axes. You will want to make sure that the X axis of your joints is in the direction of the length of the bones, with it pointing in the direction of the child. You will also want your Z and Y axes pointing in the same directions, ideally with Z pointing toward the back and Y pointing down. This will make natural movements easier to handle in your control setup. If you do not have your joints properly oriented, you may run into difficulties such as a gimbal lock. A gimbal lock is what happens when two

Figure 7.6 The joints with all the axes aligned together.

axes overlap. This makes their rotations the same and makes it impossible to rotate the joint in the three different directions.

Once you have placed and aligned the axes, you can set the values of the rotations at X, Y, and Z to zero. This might be called freeze rotation. The neutral pose values will be at 0, a logical starting place for your controls.

As you build your skeleton, using things like mirror and duplication, limbs can get messed up, even if they were aligned previously. When your entire skeleton is in place, take the time to go through and check each joint so that it is well oriented. It's possible that it won't be a problem later on, but if it does rear its ugly head it will be a difficult one to fix in the middle of some other task you're trying to do.

Joint Limiting

Turn your head to look back as far as you can. You probably can't get your chin much further than your shoulder. This is a limit of your anatomy. Every model, organic or not, will have such limits. To put them in your model, you will need to add limits to the joint rotations.

Finger knuckle joints, for instance, can only bend along the Y axis (up and down) and they cannot bend back much. The knuckles allow for some back-and-forth movement, however, and can be bent a bit farther back. Adding limits like these is important to enable you to move your skeleton, and therefore your model, through inverse kinematics.

Kinematics

Kinematics is the study of how things move when forces act on them. In the animation of a rig, it involves figuring out the angles of each joint as it is moved. There are two approaches to this: forward kinematics (FK) and inverse kinematics (IK). In order to achieve good, natural movement, you will use both of them.

Forward Kinematics

With FK on a bipedal character, we are working directly with the angles of the joints in order to achieve a specific position. We commonly see this when programming a robotic arm. Being a machine, it cannot have a goal. Each joint is moved individually, starting with the base joints: the ones at the top of the hierarchy, and then moving each child joint down the hierarchy to the position you're aiming for. It is comparable to animating

a stop-motion armature. So, if you were to animate a motion such as grabbing a glass of water, you would start at the shoulder joint, rotating it to move the arm. Then you would rotate the elbow, the wrist (if necessary) and then each knuckle joint of each finger to grasp the glass. This works just fine, but it takes a little time, and it can be harder to do with large limb movements that are repetitive, such as walking. FK walking would start by moving the hip forward, then rotating the thigh joint (the joint that connects the thigh bone to the hip and rotates at the hip) forward, rotating the knee properly, then rotating the ankle to touch the ground, and then again as the weight moves onto the leg (Figure 7.7). Recall

Figure 7.7 The root hip joint was rotated before starting to rotate the knee to get the joint chain in this position.

that when the parent joints are rotated or moved, all the child joints move as well. This leads to several particular difficulties with FK for walking such as keeping feet from sliding on the ground, sinking into it, or floating.

Still, there are some advantages to using FK. In fact, you must have an FK rig before you create an IK system, but that isn't too hard. It comes about automatically with the setting up of the skeleton rig. Since the controls to rotate and move joints are pretty basic, FK has the advantage of being easier to export than IK, which suffers from being developed in different ways in each application. FK is also very important for tweaking and adding character and emotion to movements.

Inverse Kinematics

With IK, the question being solved is: "If the hand is here, what angles will the joints need to have?" Our brains do this constantly. As I type these words, I know where each letter is and, without conscious thought, my brain is calculating how my hands must move to get my fingers to the keys. In other words, I have a target. My conscious mind does not move each finger to figure out how to get it to each letter.

IK lets you move the last joint in the hierarchy and have all the others follow it. For instance, the foot must step on the floor at a point and remain there while the hip moves along, and the other foot moves toward Y. Not only is IK faster than FK, but it can help with the slipping and sinking feet problems. Once you have good limits and constraints integrated into the rig, you can grab a handle of your rig and move it around easily. The other joints will smoothly rotate to make this happen. So, if you want to move the leg, you can simply grab the foot handle and move it around. The hip/thigh joint, knee joint, and ankle joint will all rotate accordingly (Figure 7.8).

Applications can make this happen in a several ways. You may set up a second hierarchy of joints that control the main hierarchy. Your application will have a variety of IK tools to solve how your joints should rotate to get them to the place you want. The number of solvers you will need to use will depend on how many joints you have. As you set up your IK rig, you will create control objects using shapes that are constrained to the joints. Moving these shapes will move the joints of your rig. These controls and other customized settings can make a complicated movement such as closing a fist simpler to achieve.

To achieve the best of all movements, it is common to have an FK/IK switch. For instance, what if you want the pinky to be

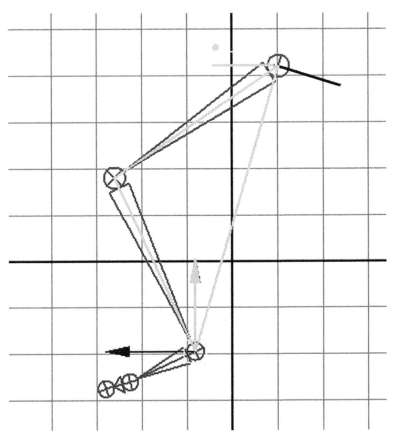

Figure 7.8 To move the leg here, the ankle joint was connected to the hip joint in an IK solver, so that the IK handle only has to be selected and moved.

extended when you have your character pick up a cup? The grasping motion will use IK and the pinky movement will be done with FK. It's important to use FK to add personality to your character's movements. Otherwise, they may end up looking robotic. We do not expect perfectly flowing movement from humans or animals, and having it can make your creation slip into the uncanny valley.

Skinning

Even if you have been creating and aligning your rig within your model, it will not move the surface of your model until you connect it to that model. This is called binding or skinning. The simplest way to have a rig move a surface is to parent the surface

to the rig. This only works well if your model is broken up into different objects for each part that must move, but it is a good solution for things such as insects or robots.

Rigid Binding

Another good solution for such objects is rigid binding (Figure 7.9). It works in a similar way to parenting, but can be used on models composed of a single surface. How this works is that one vertex is assigned to only one joint, and every assigned vertex is influenced at 100% by that joint. You can see the problem with a direct rigid bind: you'll get strangely stretched and pinched parts of your surface where the bend is. Using a specialized lattice like a flexor (which rounds out the surface at a bending location) can improve appearances while flexing. This works well for lower end character animations such as for gaming. Another solution is to rigid bind lattices to the joints, instead of the surface itself. The lattice is then bound to the surface, so as it is moved with the joint, the model moves as well.

One thing to point out is that rigid binding is different than rigid bodies. Rigid binding is a type of influence of the joint deformer on the surface, and a rigid body is a surface that cannot be deformed.

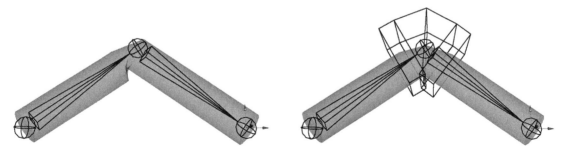

Figure 7.9 A joint that uses rigid binding directly to the surface, with and without the special flexor lattice.

Smooth Binding

When dealing with an organic model, smooth binding offers an even better solution (Figure 7.10). Rather than have the influences of a single joint on the vertices be the same, you can weight the influence, so that a single joint influences some vertices more than others. Assigning weighted influence can be

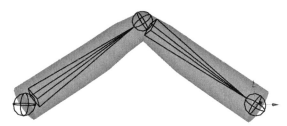

Figure 7.10 The same cylinder as in Figure 7.9 with smooth binding.

achieved in a few ways but it is often done with a brush to paint a black–white gradient indicating the strength of influence. A vertex can be influenced by more than one joint. This can get a bit tricky, especially when you use an automatic operation to assign a smooth bind. Joints can be assigned by their closeness in space or in hierarchy. If things are not acting as you expect, you should check out if one or more vertices are bound to an odd joint, like something on the hand being bound to the hip. Just like modeling, setting up good weights for a smooth bind takes practice and time.

Muscles

Even better for realism is simulating the muscles under the skin. Not only do you get the bulging when a joint is bent, but good simulations will have the surface or skin slide over the virtual muscle, further enhancing the animation. There are several different systems to simulate muscles, available within the application you're using or sometimes as separate applications or modules.

As you have learned, typical joint deformers are the active movers of the skeleton, not the movable part of a rigid skeleton that requires muscles to move it. When these virtual joints are used, muscle deformers take on the task of making the surface appear as if it were muscles moving the skeleton. These muscles are usually some kind of NURBS curve or surface. They're attached at the right places between joints and change shape as the joints are moved, then translate that shape change to the surface of the model (Figure 7.11).

Another way this is accomplished is to make the bones themselves dynamic so that they change shape, and in turn affect the shape of the model.

It is also possible to simulate a real musculoskeletal system with specialized joint deformers, bones that govern structure, and

Figure 7.11 An arm with the muscle flexors visible.

muscles (still NURBS surfaces) that connect to these joints and bones. This lets you build a working anatomy, bringing your model one step closer to realism.

Other Uses for Joints

All the attention has been on models of things that have skeletons. But joint rigs can be useful for other things where you need control over movement that is not necessarily jointed, such as ropes or horses' tails. Here, you can use a skeleton chain which controls a lattice that controls the surface. Using joints and lattices in this way can also work better for highly jointed objects such as chains or snakes than assigning a joint to each link or vertebra.

Making Your Own Controls

Sometimes, on the model itself it might be difficult to select and operate some kind of control, object, group, etc. You can create a simple shape that is easy to grab and parent the difficult-to-manipulate objects to it. Then, when you move, scale, or rotate the shape it will do the same with your objects.

Tutorial 5
Robot Gets Jointed

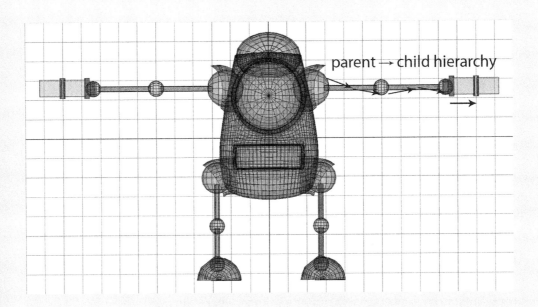

parent → child hierarchy

Step 1

The first thing to do is to create a parent—child hierarchy for your robot. This will be needed for the skeleton rig later on. Start at the left shoulder sphere (this refers to the robot's left, not your left) and parent the left upper arm cylinder to it. Usually you select the child first, then the parent, and then use the parent command. Now when you rotate, move, or resize the sphere, the cylinder should change with it. But if you move the cylinder, the sphere will not follow. Parent the elbow sphere to the upper arm, the lower arm to the elbow, the wrist to the lower arm, and so forth. Do the same with the right arm and each leg. Now parent each shoulder and each hip to the main body. You'll also want to parent the shoulder and hip guards to the main body, as well as the eye and brain case. Theoretically, you could pose your robot using this, but it would be more time consuming than with a proper rig.

Step 2

Using a joint creating tool, in the side view start at the hip and create a joint. The first joint won't have a bone, but if you click again with the joint tool still in action, another joint will be created with a bone between it. Create another joint on the knee, ankle, and toe. Though that end toe joint will not rotate anything, it is an easy handle to grab and move the toe, and is useful for connecting other joints in an IK rig. In the front view, make sure that the leg joint system is placed in the left leg. With leg joints still selected, use the mirror joint tool to create a copy. It will be mirrored against one of the axis planes, probably YZ. You can choose which one. If your robot is properly centered, then the new leg joint system will appear where the right leg is.

Step 3

Start at the left shoulder and create the joints for the elbow and wrist. Without creating a new bone between them, start another joint hierarchy at the base hinge of the clamp and continue to the tip. Make another set of joints for the thumb. Select the base thumb joint and the base clamp joint at the same time; then select the wrist joint and use the parent tool. Bones from the clamp base and thumb base will be drawn, connecting them both to the wrist joint.

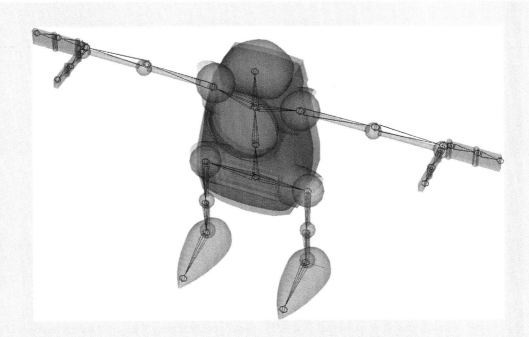

Step 4

In the front view, create a root joint between the two legs; then continue creating joints, moving straight up with one between the eye and mouth, one in the middle of the eye, and one at the top of the main body. Parent the hip roots to the main root. Then parent the shoulder joints to the third joint up of the spine system. With all of the joints created, you will want to bend each joint just slightly in the direction you want it to go. Make sure to do this for the elbow, knee, and clamp and thumb joints. This is for the IK solver. At this point, you may want to make sure all of the rotations on your joints are properly aligned. Set this skeleton pose as preferred.

Step 5

Select the left ankle joint and the hip joint, and create an IK solver with them. If you did not bend the joints, then you would be able to grab the IK handle and move the end all around, but the joints might not bend. Try moving the IK handle to see how it works. Now create an IK solver for the right hip and ankle, and the shoulder and wrists of both arms. Create IK solvers for the clamps and thumbs as well.

Step 6

Once you have created your skeleton, select the whole skeleton by selecting the root and then select the main body of the robot. Since there is a hierarchy, all of the objects that make up the robot will be selected. With the skeleton and robot selected, choose the smooth bind tool. The robot's mesh will become a skin. The vertices of the robot's mesh will be influenced by the joints (not the bones), and this influence overlaps between joints. The influence is not always intuitive. For instance, moving the arm will also deform the main body. To control which joint controls which vertices, you will need to paint weights on this. Select the robot's mesh and use the painting tool for joint influences. White is fully influenced and black is no influence. Choose a joint and then paint where that joint influences. The vertices will need to be influenced by at least one joint. For the main body, shoulder guards, eye, and brain case use the spine joints, with a bit of overlapping for smoother deformations if you bend the spine joints. Select the left shoulder, choose the left shoulder joint, and make the sphere fully influenced. Make sure that the elbow joint, the shoulder guard, and the body are not influenced at all by the shoulder joint. Do the same with each joint. Now you can pose your robot.

ANIMATION: IT'S ALIVE!

Artists have been trying to make pictures look like they are moving ever since early humans drew on the walls of their caves. The very idea of moving art was, and still is, magical. And though many digital artists enjoy creating still images using 3D applications, this barely taps into the power of the technology. It takes thousands of still images to produce animation. Whether for cartoons or to fit undetected into live-action movies, the purpose of 3D digital art technology is to animate objects that don't exist in the real world. 3D artists today use several ways to create animated pictures such as keyframing, motion capture, and simulations (where the computer calculates the movement of objects, usually based on physics).

The Twelve Basic Principles of Animation

The purpose of animation is to serve the story — to capture images of life, and in the process communicate to others, even if it just means giving them a thrill ride. To this end, you need to make your animation believable. This doesn't just mean realism. There are cues that pull people into the action. Animators at Walt Disney Studio wanted to create a kind of animation that felt real and let the audience respond to the character and story. As they observed and practiced what was at the time a new art, they developed a set of guidelines for animating. Two of these pioneers, Frank Thomas and Ollie Johnston, set them out in 1981 in their book *The Illusion of Life: Disney Animation*. These guidelines have become standard for the animation industry.

Most of them are not hard and fast rules. Lots of great animation has been done without specifically referencing them. But they do remove the abstract idea of "good animation" and replace it with solid terms to understand and explain why something works for the audience or does not.

Though they were developed before computer animation, they still apply with some modification.

Squash and stretch

Of all the principles, this is the most important one. The simplest example is the bouncing ball. As it hits the ground, it squashes. Its volume, however, must stay the same. So it also stretches. Squashing and stretching are ways to give weight to your objects (Figure 8.1). This isn't just limited to things like bouncing balls or tummies, and collision with a floor or another object is not required. These kinds of movements happen in facial expressions and with just about any kind of motion. When the upper cheeks bulge up, you should see stretching around the mouth. What you always need to remember is this: bodies (organic or not) have weight and respond to gravity, and they must retain their volume.

Figure 8.1 Squash and stretch.

Anticipation

Iron Man crouches and places his hand on the ground. You know what's going to happen next: he'll spring up into action. This is an example of anticipation. It helps your audience to clue in that something is going to happen next. Any kind of thing that invites the audience to watch what happens next is anticipation. If there is no anticipation, this can be a way of surprising the audience. If nothing happens after you've set up anticipation, this can be anticlimax. Understanding how this works can help you to move the story forward, set up comedic effects, or startle your audience (Figure 8.2).

Figure 8.2 Anticipation.

Staging

This is the art of communicating an idea clearly through imagery, whether it be a personality, a clue, a mood, foreshadowing, etc. (Figure 8.3). You will do this with how you present the character, objects, and surroundings. You must make sure not to have anything unnecessary in your scenes, or the scene would lose focus. What if the idea is chaos and confusion, a character lost in a city? Well, then, a cluttered scene might be appropriate, but you would want to avoid sunny skies or friendly faces until the hero who comes in to help your character appears. This is not real life we're trying to portray; it's life through a filter. It is emotion, conflict, resolution. With computer animation, you have complete control over the scene, and over every aspect of your character's appearance, gestures, and expressions. Take advantage of this. Staging can also be set in postproduction, with lighting and color adjustments.

Figure 8.3 Staging.

Straight-Ahead Action and Pose to Pose

These are styles of drawing your animation. Straight ahead means you draw or change poses through the scene, from beginning to end. This is good for dynamic action and sponta-neity. However, often when characters are hand drawn, things such as proportions and volume are lost. With pure straight ahead posing of a model, you may find yourself in a dead end, unable to get your character to the next part of the storyboard. With pose to pose, the animator would carefully plan the animation, draw in key poses, and then fill in all the movement between those. In computer animation pose to pose is very natural. The computer fills in the movement between key poses for which you set the keyframes (see Keyframing, later in this chapter). But you can consider things such as motion capture and dynamic simulations as straight-ahead action.

Follow Through and Overlapping Action

If a person in a cape is running, and then stops, that cape will catch up and then continue to move before it also comes to a standstill. This is called follow through, when things such as hair, clothing, limbs, and loose flesh continue moving after the core part of the character stops. A corollary to this is "drag", when a character starts to move, and other things must catch up with it. Another part of follow through is the expressive reaction of the character to their action. Overlapping action is when things are moving at different rates, such as a head turning while an arm is moving.

Slow In and Slow Out

Action never begins or stops instantly. As it begins, it starts slowly and then speeds up. As it ends, it slows down. This is exaggerated a little in animation, in order to pull the audience's awareness through all the action. This used to be accomplished by manipulating the images through frames, maybe doubling up a pose into two frames. In computer animation, this can be achieved by using curves in the animation graph to control speed (see Animating With Graphs, later in this chapter). If using motion capture, you may need to coach the performers to do slow in and slow out. For more surprising action or comedy gags, you can omit slow ins and slow outs.

Arcs

The actions of people and creatures, and often even objects, tend to move in an arc (Figure 8.4). Wiggle your hand and move your fingers. You'll be able to trace their paths as curves. Imagine the hooves of a galloping horse or the swaying of a tree in the

Figure 8.4 Arcs.

wind. Linear movements are seen as mechanical, working well for robots or characters that you want to make disturbing.

Secondary Action

As well as the main action on the screen, there will be secondary action. For instance, hair, clothes, and background leaves blowing in the wind are secondary actions to the main action of a character's attempt to change a tire on her car. Notice how this can be part of setting the stage. This can also show personality, in the way a person moves their arms while walking, or their expressions. Secondary action should always serve the main action. If it distracts from the main action, you will need to eliminate or rethink it.

Timing

This has to do with both the timing of story action and the timing of physical action. Physical action is a bit easier to grasp technically. This is just making sure the right actions occur at the right pace, in a manner consistent with the laws of physics. For instance, you would want to keep in mind that a cruise ship is going to take a lot longer to get underway than a small yacht. Story timing occurs at every scale of your animation: each shot, scene, and act. It is part of both acting and storytelling, and is something that takes experience to get right.

Exaggeration

Exaggeration is taking reality and making it a bit more extreme. In animated cartoons, exaggeration is important to keep the visual interest up (Figure 8.5). Realistic action and visuals tend to fall flat when illustrated. How much and in what way you exaggerate depend on the feeling you're trying to project. It can be used for comedy, superheroes, to portray a mood, etc. Anything can be exaggerated: body and head shape, expressions, action, aspects of the setting, the storyline, and many of the principles here. Keep staging in mind though: what you exaggerate is what will draw attention.

Solid Drawing

Technical knowledge is just as important to cartoon animation as it is to scenes meant for live-action films. For instance, the artist creating an exaggeration of muscles for a superhero needs

Figure 8.5 Exaggeration.

to know exactly where each muscle is to be placed before they can be bulged out. Solid drawing is part of the good workflow discussed in Chapter 2. Reference real life. Even if you are just interested in doing 3D art on the computer, take a few drawing classes, where you will learn things such as proportion, composition, and perspective.

Appeal

This is the other most important principle of animation. The character must appeal to the audience. Even characters not meant to be sympathetic can appeal. Villains often look cool, and we enjoy rooting against them. Character appeal has to do with the features you give them, the clothing they wear, their facial expressions, and the way they act toward others. There are good studies on how appearance affects our reaction to

people and things. Symmetry is considered beautiful by people. Also, features that tend to parallel those of the young, such as a large head in proportion to the body and large eyes, tend to gain more sympathy (Figure 8.6). For less sympathy, you can go in the opposite direction, with small beady eyes and a narrow head.

Figure 8.6 Character appeal.

These principles encompass three main things you must do to keep your audience interested. It must be believable. It must be clear. The audience must care about the characters. These days, animation may not be in the form of a narrative story; it could be part of an advertisement or a music video. But your work must still make the audience want to watch more.

Keyframing

The still images that make up a motion picture when sequenced together are called frames. These days, typical frame rates vary from 24 to 30 frames per second (fps) depending on the format. For video, these are often doubled and smoothed together to have 50i–60i fps (the i standing for interpolated). In film, a camera takes a sequence of photographs. In traditional animation, someone draws movements of the characters onto transparent cels for each frame. The backgrounds are static images that are set behind the cels. In computer-generated animation, the computer renders each frame based on what you create for models, lighting, background, and so on, and how you direct their movement.

You direct the movement of your scene through time using keyframing. This is the most fundamental tool in digital animation. With keyframing, you define key starting, middle, and ending positions and attributes of objects. Just about anything can be keyframed, including position, rotation, size, deformation color, and texture.

As an example, let's use a character named Susan throwing a ball underhand. Our starting keyframe would be when she is holding the ball with her hand cocked behind her back, ready to toss up. You would put her and the ball in this pose and assign the keyframe. Once you start keyframing, assigning keyframes is often done automatically as you move a slider along a timeline. The ending keyframe of this sequence is when her arm is stretched forward at the end of the throw, with the ball leaving her hand. You alter the pose and assign that next keyframe. If such an action were to be filmed, this quarter of a second action would take more than two frames. The frames that come between these keyframes are called inbetweens. The computer figures out or interpolates what Susan's movement should be between those keyframes. You can see how inverse kinematics can be a lot of help here. So far, the ending keyframe is when the ball leaves Susan's hand. But this would not necessarily be the end of the animation. The camera could follow the arc of the ball. In this case, a new keyframe or several new keyframes can be added: one

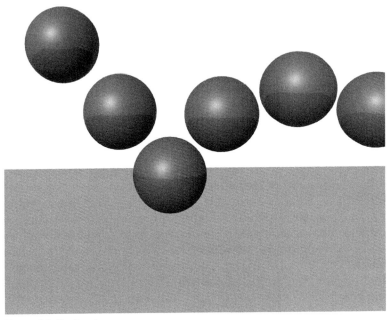

Figure 8.7 Keyframing.

for the top of the ball's arc, another for when it hits the ground, and more if it continues to bounce and roll (Figure 8.7).

Animating with Graphs

Keyframes are placed on a timeline. The timeline may not exactly be a graph, since it's just a line, but it is one of the most important displays for your animation and it's the foundation of the animation graphs (Figure 8.8). Time is sometimes

Figure 8.8 Animation timelines from several different applications.

considered the fourth dimension. Well, then the timeline would be the axis of the fourth dimension. An object's change in location, speed, size, or anything else is plotted against time here.

All of your animation graphs will follow this one line. It shows how long your animation is and contains a pointer or highlighted portion which is the current time indicator. You can move this forward and back. A common technique for adding a keyframe is to move the current time indicator forward in the timeline, change the pose or position of your object, and then key the change. You can see the motion playback by either moving the pointer again or pressing a play button. This simple, real-time view of the animation (with textures and lighting turned off) allows you to fix any obvious problems you might see.

When you place a keyframe, this will become a point on an animation graph. For the x axis of this graph (not to be confused with your 3D axes), you have the timeline. For the y axis, the numeric value of your object's attributes and position is shown. A keyframe is not necessarily set for each frame. So the computer interpolates between the frames, and the animation graph is where you can see the values of this interpolation, drawn as lines or curves (Figure 8.9).

Figure 8.9 The animation graph of the translation curves of a bouncing ball. Since it did not move back and forth, only up and down and side to side, only the X and Y translation values changed and so only those were keyframed.

There are three main types of interpolation (Figures 8.9 and 8.10). The most basic is sometimes called stepped mode or key. In stepped interpolation, values do not change until the next keyframe, resulting in an instant change from one keyframe to the next. This looks like stair steps, hence the name "stepped". In linear interpolation, each keyframe point is connected by a line. The movement is much smoother, but still jerky. With curved interpolation, the points are connected by curves. Changes in speed or direction, or any other trait, are eased into and eased out of. A ball curves up, over, then down. A car takes several seconds to reach its cruising speed. A chameleon gradually changes color.

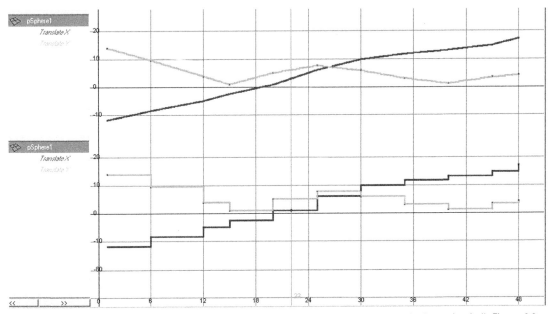

Figure 8.10 This animation graph shows the linear and stepped interpolation curves of a bouncing ball. Figure 8.9 shows curved interpolation.

With a finished animation, your graph should be using curves to smooth everything out.

Like the curves we've already learned about, you can control them using tangent lines at keyframe points and any others you may want to add on. This allows you to fine-tune the animation between keyframes. Manipulating the curves on graphs is great when you want to be more exact as far as what the numbers say. It also helps with repeating actions such as shaking and revolving. But it does not let you see right off hand the changes to the animation, and it is limited to adjustment of what is between the keyframes. To really see how you are changing your animation, you need to work directly in the 3D views to change the poses. A good animator will use both methods, going back and forth to perfect the motion.

Motion Capture

Motion capture is a way of letting the performer drive the animation of a character (Figure 8.11). A performer generally wears a skintight suit that has markers on it. The computer can easily pick up the markers as the actor is being filmed. If expressions are wanted, the actor may also have green dots all over her face. On the soundstage, several cameras film the actor from different angles as she goes through the performance, maybe

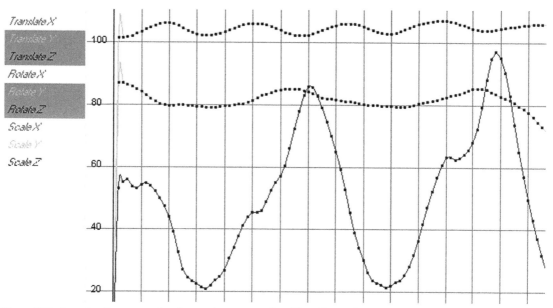

Figure 8.11 An animation curve showing motion-captured walking. Every single frame has been keyed.

scrabbling across a tumble of rocks, or at least rock-shaped foam. Often, the director can see a low-polygon image of a figure copying her actions exactly in real time. All throughout, the motion of the markers is being recorded as motion data.

In the animator's studio, they'll take this motion data and use it to animate a computer-generated character. Care must be taken that the rig matches the data well enough to match the performance to the model. Though this is a much faster way than manually keyframing the whole thing, the character's animation is not complete. Limitations of the technology include the problem of limbs interacting with the virtual environment, body, and facial structures which are very different from the actor's, and plain errors in capture. All of this means that the animator needs to clean up the motion-capture data. They may also do things to exaggerate or enhance the poses. This makes the performance on screen a true collaboration between actors and animators.

Technology is moving forward quickly with motion capture. We are beginning to see the use of it more and more in movies not meant to be special effects extravaganzas, as computer graphics have become realistic enough to age actors or make them much younger. Recent technological developments are moving toward being able to achieve motion capture without the need for markers. There is even a low-level system for home console games on the market. The implications of these technologies for film

making are exciting both for large products and for bringing the ability to produce high-quality work in the hobbyist's home studio.

Facial Animation

The Facial Action Coding System, or FACS, was developed in 1978 by Paul Eckman, a psychologist studying emotion and facial expressions. It describes 64 distinct facial action units (AUs). These are not a list of expressions like "raised eyebrows"; rather, they describe what the muscles can do, such as brow lowerer and cheek raiser. The extremes of these movements can be created as morph targets, and then added into an expression using a slider. This kind of technique was used for Gollum, using Andy Serkis as the model for the AUs and then using his performances on camera for reference.

It is important to understand universal emotional expressions. These are involuntary when emotion is felt and so are recognized by people across the globe. There are six universal expressions: happiness, surprise, disgust, fear, sadness, and anger (Figure 8.12). Some also classify contempt as universal.

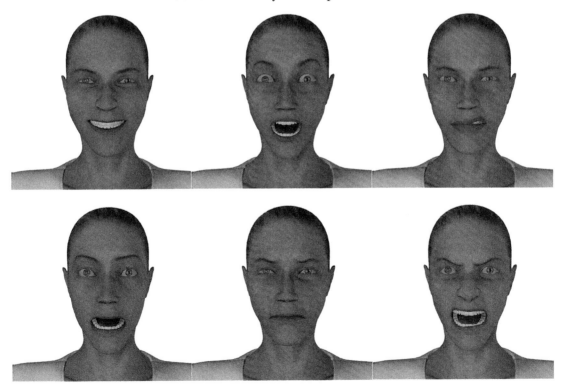

Figure 8.12 The six universal expressions: happiness, surprise, disgust, fear, sadness, and anger.

Universal Expressions

Study expressions and get them right. One of the stumbling blocks of both 2D and 3D animation is that of the uncanny valley. This is a problem where, because an expression is close to but not quite realistic, the audience may be unable to relate to the emotions of the character and may actually feel revulsion toward it. The uncanny valley can be used to give the audience a sense of discomfort, as it was in *Harry Potter: The Deathly Hallows Part 1*.

It is one thing to carefully craft a facial expression for a single shot; it is quite a bit more to animate expression. It starts out with creating a well-done rig. This involves not only deformation, but also a skeleton rig with the jaw. As discussed before, natural-looking deformations require a good underlying topology. A facial rig may also be a full musculoskeletal simulation.

You will need to use the facial rig to create several expressions, called morph targets. You can use sliders to move back and forth between two morphs, and/or key in each of these targets or combination of targets to create a series of expressions leading to facial animation. Motion capture can also be used, but in order to tweak things you may still want a good set of morph targets.

As well as having emotions, you will want your character to talk. A well-rigged character will include a joint that controls the jaw, as well as deformers. The sounds of speech can be broken up into phonemes. The shapes that the jaw, tongue, and mouth must make for those phonemes are sometimes called visemes (Figure 8.13). The problem with only the use of visemes is that during speech, these shapes tend to blend together. Using sliders between morph targets, and keying the blended viseme in, you can achieve more realistic speech movements. It's very important to make sure that the character's mouth animation syncs with the recorded speech. As well as listening to a speech track, you'll have each sound plotted out according to what frame that sound will fall on. There are automated ways to synch speech animation to sound. Motion capture can work fairly well with speech and there are also automated systems using algorithms to match sound to the shape of the mouth. Though it may not lead to revulsion, getting speech movements wrong will take the audience right out of the story.

Automation

Lots of the motion in your animation can be automated. You have already seen this a bit, using graphs to add vibrating or spin motions and with hierarchical animation. Another way to have

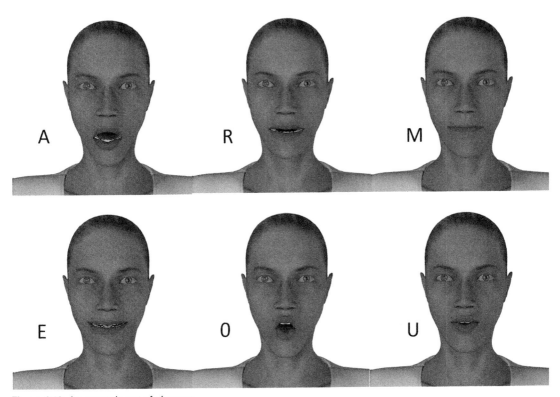

Figure 8.13 An example set of visemes.

the attributes of an object animated is to connect them to the attributes of other objects. You can link any kinds of characteristics of objects to each other. The position of a switch can determine whether a light in the scene is on. As a cart moves forward, its wheels can be made to turn at a rate that matches the distance traveled to the circumference of the wheel, thus controlling the rotation of the wheel. Other ways to add animation without needing to keyframe it in manually are through dynamics (see Chapter 9) and through scripting (see Chapter 18).

Fence-Post Errors

One last thing to look out for in animation is how time is handled. When filming at 24 frames per second, a frame is an image captured over 1/24th of a second. Computer-generated frames, however, are an image that is rendered, so that they only represent a point in time with 1/24th of a second between each frame. This can create something called fence-post errors. Things like motion blur that would occur over a period of time on an

exposed image may be rendered incorrectly because after the last frame, time is no longer moving forward and so the computer does not add the motion blur; or it adds only half of it, depending on how the application handles fence posts. It is usually up to the animator to correct such problems. Frames should be thought of as periods of time, not points in time, even if your application handles them differently.

Animation Workflow

Sitting at the computer and animating is one of the later steps in bringing your character to life, but it is a big process that takes its own workflow. Of course, everyone works a little differently, but there are some important steps that need to be part of that. The first few steps of a good workflow happen away from the computer.

At this point, you should already have a script, and you may have a storyboard. If there is voice acting, you should have a recording of that as well. With these in hand, it's time to brainstorm. During the brainstorming, gather references in video and pictures. Listen to the dialog track. Then, act out the motion yourself, sometimes while listening. A good animator is also an actor, who is just using the computer for their performance. So act out the shot and get a feel in your body for how it should go. Then draw it. You should draw quick thumbnail sketches of the ideas for poses that you get from acting out. The emphasis is on *quick* because they are disposable. This is still brainstorming, which is the time for quantity, not quality. They should be simple stick figures or the lines the body makes in its pose. Draw a pose: if it doesn't work, throw it out. Quality will come from doing a lot of work here, and then only picking out the best.

What you're getting here are the key poses, not every single pose. Sometimes these sketches can make up a kind of thumbnail storyboard (Figure 8.14).

Next, you need to consider the timing of the poses. Timing and pose are both very important. You can arrange your poses on something like an exposure (X) sheet, also called a dope sheet. An X sheet is where you write instructions for each frame. They are especially useful if you have dialog. You will have a rough idea of the timing going on in this, and you will be able to apply it to the sequence of frames. For instance, you can write down what sounds of each word are happening on what frame. Then you can easily match the pose to the sound. Even if you choose not to use an X sheet (bad idea with dialog), you will want to make sure you know what frame each key pose belongs

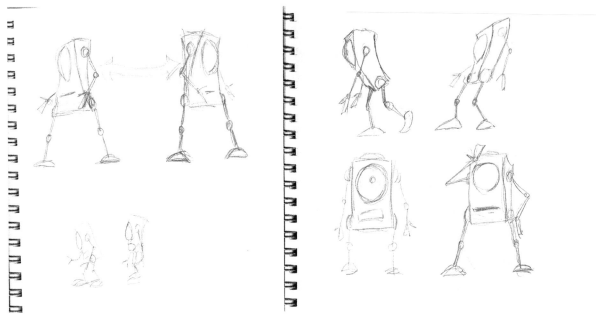

Figure 8.14 Storyboard of sketches.

in. It's also a good idea to have a draft X sheet with lots of scratching out and then from that create a more refined one. You might also do the sorting of which poses are good, as you are working out your timing here.

Once you've got this done, it's time to get back to your computer, take your rigged model, and keyframe all the poses. You'll want to work with heavy things first: legs if walking, or torso. Work your way from main body parts and big motions to tiny motions and facial expressions. Many leave facial expressions and speech for after refinement of body motions. You may have noticed that this is pose to pose, where all of your key poses are now present in the shot. Once you've got these all keyed in, you'll want to take a quick preview render while using stepped mode. Linear interpolation is often the default mode, so you need to switch to step before rendering. At this point, all of your keyframes should be in the same place for everything on the model you're animating. They will be very organized and easy to change.

Then you (and your director) will be able to see all of the key poses with their timing. You will see any problems, receive feedback, and then it will be time to go in and refine this. Make sure you take notes here. You may want to get feedback at each point in your workflow.

With timing down well, you can now fill in between the key poses. Keep in mind that your character now moves into key poses all at the same time. This ends up looking robotic. There are two schools of thought for fixing things. One is that you go in here and create more poses. This more traditional method gives you more visual control, and in the end may save time with trying to fidget with each bit. Keying in more poses between the others also keeps your keyframes organized. Plus, while you are filling in these new poses, you are now free to use straight-ahead action. The timing is already down and you are unlikely to hit a dead end. This frees you up to make the animation overall more dynamic. You may also want to modify your key poses just a little. The other method is to modify poses using the animation graph, moving this or that part so that you offset parts of the model so they do not all fall into the pose at the same time.

You will want to take another look at it with these refinements, in stepped mode or linear mode. However, don't try to render each section as you progress. You do not want to take up too much time waiting for render, watching, then fixing. Refine the whole shot, then do another test render. You may go through two or more cycles of this. Most of the time spent on working may be on that last fifteen percent of the job: refinement. However, if others cannot see what is wrong with it, then that might be a clue that it's time to call that thing done. Another consideration is some production houses have a high quantity output. They might not be looking for your most excellent work, but the best work you can produce within a certain time frame or budget. In this case, you need to learn when a project is good enough for them, even if it isn't good enough for you.

Things to do when you are animating and refining: watch for weight (squash and stretch), arcs, follow through and overlapping action, etc., as well as your timing. If you left your facial expressions for later, this is probably the time you want to work on them.

When you are happy with things in linear mode, you'll want to switch to curved interpolation. This will facilitate slow in and slow out, but the computer's literally thoughtless calculations to create the animation curves may mess things up a little. You may do a quick play through to see what it looks like at that point. Once you have seen the full animation with curves in it, you can go in and refine it some more.

You may be doing most of the animation with a low-polygon version of the model for a couple of reasons: if you're the animator then you probably are not the modeler. The modeler and texturer are still working on the model while you are animating. The second is that it can save time rendering. So you

might get your whole animation keyframed and refined, and then replace the rough model with the finished one. Once again, you will need to see if any refinements are necessary after this step.

Animating these days is very technology driven, and a lot of exciting things are happening because of the advancements in computing technology and 3D algorithms. We can do more than we've ever been able to do before. However, don't lose sight of the art. Even if the computer can do a task for you, you might want to do it yourself. After all, the computer has no heart or even a brain.

Tutorial 6
Juggling Robot

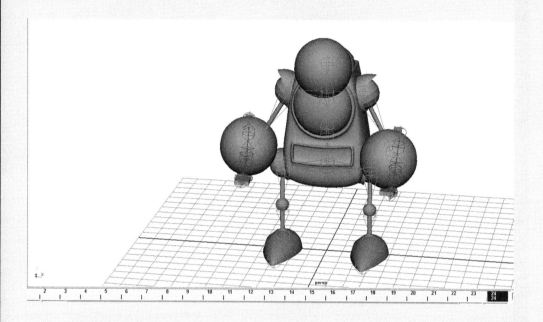

Step 1

This is going to be a looping animation that is similar to The Juggler, created by Eric Graham. Start by posing your robot so that its hands are in front of it and the clamps and thumbs are in a position as if they were holding something large. Then create three spheres. Place one in each hand and another up above them, at the top of a triangle.

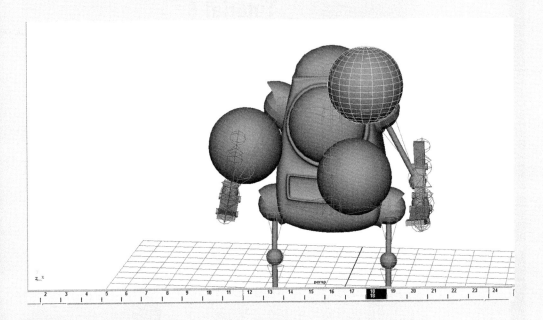

Step 2

Your timeline should be below the views. Set the timeline so there are 24 frames and you will be looking at all of them. Select the ball in the left hand. Your timeline indicator should be at frame 1. Add a key to the frame. This will put a key only on that ball. Move the time indicator to frame 24. Move the left hand ball up to exactly where the top of the triangle ball is. Add a key to the frame. Move the timeline indicator back to frame 1; select the top ball. Add a key to the frame. Move the frame to 24, move the top ball exactly to where the right hand ball is, and add a key. Now with the timeline back at 1, add a key to the right hand ball. Move the indicator again to 24, and move the right hand ball to exactly where the left hand ball is at frame 1. Now if you hit playback, you will see a looping animation of the balls moving. However, there are two problems.

First, the movement of the balls is not natural: they should be arcing up, but instead are moving in a straight line. To correct this, for each ball you need to add more keyframes. Draw the arcs using curves. Add three more keyframes to each ball, at quarter increments of time. Use the curves to guide your adjustments. Remember that a ball thrown up doesn't move at the same speed through its whole arc. A ball going up should travel a bit farther between frames 1 and 6 than between 7 and 12. The ball moving from side to side should be in the middle at frame 13. The ball going down should gain speed.

Second, the hands are not moving.

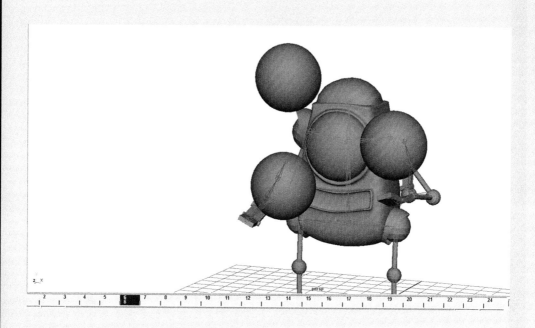

Step 3

With the balls moving pretty well, now keyframe the hands so it looks like they're catching and throwing the balls. For the right hand, it should be tossing a ball to the side, toward the left hand. You will want the right wrist to rotate, so the clamp is pushing to ball to the left. Then it must move back to catch the next ball. The left hand should be tossing a ball up in an arc toward the right, and then moving back to catch. You'll want to make sure the hands are in sync with the balls as they throw and catch them.

Step 4

It can be both fun and a bit nerve-wracking to juggle. To have the robot look nervous as he tries to catch the balls and smile as he succeeds, use the morph target controls to change its expression. The shape information will be within the morph target, rather than the robot's base body, so you will probably have to add a key using the morph target controls, rather than with the shape of the main body.

9

DYNAMICS: LET'S GET PHYSICAL

Picture a soldier aiming a rocket launcher. He fires. The missile arches toward a helicopter and hits it (Figure 9.1). It explodes into a fireball and pieces fly out in all directions, hitting other objects. One particular piece tumbles through the air toward the soldier, who runs to avoid it.

What about a ballroom with skirts swaying as dancers spin through complicated forms? Animating a dancing form could be simple enough, but animating the clothes on even one individual becomes very difficult. A whole ballroom full of them would be impossible to digitally animate one by one.

Animating such scenes, with explosions or moving cloth, can be achieved by using dynamics. With dynamics, the vast amount of work is done by the computer which is programmed to simulate the laws of Newtonian physics. These types of algorithms which are used for automated animation techniques are called motion dynamics solvers. Other kinds of behavior such as the random and non-random movement of crowds can also be automated.

Figure 9.1 A missile being launched at a helicopter.

Physics

Let's begin with the missile launcher example. To simulate this scene, several characteristics need to be added in. Across the entire virtual space will be gravity, friction, and wind, which has strength and direction (Figure 9.2). All of these attributes can be changed to suit the scene. Air that is made very thick will have more friction and can be used to simulate being underwater. Friction can also be a characteristic of a surface when objects are pushed along it.

Figure 9.2 Influence of gravity, friction, and wind.

For the missile, we need to know its mass, flexibility, and elasticity (Figure 9.3). These are constant to the object. But it may also have unique forces applied to it, such as the force which pushes

Figure 9.3 Influence of force, mass, friction, and rigidity.

Objects can be rigid or flexible. Flexible objects are often dealt with using lattice deformers, which can respond to the forces and deform the object as necessary. When no forces are influencing the lattice, it will return to its resting shape. When dealing with flexible objects, we also need to consider how elastic they are. An elastic object will bounce back to its original shape. A lump of clay is very flexible, but is not elastic at all, whereas a rubber ball is very elastic (Figure 9.4).

Forces in a scene can have different shapes as well as strengths. To launch the missile, a linear pushing force must be

Figure 9.4 After these flexible balls are dropped, the one elastic one on the left bounces but the non-elastic one collapses.

applied to it. Forces can be conical, with a force pushing out in the shape of a cone. Conically shaped forces are stronger in the middle than the edges. The airflow from fans is a good example of this. Another common shape for a force is spherical, with a force pushing out from a single point. This is great for creating explosions.

Exploding or shattering objects in a virtual space can be achieved in more than one way. The most intuitive way is to use a true simulation. Algorithms will break apart the model, which is especially challenging if it is an object that in real life is constructed with parts of differing flexibility and density. Then the computer must figure out the forces on each piece, and assign them their speed, direction, and tumble. While this may be more realistic, it can be a bit harder to make happen, and it actually might not look as cool. For feature film production, it is generally easier to replace the model with a copy that is already broken and then apply a spherical force to it at the time of the explosion. Add some details such as tumbling, a carefully crafted fireball, and something coming straight at the camera or something else important, and no one will know the difference.

Collision Detection

You probably don't want your objects sinking into each other when they are moving. The solution to this common problem is collision detection. Collision detection can be thought of as being in two parts: figuring out when an overlap occurs and then responding to it. The most difficult is determining when a collision takes place (Figure 9.5). Typically, your software checks to see whether any polygons or edges overlap as the objects move. In games, collision detection is part of the game engine.

Figure 9.5 Collision detection.

Once a collision is detected, simplified Newtonian laws can come into effect. The objects may bounce off of each other, changing the direction and speed of each object, such as in billiards. A ball will deform the net when it impacts, and then gravity will cause it to fall to the ground; meanwhile, the net regains its shape after a rebound (Figure 9.6). A thrown dart would penetrate a dartboard before stopping, leaving a small hole. Good detection also takes into consideration the center of the object, either its geometric center or its center of mass, so that an object may be made to spin if it is hit on the side. Some applications let you move this center.

Not only is an application's collision detection faster and easier for you to do — enabling a few checkboxes is all it takes — it is also more accurate. This is especially true when working with highly flexible objects such as cloth. Another option to prevent overlapping is to add forces that push away from the surface of a model.

Figure 9.6 This shows how two objects can be made to affect each other while also affected by gravity.

Particles

You've met particles before, as part of soft bodies. But they don't have to be part of an object. They can be as numerous and scattered as you need them. These points can have physics, either natural or unnatural, applied to them. They can be given mass to react to things such as gravity, wind, and forces. Particles can be used to simulate things such as rain and snow, fireworks and explosions, fluids, cloth, and more (Figure 9.7).

They most commonly originate from an emitter. An emitter can be a point, a curve, a plane, or any kind of 3D object. Particles are randomly generated from surfaces or points, and then move according to a random speed and direction (within certain limits you define) that could changed if they are made to react to gravity. Emitted particles can have a limited lifespan so that they disappear after a while. This is very useful for things like fire, where particles, with glowing fire effects applied, would be made to flow up from an emitter and eventually disappear, as flames do. Smoke disappears much later than fire does, and so you would give smoke particles a longer lifespan.

As soft bodies, particles are often used to simulate cloth. With their ability to respond to physics, they deform the mesh according to the simulated forces being applied, making the cloth

Figure 9.7 Particles used for fire effects. The spheres are the particles, which shrink over their lifespan until they disappear. A special material is then applied to make them look like fire.

move in a realistic way. You can change how cloth or any soft body behaves by working with the mass of the particles and the values of the spring constraints. Heavier particles with fairly rigid spring constrains would give you a thick canvas type of material. Lighter particles in soft bodies could be silk, and if you give the spring constraints a lot of flexibility you could create an elastic material. When creating cloth though, remember that you are still making models out of polygons. While the edges and faces can stretch, they can't bend. Make sure you have enough polygons in them so you don't have jagged edges where the cloth bends.

Hair

With thousands of individual strands on your mesh's head and more if we're talking about fur, hair is another complex problem. The solution is to simplify. Instead of computing the movements of each and every hair, we can use guide hairs which control the hair strands around them. But that is only part of the problem. Hair shimmers in the light. This makes rendering those thousands of strands very time consuming. Another simplification is to make hair a volumetric object: an object that has its whole volume rendered. This works well because hair is mostly perceived as a single object. Even with the complicated hair material and all the other algorithms it takes to make it look good, this ends up being easier on the CPU. This technique was used by Pixar in *The Incredibles*. In games, with their real-time rendering, hair is often made into surfaces with very little movement. No matter how it's modeled, hair typically is dealt with dynamically (Figure 9.8).

Figure 9.8 Hair.

Fluid Dynamics

Whether it's a puddle of spilt milk spreading on the table or the majesty of the Niagara Falls, fluids are intriguing. They can be simulated in a number of ways, including working with full volumes or as particle systems. Fluid dynamics are often used for smoke, clouds, and explosions (Figure 9.9). Many applications don't have good capabilities with fluid simulation, and so you will need to use tailor-made software or plugins.

Figure 9.9 This wisp of smoke was created using fluid dynamics with a particle system.

Crowds and Populations

Crowds can be any large number of objects in a scene such as a handful of nails dropped onto the table, a flock of seagulls, a forest, or a battle. Their movement can be simple or complex. Before you control a crowd, you need to have one. The simplest way to populate a crowd starts with a single object that is copied and then randomized by scale, position, orientation, etc. You have a lot of control over how and where your population can be placed. For instance, you could create a city scene with cars on the road and people on the sidewalks and walking through a pavilion. The cars would be constrained to the roads, and also have their rotation constrained. The people

could be facing in any direction, but only on the sidewalk, pavilion, or crosswalk. If you want more variety, you can start with several objects that are randomized into the scene. Some applications even have the ability to scatter things such as plants, where each object is a unique instance with different structures.

In our city example, the cars would stop and go according to traffic laws and proximity to each other. People could be given similar rules. Both cars and people can be "born" during the scene and have goals they move toward. The behavior of flocks of birds can be controlled using the same methods as particles. Simpler population animation could be plants that remain in the same place, but sway as they are affected by a wind force.

You may find these abilities in your main 3D application or in a different tool, or you can program the generation and behavior of crowds using scripting language such as Python or your application's proprietary language. See Chapter 18 for more.

Quality

As your objects move through a scene, the computer needs to figure out what their path is according to all the forces and characteristics you have applied to them. For some things, such as particle effects and fluid simulations, if these calculations are done only once for each frame, you may get motion that looks too fast or appears to skip. The more times your objects' movements are recalculated, the better they will appear, up to a limit. It is this very same limit of our own brain's perception abilities that makes us need only 24–30 frames per second. Just like with the number of polygons on a polygon mesh, after a while the human eye cannot detect improvement. You can control how many times the calculations are made between frames. Trial and error with a limited animation sequence can help you achieve the best possible appearance with the time and computer power you have available.

Tutorial 7
Draping Cloth

Step 1

For this tutorial, we will need three objects. Create a plane for the floor and a cube for the "table". Create another plane that will become the cloth. Make sure that it has at least 50 subdivisions on each side, making for a total of 250 polygons. Polygon faces cannot bend, so if your cloth has a low polygon count it won't smoothly drape over something. The higher the polygon count of your cloth is, the longer it will take the computer to play back or render each frame. This isn't just about polygon counts. You may recall that with cloth, each vertex is a particle and is being affected by forces and collisions. This takes time to calculate. The more vertices, the more time. Place the cube on the floor plane, and the plane you intend to be the cloth above the cube. Turn the cube on the up axis so that it's diagonal from the cloth plane; in other words, the corners of the cube are pointing toward the middle of the edges of the cloth.

Step 2

Select the cloth plane and turn it into a soft body. Your application may have a specialized soft body specifically for cloth. If so, use that. In some cases, there may already be physics solvers like gravity associated with the cloth upon creation. In other cases, you will have to add gravity and/or a solver for collisions. When you add things such as collision detectors and forces, you may see markers in the scene representing them. Change the cube and the floor to passive rigid bodies with colliders. This means that while other objects may hit them and bounce, they will not be affected by those objects. Collision detection on all of these objects should be set to face rather than vertex or edge. Otherwise, meshes could intersect through the faces over the course of the dynamic animation.

Step 3

Now that all of the objects have been configured, set your timeline to about 100 frames, and make sure you have it so you can see all of those frames. Hit the play button, and watch the cloth drop and interact with the cube. You will notice that the playback of the dynamic cloth takes longer than your keyframed animation; how much longer depends on your computer's processor. Also watch how the cloth folds. (The cloth shown here has a special non-default shiny material on it so you can see the folds easily.) Even with a higher polygon count, you may still notice the jagged edges of the cloth. The cube is hitting the cloth diagonally, so that the faces are hitting the corner of the cube at different angles causing the bumps. You get this effect if there are any folds that are not parallel to the polygons. Set your animation back to the beginning and try moving the cube so that it is aligned with the cloth; then hit play again and watch how the cloth falls a bit differently. To make it look "perfect" in a virtual dynamic world, you would need a prohibitively large amount of polygons.

Another thing that could be happening is that the collision detectors of both the cloth and the cube have a thickness. The cloth is not actually "touching" the cube. You need the thickness, but you can often reduce it in the options.

HOW THE PIXEL GETS ITS COLOR

When a 3D model could only be drawn using lines, it was always depicted in wireframe. With a model of anything more complicated than a simple shape such as a cube, it gets hard to see what it is. Figuring out how to show only the visible side, so the model appeared solid, was one of the first orders of business for the pioneers of the field. The solutions they came up with, as they pushed the technology to get more realistic results, are still with us. Understanding how they solved the problems of making images out of virtual 3D shapes is important for you to know, to set up the materials lighting, and other effects you'll want.

At the base of the problem is the question of how to translate the shape of the model to an image on the screen. How should each pixel on the screen be colored? The earliest rendering to accomplish solid color. Here, a line is traced from the "camera" through the pixel into the scene (Figure 10.1). If that line hits

Figure 10.1 Scanline rendering.

a surface, the pixel gets the color assigned to the object. If it does not hit anything, the pixel will have the color of the background. Notice that this solves another problem. Only the first surface met (and the computer knows the 3D coordinates of all the surfaces) is considered in the calculation. The image this gives is just a silhouette.

Another algorithm, called Z-depth, figures out which surface should be hidden by determining whether a surface is behind another one. If there is no surface in front of it, then the edge is drawn. Otherwise, it is not drawn. You can combine this with scanline to have a silhouette with the wireframe of only the visible surfaces drawn on it (Figure 10.2). Z-depth is still used to determine how far away an object is, so that distance effects can be applied to it.

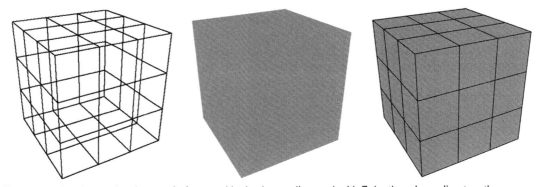

Figure 10.2 A cube rendered as a wireframe, with simple scanline, and with Z depth and scanline together.

Shaders

Images drawn with this first scanline renderer now had a solid color, but the objects looked two-dimensional. To give them the appearance of three dimensions, the color of the object need to become shaded in the same way it does in real life. A ball that is all the same color of red will seem to have darker shades of red where its side faces away from the light, and paler shades than the original color where its side is pointed right at the light source. The algorithms to add the shading to objects in computer graphics are called shaders.

Lambert

The first solution to adding shading to an object was to change the color of each face according to what angle it's facing, and it's

distance from a virtual light. When light hits directly, the color is made brighter. When a polygon is angled somewhat away from the light, the color gets darker, and darker yet for faces in shadow (Figure 10.3). This is called Lambert shading, or flat shading. It's the simplest of all the shaders and the foundation for all others because it calculates the angle of the light.

Figure 10.3 Lambert shading.

Gouraud

For a smoother look you could use Gouraud shading. This shader uses the normal of each vertex. These are gained by averaging the normal of all the faces which that vertex is a part of. Then it calculates the angle of light against the vertex normal to get a color at each vertex. At this point, it creates a gradient of colors between the vertices and the edges. It is this kind of shading that is most common when you are looking at a real-time, gray-shaded display of your model. It works well for having a feel of the shape of your model, and is decent enough for matte plastic types of materials. However, Gouraud shading doesn't present specular highlights well (Figure 10.4).

Phong

Depending on an object's reflectivity, light from a direct light source is reflected straight back at the viewing point. This causes a specular highlight (Figure 10.5). It's the bright spot you see on a shiny (smoother) surface. Since a highlight is made of light that has been reflected, the color of the light does not

Figure 10.4 Gouraud shading.

change. When the light is white, the highlight is white. Phong shading handles specular highlights by using a reflection model which accounts for this. It creates spots of brightening colors where the angle of light would reflect directly at the pixel. Then, it incorporates the reflection model into a slightly different type

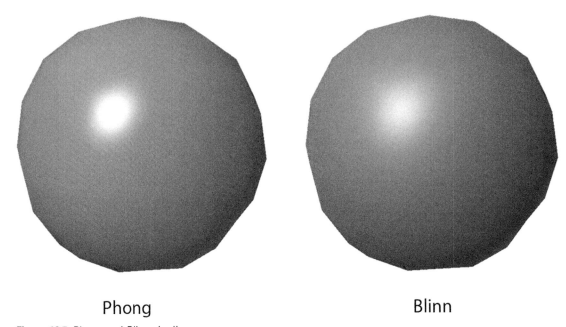

Phong

Blinn

Figure 10.5 Phong and Blinn shading.

of smoothing. First, like Gouraud it starts with the vertex normal, but then it interpolates the normals between each vertex (rather than the colors between each vertex). Then it calculates the color of each pixel. Since it is using the angle of light for each pixel, it takes a lot more calculations and so takes longer to render. However, it works better for shiny materials like the plastic of a beach ball.

Blinn

This is a very similar shader to Phong and is sometimes called Blinn–Phong. It is more efficient if the light you are using is "infinite" − coming from no particular source but a general direction (simulated sunlight is treated as infinite). However, Blinn shading is slower to render than Phong in some circumstances, such as if there are point lights in the scene. Another difference this produces is how the specular highlights look. Phong highlights are a little more concentrated and circular even on flat surfaces, while Blinn highlights are softer and stretch out when viewing the surface from a shallow angle, making it better for objects such as cars where you see large flat surfaces.

Rough Surfaces

Most surfaces in real life are not completely smooth, causing light to get scattered a bit more. This spreads reflections out and can soften highlighting effects. Neither Phong nor Blinn shading really accounts for this, but there are several shaders that do. Oren–Nayar shading is useful for surfaces that are rough, such as plaster, skin, and sand. Cook–Torrence also does this, but works better for metallic and plastic materials. Sometimes, materials are rough in parallel lines, such as with CDs, hair, and brushed metals. These create highlights spread across the surface that run perpendicular to the lines (Figure 10.6). You can get this effect with anisotropic (directionally dependent) shaders, such as Ward.

Ray Tracing

The next step to realism is to use ray tracing. This method follows a ray from a light source to the pixel, determining if it is blocked, reflected, refracted, etc. But most of the rays that a light casts never make it to the viewer's eye. It would take a lot of time to calculate all those rays that add nothing to the image. The solution is to capture only those rays that will light up a pixel; rays are traced backwards, from the camera to pixel

Figure 10.6 Anisotropic highlights on a CD.

then to the light source. This is a simple thing to do, since all the angles work pretty much the same backwards as forwards. As our ray moves backwards along this course, it finds the closest object and then calculates the light sources around it that might affect the point on that object where the ray intersected. Then, depending on the material attributes (controlled using textures and shaders), it can cast three different kinds of rays out: reflection rays, refraction rays, and shadow rays (Figure 10.7) (see Chapter 13).

Ray tracing gives you pretty realistic images. You pay for this realism with a longer time to render. Not only are several rays being cast from the pixels; they're bouncing around all over the place. Some rendering engines will let you use both scanline and ray tracing rendering at the same time, which increases the rendering efficiency a lot. You mark what kind of rendering you need for which object. Perhaps you only need the ray tracer for the glass of water, but the rest of the scene is fine with the scanline. You'll save lots of time being able to use both.

There are some limitations to pure ray tracing though. For one thing, it doesn't handle indirect light very well.

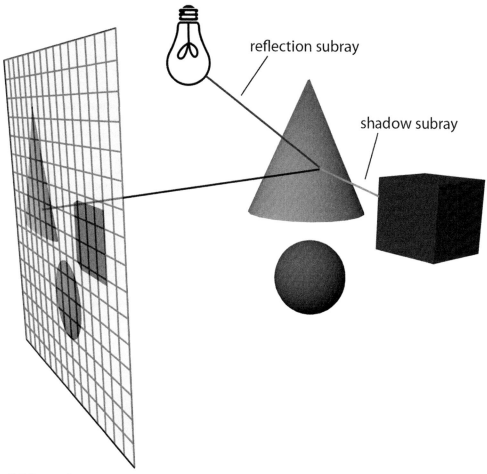

Figure 10.7 Ray tracing.

Radiosity and Indirect Light

Even if something is completely in the shadow of a light source, it is still lit up. This happens because of indirect lighting, light that comes from sources other than light-emitting objects. This could be light from reflection, refraction, and diffuse reflection. A great example of this is the sky, which produces a huge amount of indirect, ambient lighting. This light comes from sunlight which has been scattered about by air particles. Indoors, surfaces such as walls also scatter every bit of light that comes to them. Ray tracing does a pretty decent job with reflection and refraction, but not diffuse reflection. For that, we need to use a method called radiosity. It works like this. Imagine that

every surface in the scene is divided into patches. Each patch sees how much light it is getting from every object in the scene. When it sees light, it scatters it. At first, the only light that a patch can see comes from the light sources. But as it and every other patch sees the scattered light from other patches, the patch picks up on more light and scatters that. Doing this for several cycles results in a scene that has global illumination (Figure 10.8). One of the resulting effects from this process is color bleeding. Color from an object gets scattered onto a nearby surface because of diffuse reflection. You can see a soft red puff of color on a wall near a red umbrella. Global illumination is a good step forward in realistic images, especially for indoor lighting. Since they are so compatible, radiosity is usually made a part of a ray tracing renderer.

Figure 10.8 On the right, the teapot has had radiosity used on it. Notice that now there are brighter highlights and darker shadows.

Ambient Occlusion

However, global illumination takes a lot of computer power and time. Another method to get good depth in objects is to use ambient occlusion. Here, rays are cast out from the surface of an object. If these rays hit any other surface before they go off into infinity, then the surface they were emitted from will remain darker. If they do not hit any other geometry, then the surface they come from will be lit. This provides good ambient lighting shadows that are efficient and makes the object look more three-dimensional than objects that are just lit with ambient lighting without radiosity (Figure 10.9). An object using ambient occlusion is affected by all the objects in the scene, but only affects the object for which it is turned on. In some applications, you can

Figure 10.9 The same model with ambient occlusion (on the right) and without (on the left).

choose ambient occlusion by object. In other applications, it is a universal setting and will affect all objects.

Photon Mapping

The most recent method that has been developed for rendering is photon mapping. It deals not only with indirect light, but also with all the effects that ray tracing can offer with reflection and refraction. What is more, photon mapping improves on these with the addition of such effects as caustics and subsurface scattering. There are two parts to photon mapping. First, photon particles are emitted from a light source. They bounce around the scene for a while, losing intensity with each contact with a surface, how much depending on what material is assigned to the surface. If they don't touch a surface, they leave the scene. When they hit a surface, they leave information about what color that surface should be. The more virtual photons hit the surface, the lighter it will become and the fewer that hit it, the more in shadow it is. Once this is done, a photon map is created. Second, the scene is rendered much like a ray tracer, with rays referring to the photon map to determine what color the pixel should be. This yields realistic results and is more efficient than radiosity. If your renderer supports photon mapping, you can usually enable it with a checkbox in the render settings.

Tutorial 8
Easier Than a Coloring Book

Step 1

Start with the robot which you have been working on in the tutorials, specifically with the saved file from Tutorial 6, that has the animation with the spheres being juggled. Select the right-handed ball. Add a new material to it. Your application may need you to create the material before and add it to the selection, or you might pull up a material editor with the command to add a new material. Either way, make this first material a Blinn shader, and choose an ambient color, which may also be linked to the diffuse color. For the left-hand ball, add a Phong shader, and for the top triangle ball, add an anisotropic shader. Keep them the same color.

Step 2

Select the left shoulder, which should add the whole arm into the selection. Add an anisotropic shader and give it a metallic type of color like gold or silver. It should complement the color of the robot's body, which you should also add a material for. Give the brain box a material with a slightly glowing effect. Make the eye's shader white and very translucent. At this point, if you do a quick render you may be worried about the look of the low polygon count in the spheres. This will be addressed in a later tutorial.

MORE THAN JUST COLOR

A computer-generated 3D model is not really finished and ready to render until it has got some color and information about the bumpiness or smoothness of its surface. As we embark on this stage, you need to be aware that each application has its own way of dealing with color and light and sometimes uses the same name for things that are completely different in other applications. But that is just a matter of words and mechanics. The basics of input to output or what you must add to the object to get the image you want remain the same.

You have already learned about shaders. Using a shader is the most basic way that your model will get some color and lighting.

A texture is the color assigned to an object. That color can be just a solid color, in the form of a bitmap image applied to the surface, or it can be procedural, or created with a variety of nodes that use a combination of these. A procedural texture is created using mathematical algorithms which generate patterns that may appear ordered or chaotic. Textures can also incorporate surface information, such as what you might get with a bumpy cobblestone road or an engraved invitation.

A material can typically be described as the combination of texture and shaders that produce the appearance of a substance (or material) that an object is made of.

Working With Shaders

Shader attributes can all be changed within the shader controls, giving you a lot of power to create different materials without needing textures at all. The process starts with picking a shader appropriate to the material you're trying to emulate, and then setting the specific characteristics that make it look like the material required. For instance, if you wanted to make something that looked like paper, which has a matte and ever so slightly rough surface, you might choose Oren–Nayar and make the ambient and diffuse colors white.

All of the shaders approximate how things look, but don't do true simulations of light and surface interactions. As a result,

3D Art Essentials

some problems can creep up as you are adjusting settings, such as having more light reflected from an object than was directed at it. Also, these shaders don't work well (by themselves) for materials that are transparent, such as glass, or have volume, such as a glass full of water, or clouds. There are often other attributes that you can add to give the right effect.

Texture Mapping

A common analogy for how to apply 2D textures to 3D objects is that of wrapping a present, shaped as a cube. This works well to imagine the final effect, but doesn't describe all the things that must be considered when mapping a texture to an object. Most objects aren't simple boxes. The edges of the texture will need to match up and not overlap or leave gaps.

One method of transferring an image to an object's surface is called planar projection (Figure 11.1, left). As the name implies, the image is projected onto the surface, similarly to how a movie projector works. This image can be moved, rotated, and sheared (keeping one edge fixed while moving the opposite edge in a parallel direction). Planar projection works best when the surface is flatter, such as a billboard. On non-planar surfaces, the image can get warped or appear chopped up when it is projected.

There are other types of projection mapping as well. With cube or box projection, the texture is split apart into six different squares which will then be folded up into a cube and projected onto the surface. With cylindrical projection, the image is rolled up into a tube before being projected (Figure 11.1, center). There

planar cylindrical spherical

Figure 11.1 Planar, cylindrical, and spherical projections.

are several ways to create spherical projections, but the basic idea is that the image or pattern is shaped into a sphere before being mapped onto the surface (Figure 11.1, right). A few other odd shapes can sometimes be found to project, such as cones or tori (plural of torus, a donut shape). Your choice will be based on what shape is closest to the geometry you're projecting the texture onto.

Simple projection mapping is efficient for texturing basic shapes like a die or a ball. But it's not quite up to the task of getting an image on a detailed model without any stretching or bunching artifacts. Not only that, it can be difficult for an artist to place the texture (usually using settings like offset, projection, or image center) so that the image details match the geometric details.

UV Mapping

The solution for mapping a detailed model is to use a system of coordinates. Instead of the XYZ coordinates in space, these are of a grid on the model's surface and are the UV (and sometimes W) coordinates. Just like X, Y, and Z, these letters were picked as the standard letters to use when discussing surface coordinates. U usually corresponds to horizontal or latitude and V to vertical or longitude.

NURBS surfaces, with their neat grid of curves, automatically have UV coordinates (Figure 11.2). Polygon meshes, including subdivision surfaces, must have UV coordinates assigned. The purpose of these coordinates is to assign points on the surface to points on an image. Projection mapping does this in a primitive way, often with just the image center, and you don't have much control over it. In UV mapping, coordinates are assigned to every vertex. You can then match the coordinates to points on a texture map. These are called texture coordinates.

For UV mapping, the ideal surface between all the vertices on the 3D model's surface is flat. This is true of polygon meshes, but not of NURBS. This is why even though it is easier to have UV coordinates on a NURBS surface, UV mapping doesn't work as well for NURBS as for polygon meshes.

In practice, to match the texture coordinates of the bitmap image to the UV coordinates of the 3D model, we need to flatten the model's surface. The idea of it is easy enough, since polygons are already flat. You could just take every face and lay them out on a single 2D plane. But that's kind of messy and indecipherable. Instead, the technique is to carefully unfold or unwrap a mesh

Figure 11.2 A surface showing UV coordinates with an image showing the texture coordinates.

copy at seams, keeping as many polygons connected at their edges as possible, and lay it flat.

To unwrap a simple cube primitive one starts out by selecting which edges become seams (Figure 11.3). Seams are edges which are split apart to become the boundaries on your UV map, and then "stitched" back together to single edges when you apply the map to the model. Once the seams are defined you are ready to create the UV map.

Figure 11.3 The common way to unwrap a cube.

Figure 11.4 A sphere and two common ways spheres are UV mapped.

Each polygon in the map refers to a polygon on the model, letting us map a 2D image onto a 3D model.

Now let's try a more complicated object like a polygon sphere (Figure 11.4). To unwrap a sphere in the same way, with all of the polygons in the map keeping the same proportions as those on the model, takes a lot of seams, which are hard to create by hand. It is really difficult for an artist to draw or place an image on the splattered UVs, because it is hard to visualize and there are a lot of seams to match when it is applied to the model.

Some stretching or pinching is acceptable while unwrapping. The idea for a good UV map is to make it easy to match the image to the map with the smallest number of seams possible. The shape should be modified to map the geometry with the least amount of distortion possible. Often while doing this, a checkered texture is used to visually track any distortion. A seam is created, either by selecting edges or by selecting all the faces of a section of the model. The same concept as projection mapping is used to flatten non-planar surfaces. The mapping type (planar, spherical, cylindrical, etc.) is chosen, and a map is created. For instance, if you were working with an arm, cylindrical mapping might be suitable (Figure 11.5).

For other areas such as a head, unwrapping requires meticulous attention to detail (Figure 11.6). It is often done in parts: scalp, sides of head with ears, back of head, face, neck, throat, so that the right mapping type can be used. Then the parts are stitched back together to get a whole map. This reduces the number of seams before mapping the texture on and makes it easier to visually match to the 3D model. Other times, seams are specially chosen before being unwrapped.

Figure 11.5 Cylindrical mapping of an arm.

Figure 11.6 A UV map of a head.

A Few Tips

UV mapping is an important part of 3D creation. Getting it right can be the difference between something great and something so-so. Keep in mind the following.

• Good UV mapping starts with good modeling, and especially good topology. When the topology is poor, you will be more likely to have a stretched or pinched texture and seam splits or overlaps with the UV map.

- Do not start on a UV map until after you have finished modeling. Editing the mesh after the UVs have been mapped makes the UVs no longer fit the model, causing artifacts.
- Pay attention to seams when painting or placing the image in the UV map. Each seam that needs to be stitched back together into an edge needs to have its pattern match. Think of papering a wall, where you match the edges of each strip. It can be useful if you are using a good 2D editor to have each of your faces in layers. There, match two faces that need to be stitched back together, and paint them while they are aligned together. Once the painting is done, place them back where they belong. If you have a model with visible seams, this is a good way to clean them up.
- Pay attention to the relative area of your UV map. As you are stitching patches together, stretching or pinching some faces in the process, you may accidentally create a map that is too small or too large. This causes gaps and overlapping.
- To reduce the difficulties associated with seams use as few as possible. This also helps you to visualize the rewrapping of the map.
- If you have an object with more than a handful of faces, but no strong detail landmarks, you can make things easier by creating a simple UV texture map where each face is numbered. Apply the numbered texture to the model to see how they all relate to each other; then use that texture in whatever UV texture or image editor you have. Set it above the layer you're working on and make it nearly transparent; then on the working layer know on which face you're drawing.

A few applications are available that specialize in tasks related to mapping. They still need a lot of oversight and you have to correctly import and export. Even if you use them, it's good to stay within your application and attempt a few on your own so that you are familiar with the process and know how to evaluate and fix problems.

Painting in 3D

Some applications and plugins allow you to paint directly onto a 3D object without having to unwrap it. This can be intuitive and much easier than cutting apart an image or painting one onto a set of UVs. In the background the application has automatically set up UV coordinates and is creating an image texture with texture coordinates that are mapped on to your object. When you export your model to something else, the UV texture map is usually a patchwork of color, but the computer knows how to implement it.

Other Maps

Now that you are familiar with texture maps and mapping techniques, let's move on to other types of maps. After all, there is more to the appearance of an object than just its color. Bumpiness, transparency, and reflections are a few factors. Using additional maps you can add more detail to your model without adding to the polygon count. Consider a brick. Real bricks have a rough surface and are flecked with little stones. Some are shiny while some are dull. Or how about a rusty bolt, an orange, or a corrugated box. These are objects that need more than color or an image to appear convincingly realistic.

Images can be used to govern characteristics other than the color of the surface. When they do this, they use ramp gradients where the color controls a value. Black to white gradients are best to use when you have two extremes between which there can be a lot of variety: down and up, opaque and transparent, shiny and dull, etc. Black represents either 0 or a minimum value and white is 1 or a maximum value (Figure 11.7). For instance, a grayscale

Figure 11.7 This image could create the appearance of a lumpy hole or if inverted, a mound of dirt when used as a bump map.

image of a footprint, with the background white and the deepest part of the footprint black, can be used to drive the height of a surface. The maximum value would be the height at the surface itself, and the minimum value would be set as a bit below the surface. A footprint would then appear on the surface as an indent. If the minimum value were set even lower from the surface, the indent would be deeper.

Sometimes, we might need more information. A color ramp has within it more information, in the form of RGB channels. A color image will have three color channels: Red, Green, and Blue. Each channel works similarly to the grayscale ramp, with the darkest shade being the minimum value and the lightest being the maximum. This gives you three sets of data, perfect for storing things like X, Y, and Z coordinates, which is exactly what you need if you want to change the geometry on the surface of a model.

Changing Geometry

If you were to model a brick down to the tiniest detail it would take a huge number of polygons to portray the rough surface. However, there are other solutions. Most surfaces in the real world carry some amount of bumpiness. Different kinds of maps can be used to solve this and create more realistic looking models.

Bump Maps

Bump maps are grayscale maps that add simulated height or depth to a model's surface. Black represents the lowest elevation and white is the highest. It works like this: say the renderer is using Phong shading to figure out how dark or bright a pixel is based on the angle of the surface (the normal) reflecting light, then it adds the information from the bump map, which changes the normal. If you have a single face with its single normal, but a variation of height provided by the bump map, that face can have several normals, each one now different. This creates the appearance of depth. However, it doesn't actually change the geometry so the silhouette and shadow of the object will remain smooth as it is unaffected. Also, this only happens in the direction of the camera. Bump maps are sufficient for shallow types of roughness such as from a brick, an orange, or a golf ball.

Normal Maps

What if, rather than just adding height or depth, you could simulate geometry on all three axes? Then the simulation could

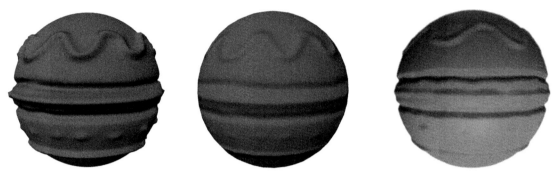

Figure 11.8 From left to right is the original geometry, a sphere with a normal map based on the geometry, and then one with a displacement map.

occur not just toward the camera, but in all directions. Normal maps do just that (Figure 11.8). Normal maps use RGB color images, giving the three channels needed for X, Y, and Z coordinates. The information in a normal map directly affects the angle of a normal. This gives more accurate bumpiness, especially for more orderly details like rivets or the pitted dots on dice.

To create a normal map, an artist often creates a high-polygon model with all the detail they want. They then create a UV map of the model, and map the normal using the RGB channels, applying this texture to the UV map. Since the UV map is of a subdivided version of its low-polygon self, it will still fit. As it contains all the normal information it allows the renderer to add shadow or highlights as needed to give depth to the material. Unfortunately, normal maps retain the problem of having a smooth silhouette and shadow. Normal maps are commonplace in video games.

Displacement Maps

To really get rid of this problem, you need a displacement map which will affect the silhouette and shadow. Displacement maps are grayscale and truly change the height of the surface along the normal, changing its geometry. This means that even the silhouette of the model gains detail. In most applications, this step happens during the render. But displacement maps or similar can also be used to model, which is helpful for adding random roughness to surfaces such as water.

Alpha or Transparency Maps

Alpha maps or masks are grayscale bitmaps used to change the transparency of a texture. With an alpha map, you can make

Figure 11.9 A color map and an alpha map of a leaf. The black parts of the alpha map will cause those parts on the color map to be completely transparent.

any part of your model completely invisible or partially transparent. Areas of the image that are black are totally transparent. Another texture map is used to add color. When used on simple planes, it is a great way to create leaves for plant models. Take a look at Figure 3.4 in Chapter 3. To illustrate the planes used for leaves, the part of the alpha map that would have been black, making it transparent, was changed to gray so that it could be seen. For the leaf, a picture of a leaf was used with the alpha map. Planes that use alpha maps are often called alpha planes. Not only are they good for adding in objects that are mostly flat; they are also useful for adding background details that don't need to be fully 3D. Even entire plants can be added into a scene as alpha planes, a method you might recognize in game environments.

A helpful use of alpha maps is to add another layer of texture onto a material and make part of that texture transparent (Figure 11.9). This technique is a way to add details such as a label on a bottle, rust, and peeling or splattered paint. Alpha maps are also used a lot in 2D image editing and compositing.

Seamless Repeating Patterns

When you have repeating patterns, you will want to ensure that where their edges meet, you cannot see any seams (Figure 11.10). There are well-documented ways of doing this in 2D image editors; it is often an automated process. There are also textures you can easily source from the internet that are created to be seamless. Textures can be seamless on all sides, or only on the two opposite sides (nice for things like scrollwork). To maintain the illusion, be careful not to have features that are

Figure 11.10 Obvious seams (left) and seamless repeating tiles (right).

Figure 11.11 Notice how easy it is to see the repetition of the pattern. This is a drawback of using seamless tiled images.

obviously repeating. Tiling textures are good for where a repeating pattern is expected, such as a chain-link fence. If you are using it for things like wood grain or water, the repetition can be seen easily (Figure 11.11). An alternative to tiled textures is to use a procedural texture (see Chapter 17).

Multiple Maps

You can map just about any visual aspect of a surface using maps. A useful aspect of this is that you can easily match maps together. For instance, think of a speaker that has a shiny case but the speaker units themselves are covered in fabric. You can use a map to control shininess that matches the texture map and the bump map. You can also layer materials, using several maps for

Figure 11.12 Using multiple maps.

each layer. Let's say you want to render the back of a car covered with bumper stickers (Figure 11.12). Although you could have a texture map and an alpha map for each bumper sticker, it is easier to create one map for the bumper, the body of the car, and the window. It's an old car with a bad paint job. This requires a texture map layer of discolored yellow paint, a dull steel layer for the bumper object, and the slightly blue glass of the tempered window that has lines going through it. You can also add age with a few dents and including rust all over the car. That would involve making a displacement map for the dent, and a bump map, texture map, and alpha map for the rust.

Resolution

You need to take into consideration the size of the image you're using as a texture map. This size should relate to the size of your object to result in the right texture resolution. The appropriate resolution depends on how noticeable the object is in your scene. You don't want to use a very high-resolution texture for an object that will be in the distant background, and you don't want a low-resolution texture for a highly detailed object that is prominent in the foreground (Figure 11.13). Another thing to keep in mind when using multiple maps to create a material is that you want to ensure that the resolution of each map matches the others. There isn't really a standard regarding the size of the map, except that you should stay with sizes that are 2 to the power of n or 256×256, 512×512, etc. This is because of the way memory works and will optimize the texture's rendering

Figure 11.13 The resolution of this bitmap is too close up, but looks just fine in the background.

performance; this is common in video games to keep file sizes smaller and rendering times efficient. You will be aware of problems of low resolution. For instance, if you're seeing pixels in your rust, then you need to increase the resolution. This is why seamless tiled textures can be useful. Smaller images tiled together can give lots of resolution.

Tutorial 9
Mapping the Robot

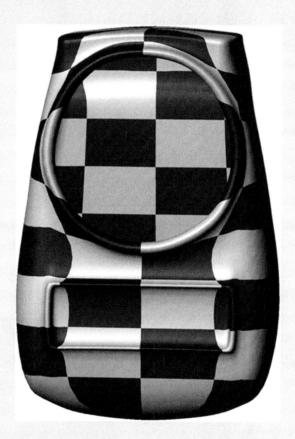

Step 1

Start with the robot as finished in the last tutorial about shaders. For clear illustration, all of the other parts of the robot have been hidden. With your ambient color, you should have a way to add a texture or pattern. Change the color so that it is a checkerboard pattern. The way your application applies the checkerboard may be different in scale. You will be using the checkerboard simply for diagnostics. If you render it, you will see that it doesn't look horrible, but there is some stretching and warping of the pattern going on, especially around the eye border. To correct this, you will add a UV map with an automatic operation. A more complicated model will need some more preparatory work such as creating seams before unwrapping.

Step 2

You should still have the main body of the robot selected. Open the tool to create a UV map. Choose the type of projection that would work best for the robot's body shape. You can experiment with projections and use the undo command to go back. It turns out that a cylindrical projection unwraps the mesh in a way that produces an easy-to-visualize UV map, though it will be difficult to make the top and bottom of the robot look good. Since a solid color will be used, it will be okay in this case.

Step 3

You will have a square which represents the UV coordinates that have been applied to the robot, usually in a 0—1 range. This UV texture space is the square where your image should be. Your whole UV map should be contained within that square as well, but chances are it isn't. You will need to move and scale the map to fit the square.

Step 4

You can view the image map in the UV texture space while you're editing the UV map. This makes it easier to align the UVs with the image. This is useful especially if it is a preexisting image. View the image and render the robot again. You will see some improvement, but the eye border is still a bit messed up. Looking carefully at the UV map, you can see why. The eye border has been laid out so many of its faces overlap.

Step 5

Use unfolding and relaxing tools, or move the vertices yourself to pull them out so they do not overlap in the image. They will still be very dense, but no longer overlapping. As you're selecting UV vertices, you may be able to see them highlighted on the mesh as well if you have both your mesh and UV editor in the views. Editing a UV map can feel a lot like modeling. Once you have a UV map that looks good, you can export it to work with in a 2D editor. Create a simple image map for the eye border and the mouth, carefully following the appropriate UVs so the color is in the right place. Here, the UV map filled up the whole square, except where the hole is. UV maps do not have to do this. Often a UV map looks like puzzle scattered across the image. What is most important is that each face is mapped.

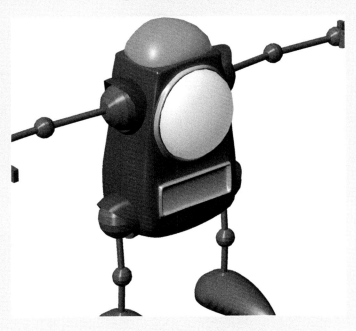

LIGHT EFFECTS

Light interacts with objects in lots of ways. We take for granted how light gets bent as it travels through transparent objects, how it reflects off surfaces, how it gets scattered. To create photo-realistic images, we need to simulate how light interacts with objects (Figure 12.1). Shaders are okay for opaque surfaces, but how do they deal with transparent objects or reflections? Even if you have options in the window where you build your shader, such as transparency, they are often dealt with separately. Getting light effects has a lot to do with rendering. If you understand the

Figure 12.1 In this glass chess piece, several light effects are going on including reflection both inside and out, shadows both in and out, refraction, and some caustics.

concepts of light effects, you'll know a few landmarks that will help you navigate through your render options. But they are also very much a part of material creation, often coming before setting up lights or cameras.

Reflection

The simplest thing that could happen is that the light is reflected from the light source. As you have learned already, this can be a scattered reflection, which is how the object gets its color, or specular. These are handled by the shader and the indirect light from them is handled by other algorithms. But if a surface is very shiny, it becomes like a mirror and directly reflects all the light it receives so that you have an image of its surroundings. A mirror surface does not have to be perfect. It can be very reflective, resulting in a clear image, or slightly reflective, giving a blurred reflection. There can be color to it, and it can have specks and scratches. You may still be controlling this reflectivity in the shader options, but in order to get objects that truly reflect images, you will need to have ray tracing enabled.

One of the rays that is sent out from an object once the first ray bounces off it in ray tracing is a reflection subray (Figure 12.2). As

Figure 12.2 Reflection subrays.

this ray bounces from the first reflective object to other objects before it hits the light source, the color of those objects (gained from the reflection or refraction ray continuing on to the source of light) is added on to the color of the first. The totality of all the reflected rays from a mirror-like object is the reflected image of the objects surrounding it.

Reflection Maps

While the above method achieves a realistic result, it takes a lot of computing and you have to model a lot more in the scene. Another option (and the only way with a scanline renderer) is to fake it. A reflection map is an image of what you want reflected (Figure 12.3). It's a great way to get a sky or ceiling, or a window that is behind camera. You don't necessarily need a lot of detail in a reflection map: just a general shape of the light. Think of an apple with a window and tree reflected on its surface. The tree is just a blob, and the entire reflection is stretched over the apple's organic surface. You will want the reflection map to wrap around the object. To

Figure 12.3 Reflection map.

create a reflection map, you can take or render a picture with a reflective sphere, or you can warp a flat image using a projection similar to your object's geometry. This lowers render times, and is especially useful when you have numerous reflective objects in a scene, such as a motorbike with lots of chrome details. You also have more control with maps. For instance, if you model an entire scene around the motorbike you may get a more satisfying image by using careful placements of the reflection map than if you had ray traced the reflections. Since materials can be animated, you can get also this reflection to move just as it would as the camera pans by the object.

Anisotropy

When there is anisotropy on a surface, reflections may get stretched and blurred. Anisotropy is when you have bumps and gouges that happen across a shiny surface in a parallel way (Figure 12.4). Each bump on shiny or reflective surfaces can have its own reflection. The result is that you see a streak of lots of tiny individual reflections, running perpendicular to the bands of roughness. This can affect both reflected images and highlights.

It can also apply when you have masses of tiny smooth surfaces that are long, such as hairs. Getting the anisotropy on hair just right is one of the challenges of 3D art. Other things you may get anisotropy on are water surfaces (Figure 12.5), CDs, and brushed stainless steel.

Figure 12.4 Notice how all the reflections of the bumps mesh in together to produce anisotropy.

Figure 12.5 Anisotropic reflections of the moon on water. Notice how stretched out the light is on the waves.

Refraction

Not all objects block light. When light passes through a transparent material, it bends. This is refraction and it's caused by differences between the densities of the two substances it is passing through. Usually this is air and something else. A glass of water comprises air, glass, and then water (Figure 12.6). The more difference there is between densities, the more the light will bend. You should find a refraction index option in your transparency settings that will let you control refraction. The refraction index is a measure of the ratio between the density of air and the density of some other transparent material. Air has a refraction index of 1. Water has a refraction index of 1.3. When you're trying to get something realistic that has transparent materials, it's important to get their refraction indices right.

Light can also be refracted because of the curve of a surface. This is how lenses work. Curved reflective surfaces will also refract light, which is how reflector telescopes work.

With ray tracing, if the object has transparency information in its material, the ray will send off a refraction subray, which is bent as it continues on the first ray's path but through the material. There is more to transparency than just being able to see through an object. A transparent material can have color and it can be

Figure 12.6 Refraction through a glass of water.

only partially transparent. All of these will affect the color and light information being transmitted with the ray.

Keep in mind though, that the transparency that is ray traced and causes refraction is different than the alpha transparency seen on maps. Alpha transparency is a way to make part of a mapped material unseen by the renderer and it does not affect light.

Caustics

When you have light either reflecting or refracting from a curved surface, it can become concentrated in arcs. If the surface

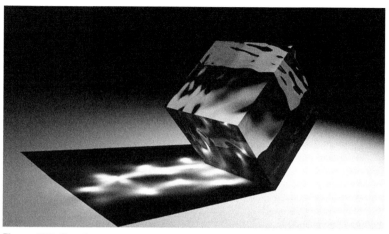

Figure 12.7 Caustics.

is curved enough, this might become a glow inside the shadow of the object. In real life, as when using a magnifying glass to channel sunlight and set a dried leaf on fire, this concentrated light gets hot. Rainbows are also the result of caustics, as the colors of light are bent into arcs by trillions of water droplets. One commonly seen caustic effect is the light patterns on a surface under shallow water (Figure 12.7). Caustics are easy to reproduce in real life — set a full glass of water in front of a brightly lit window. But they are harder in computer graphics. For calculating caustics, photon mapping works the best, but you can also use an algorithm to approximate caustics with ray tracing. You will have to turn on caustics, which is typically found in the render settings. Realistic caustics require more than just a few rays to be traced and are not practical in most off-the-shelf applications.

However, you can fake caustics in some situations such as when trying to achieve an underwater light effect. You do this by using a gobo (GO Before Optics) map, also called a light gel, which is applied to a light source. This map has the pattern of water caustics on it, and can be animated.

Translucency

For years, computer graphics artists struggled with getting natural skin that didn't look plastic. The problem was that skin is translucent. Translucency occurs when some light passes through a slightly transparent surface, gets scattered, and comes back out. This is called subsurface scattering and is different from diffuse lighting, where light is absorbed and scattered on the

surface, giving it a color. With translucency, the surface gains a subtle glow that may be different than the color of the surface (Figure 12.8). For instance, there are lots of capillaries under the skin, which is why it has a pink tint. Other translucent materials include milk, wax, and jade.

Figure 12.8 The same model without and with translucency.

Shadows

If you have light, you will have shadows. Simple enough, but how do we get shadows in our scene? Ray tracing can do this (Figure 12.9). Shadows need to be enabled, but this is usually a default. Ray tracing shadows come from yet another type of subray that is emitted when a ray hits an object. The job of this shadow ray is to figure out whether the surface it is hitting is blocked from a light source by another object. If it is blocked, then it is in shadow and kept dark. As this happens with all the points on the object that are in shadow, the shadow gets drawn. This creates sharp boundaries between areas that are lit and those in shadow, which does not look natural. You can use radiosity for a more accurate approximation, or you can increase the number of rays that are traced. That takes more time to calculate and is not practical for animations.

Figure 12.9 Ray-traced shadows.

You can fake whole shadows, by rendering a silhouette of objects from the perspective of the light it will cast a shadow from. This silhouette is a type of depth map. It is then saved as a texture file and applied to the surface that will be in shadow. This is called shadow mapping (Figure 12.10). One strong advantage is that if the objects and lights are not moved, the renderer can reuse the same map for the next

Figure 12.10 How a shadow map works.

render. Shadow maps need to be stretched on the surface in relation to the light and the objects casting the shadow, as they are in real life. This can cause difficulties with aliasing, giving the shadow a pixelated appearance which is more noticeable in large-scale scenes. You could use a higher resolution shadow map, but one solution that leads to faster render times is to blur the edges out. This increases render times compared to not blurring, but can be faster than ray tracing. The softer the edges of the shadow, the more time is saved compared to ray tracing shadows. Even though ray tracing is a more physically accurate way of making a shadow, using the older technology of shadow maps can speed render times up enough as to be the only practical way to produce shadows in an animation.

Another workaround for high render times is to use lower resolution objects to map shadows with. This is especially useful for those deep shadows that occur under objects from ambient lighting, and gives even greater improvements when working on scenes that include crowds.

Tutorial 10
Light and Shadow

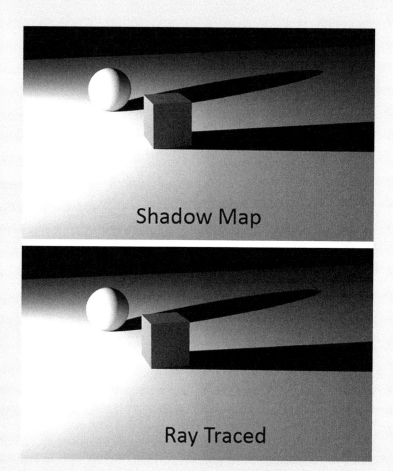

Step 1

This tutorial will simply let you see some of the differences with light effects. In 3D graphics, these are very connected to rendering. You will have to get into the render settings. For this first step, create a simple scene with a floor plane to see shadows on and a couple of objects to cast shadows. Now create a light. When you do this, the automatic lighting is turned off, and instead your light is used. In this way, you will be able to have more control over where your shadows are. In the rendering options, find the options that deal with shadow maps. You will probably find that shadow mapping is on by default. It is an efficient way to optimize rendering times. Try rendering it with shadow maps, and then without — making sure that ray tracing is enabled. At high-quality settings of either, the differences are subtle, which is why it is still so common to use shadow mapping.

Step 2

Here, you will see the difference between opacity and true transparency. Use the floor plane and set up a torus with a cone and a tall cube in front of it. Create two spheres and put them in front. On one sphere, create a simple shaded material, Lambert will do fine, and make its opacity very low. On the other sphere, create a glass material. Here, you'll work with transparency and refraction settings, among others. How you create the glass differs with each application. Once you have everything set up, try rendering to see the effect. A true-to-life glass material will refract the image so that it is all the way upside down, as well as warp it. It will also have reflections of its own and specular highlights. With the opaque material, you can simply see what is behind it with no shape distortion. To take it up a level, try adding the ability for caustics to the material and enable caustics in your settings.

LIGHTING THE WAY

Lighting a scene isn't just about being able to see things. It serves to create mood. Imagine a setting with a crooked house, gnarled trees, and a strange little bunny holding a sharp object. If the scene is dark with clouds and a full moon casting long shadows, it looks creepy. Put the exact same scene in daylight, and you can see the green grass, puffy clouds, and that the pointy object is a carrot. Though it is still quirky, it's no longer threatening. Both lighting setups are natural. There are lots of tools to recreate natural lighting, but we will also need the lighting tools that can be found in a studio (Figure 13.1).

When using artificial lighting, a standard approach is the three-point lighting rig (Figure 13.2). This is made up of a key light, a fill light, and a backlight. The key light is the main player here, lighting up the object from the front. Using just one light can result in harsh shadows, so to get rid of these we add a fill light. This softens shadows and fills them with enough light to see otherwise obscured details. A backlight is set behind the object and gives it a strong outline. There are other ways to light up a scene, but knowing this fundamental lighting system can get you well on your way.

Light Properties

Once you add a light into your scene, you'll be able to control its color, intensity, and decay.

It's very rare that a light source gives pure white light. Sunlight at full noon, for instance, is just a little bit yellow since its blue has been leached from it and scattered across the sky. There is more than one way to have colored light. One accurate method is to use color temperature, which is a way to measure the hue of a specific kind of light in kelvin. But how can color be a temperature? British physicist William Kelvin heated a block of carbon, which is black, and measured what color it became at what temperature. At first it was red, but as it became hotter it became more blue–white. More commonly you'll select a color from a color map. You can still use charts to match the color to a type

Figure 13.1 The three images in this figure are all of the exact same scene, but rendered with different lighting.

of light source by finding out its temperature, then using the matching color from the color map.

Intensity is how bright the light is, and can be measured in real-life units, such as lumen, candela, and lux, or it is measured through units set in the application. The brightness of the light decreases with distance. This is called decay. In the real world, light dims because it becomes spread out the farther away you are from the source. There are three kinds of

Figure 13.2 This figure was lit using a three-point lighting rig. The back light was exaggerated for effect.

decay: linear, quadratic, and cubic (Figure 13.3). With linear decay, the light gets dimmer in direct proportion to how far away it is from the source. So if you've set your light intensity at 4, then at a distance of four (meters) its intensity is down to

Figure 13.3 From left to right are examples of linear, quadratic, and cubic decay.

zero. Also called inverse decay, this is slower than decay actually occurs in real life. Quadratic or inverse cubed decay is the same as with real-world light, and decays in proportion to the square of the distance. This makes it much brighter closer to the source, but quicker to dim. Cubic decay is in proportion to the cube of the distance, or $1/distance^3$. This means the light gets dimmer faster than in reality. For realism, you should stick with quadratic.

There are a couple of settings that don't follow the way things happen naturally. Light may not automatically cast a shadow in some applications. In that case, you will have to turn the shadows on. The light settings are one place where you can choose what kind of shadowing will occur, such as ray tracing or shadow maps. Another atypical thing you can do is is to make light shine on only one object, and not affect any of the others. Both of these abilities, to choose whether or not to have shadows or light on a particular object, can be very useful tricks.

Types of Light

Point Light

The point light is one of the most simple in your 3D light kit. It is just a point that emits light in all directions (Figure 13.4). It's also called an omni, but in that case you may have more control over the shape, such as emitting from a curve. No matter the shape, it still emits in all directions.

Figure 13.4 Point light.

Spotlight

Spotlights emit light in the shape of a cone from a point. This causes the light to mostly hit the object at a similar angle, making it very bright where the light hits (Figure 13.5). That is why you get a spot on the surface the light is pointed at. You can increase the size of that spot by increasing the angle of the spotlight. There is also the question of how rapidly the light dims at the edges of that spot. Is the boundary of the spot hard or soft? This is called the falloff. Because a spotlight light is mostly from the same direction, it causes very distinct shadows.

Figure 13.5 Spotlight.

Area Light

An area light is one where light is emitted from a surface, usually a rectangular plane (Figure 13.6). Here, light is being emitted across a whole surface rather than a point and all the rays are moving in one direction parallel to each other. This creates high-quality soft lighting without harsh shadows. As a result, this type of lighting costs more at render time than the others. You can also turn an object into an area light, so that light is emitted from the model's surface.

Figure 13.6 Area light.

Directional Light

Though the sun is a light source, it is so far away and bright that it would be impractical to truly simulate. Directional lights are the answer (Figure 13.7). Light rays all move parallel to each

Figure 13.7 Directional light.

other in a single direction. They are like area lights in this way, except that if there were a plane emitting light, it would be an infinite plane. The theoretical light source is infinitely far away. The light does not decay. This means that it doesn't matter where in the scene you place them; it only matters where you point the light. Sometimes such as light will be called a sun light.

Volumetric Light

The stage is dark, except for the spotlight with dust swirling inside revealing a magician and his wand, which cast dark streaks of shadow in the cone of light. This is an example of volumetric lighting. You can see the light before it hits the surface. Figures 13.4 and 13.5 used volumetric lights to illustrate their shape. This is caused by light being scattered across dust particles in the air, and you can often also see the swirl of dust and specks of fiber. In the big world of the sky, clouds and atmosphere can combine to give a similar effect called godrays. In some packages this is handled as a specific type of light, while in others it is an effect that you can turn on for lights (Figure 13.8).

Figure 13.8 In the figure on the left, an extra effect of smoke was turned on. On the right is the same light with all volumetric effects turned off.

Objects as Light Sources

As well as turning objects into area lights, you can set the material on an object so that it luminesces or glows. This effect will not put a lot of light into the scene, but may cast a bit of light on the objects right around it (Figure 13.9).

Figure 13.9 Using objects as light sources.

Renderer Lights

Many rendering applications have their own lights which can give better results and may offer more control. These lights can be accessed either by changing the regular lights to the renderer's lights or by choosing the renderer's light when you are creating a light.

Image-Based Lighting

Let's say we need to have a computer-generated 3D object appear in some live action footage. How do we get the lighting on it to match the footage? The answer is to bring the lighting with us (Figure 13.10). We do this by taking a high dynamic range image (HDRI) at the location where the footage was shot, preferably at the same time if it is outdoors. An HDRI contains not only color information, but also information about the luminosity or intensity of light. To use the image to project light

Figure 13.10 This specially rendered image will project light. The light's intensity depends on how dark or light the image is.

into your whole scene, it will need to be spherical. There are cameras that can take panoramic and spherical images. If one of those is not available, you can use an HDRI capable camera with a reflective sphere. Once acquired, an HDRI can be projected as a sky dome in a scene and set as image-based lighting. Light is emitted from the image which matches the intensity of light shown in the image. For example, if the sun is visible, the place in the picture where the sun is will shine with bright light which is the same color as in the image. If the sky is cloudy, the object will be lit with the same ambient light. This is especially useful if there is complicated lighting on location, such as an interior setting with a wall of windows, lots of ducts on the ceiling, and lights. Not all image-based lighting has to be spherical and light up the whole scene. For instance, it could be used to create the view from windows which not only have detail but light up a room as well.

Gobos

One effect you can achieve is to make cool light shapes and multiple colors by using "GO Between Optics" or gobos (Figure 13.11). Their name indicates how they work. In real life, a plate (to make shapes) or gel (for color) is put between the light

Figure 13.11 A gobo.

and the surface, usually right near the light source. They are often used in dance clubs or at concerts. Achieving the effect is easy in your 3D application. In your light settings, you can enable their use and set up an image map that you've created for the effect that you want.

Tutorial 11
Enlightened Monk

Step 1

Start with a simple humanoid or animal object, though it should have enough detail in the face to see how the light and shadows change. For the key light, create a spotlight. Place it a bit to the side and aim it at the character. One nice thing about some virtual spotlights is that you can look through them and aim them like a camera, though the image may be upside down. Try rendering the image with one light. You will have harsh shadows on one side. This is also a common difficulty with natural lighting of the sun.

Step 2

To counter the harsh shadows, create a second light, preferably an area light — an object such as a plane that is a light source or whatever equivalent in your application. This will be the fill light. Place it off to the side as well and aim it at the figure. The size and shape of the lights in the illustrations are exaggerated to see them easily. You really can use any kind of light as long as it is soft and coming from a wide angle. A fill light can solve the problems in natural lighting as well. It's common to create a fully simulated outdoor scene and then add a fill light for each object of focus to reduce the shadows.

Step 3

Create one more spotlight and set it behind the character. You can place backlights up above and pointing down. This will create the three shadows as seen in Figure 12.2. Or you can place the backlight near the ground and pointing up, as in this illustration. Backlights might not be useful for a bald guy such as this, but if the object has realistic hair or fur then it will add a nice framing effect that can increase visual interest.

WORKING THE CAMERA

Cameras have been around a lot longer than computer graphics have. Even non-professionals know how to use them, and cinematographers can do wonders with them. This makes it natural to imitate. Since many principles are the same, it's easy to port real-life photography know-how into 3D digital technology, and several cinematographers have done just that. Just like in the real world, much of the success of your scene depends on how you capture it in the camera.

The Virtual Camera

Very often, the perspective view of your application is the camera view. If not, they can be linked. By moving around in your perspective view, you are moving around the view of your camera. You can have more than one camera, each with different settings, and switch your perspective view between cameras. This perspective view is the point of view (sometimes abbreviated to POV) of your camera.

The area captured by the camera as part of an image is called the field of view. As you can see from Figure 14.1, the field of view is related to how wide the angle of view is. In fact, the terms are more or less interchangeable. What happens in a real camera is that the angle of view is affected by the distance between the lens and the camera's aperture. That distance is called the focal length. Angle of view and focal length are related to each other. More on that a little later.

Clipping planes are perpendicular to the camera's view and define the area between them that will be rendered. There are two of them. The near clipping plain is close to the camera and the far clipping plane is, of course, far from the camera. These are tools to simulate not being able to see things in the distance or very close up, as with your eyelashes. They are needed because there is no "out of focus" for the virtual camera.

This is an advantage that not having to follow the rules of physics gives these cameras. They don't need lenses. Near or far, everything in the scene can be rendered perfectly clear. But it also

Figure 14.1 The field of view and clipping planes.

leads to a problem. Not only do physical cameras use lenses, but so do our eyes. We are used to seeing the world through lenses. It doesn't look natural if the mountains in the background, the trees in front of them, the meadow, and the little ant in our camera's view are all in focus.

Of course, it's easy enough to fix by reproducing the effects of lenses.

Faking Camera Effects

So now back to focal length and angle of view. You will have these settings, but this behavior is an imitation of what really happens. As you increase the focal length, your angle of view narrows (Figure 14.2). This doesn't mean your image gets smaller. It means that you're looking at a similar area, far away. There are two ways to zoom in on an object to make it fill more of the screen. One is to have the camera and object closer together, and the other is to increase the focal length. But using focal length gives a different effect than moving the camera. The perspective changes as you move the camera, but it does not as you increase the focal length because the camera is still in the same position.

Some warping of the image can also visibly occur at the extreme angles. With a wide-angle lens (having a short focal

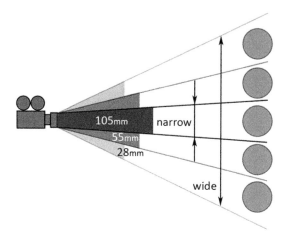

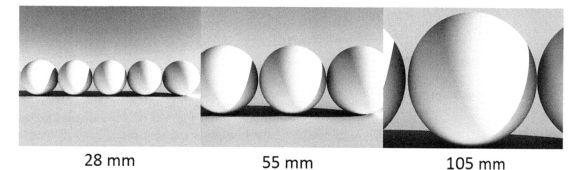

28 mm 55 mm 105 mm

Figure 14.2 Focal length and angle of focus.

length), the image bows outwards, causing what is called barrel distortion (because a barrel bulges). A poor-quality telephoto lens, having a narrow angle, will cause the horizontal and vertical lines to bend inward. This is called pincushion distortion. These distortions (Figure 14.3) are another thing that can be faked and some applications have settings to control them.

Focus and Depth of Field

In the real world, only one thing at a time can be in perfect focus. This effect not only is natural to our eye, but also enhances the ability to bring attention to a subject. Say you have two people toward the middle of a view, one in the foreground and one in the back. The one in the back is the important subject. The way to show this is to keep focus only on that person in the back. However, the neighbors of the object in question can also be

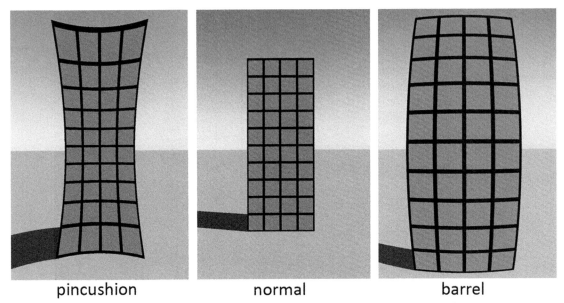

pincushion normal barrel

Figure 14.3 Focal length distortions.

somewhat in focus. Thinking of the little ant again, the eyes on its head are perfectly in focus, while the rest of its body and those plants immediately surrounding it are also pretty well in focus. The area that is in focus is the depth of field and extends from nearer to farther from the camera, much like the clipping planes. This is another effect that can be used to good purpose. It adds a sense of distance, and as mentioned before, you can use it to bring attention to something (Figure 14.4).

Figure 14.4 Focus and depth of field.

Lens Flare and Glare

Most light travels right through the lens, but some of it gets reflected and scattered inside the lens before transmitting through. This can be both concentrated and diffuse. Diffuse scattering causes lens glare, and can make the picture look hazy and dreamlike. Concentrated light comes from a strong light source near the edge of the lens and causes lens flares (Figure 14.5). These manifest as stars, rings, and globes of light along an axis. This effect is famously overused in the *Star Trek* reboot movie of 2009. The reason given for using lens flares in the movie was to create a sense that there was always something huge and fantastic just out of view.

Motion Blur

We move out of the realm of lens artifacts and into problems of shutter speed. Shutters control the exposure of light to film or the light-sensitive electronic sensor of digital cameras. The longer the shutter is open, the more movement is captured in a single image. This appears as blurry streaks in the direction of the movement and is called motion blur (Figure 14.6). It can be a frustrating occurrence when taking pictures. On a more useful note, since even our natural sight is not suited well to fast objects, it's a great subconscious indicator of motion and speed. Many times it is

Figure 14.5 Lens flare.

Figure 14.6 Motion blur.

used for artistic effect. Shutters are left open long enough to show ribbons of color trailing behind moving objects.

Matching Virtual Cameras to Real Ones

If using real footage from a camera and want to add effects generated from a 3D application, you will want to match the settings of the virtual camera as much as possible to the real one. Some applications have presets for several models of real cameras. Besides matching the camera, you can match settings that can be changed on the camera, such as focal lengths. You should keep in mind the scale, focus, and depth of field, as well as the same relative position and direction.

Cameras and Image Planes

One way that you can incorporate footage into your 3D animation is by having it set as an image plane that is attached to the camera. This image plane is set so that it is always behind the objects in your scenes. It can fill up the camera's view and can be set to always face the camera. You could render it this way, but a good use is to match the atmosphere and lighting to the footage.

Image planes can also be used to incorporate 3D objects into your scene. For instance, you could have a picture of a person standing that you want in the scene. You could go to all the trouble of modeling and texturing the person. Or you could use a 2D editor to cut out the surroundings and replace the background with an alpha map. When you put this in your scene, now you'll just have the person. Then you set it so that the image plane

only faces the camera, to ensure that its 2D aspect is never seen. Image planes used like this are called sprites.

Animating the Camera

Just like other objects in your scene, you can animate the camera. This lets you use it just like it would be used in a studio: zooming in, tracking, panning, etc. Of course, there is the added bonus of not needing extra equipment or people to fly the camera around. You can set a specific path for your camera, much as if it were on a track in the studio or being moved by a crane, or flown about. Since you can give any motion you want to the camera, you can even add some shaking to the camera, as if it were hand held.

If you want, you can link the camera to an object, so that it will always follow that object. Because the computer knows where both the camera and the object are at all times, it follows the object perfectly. This tends to look robotic. To fix that, you may have controls that will let you add imperfection to how the camera tracks the object.

Through the Camera's View

Good 3D art doesn't stop at model creation, animation, or even staging. To get the most out of your scene, you need to capture it in a series of images. Each image should have good composition. Every frame should contribute to the story arc. It is with the camera that you control what the audience pays attention to, and how you use the camera affects the atmosphere of the scene.

To achieve all of these you need to place your camera to get good camera shots as well as getting the settings on your camera right. There are several basic camera shots you should be aware of. Two main characteristics affect a camera shot: the distance being portrayed and the angle of the camera.

When you can see most of the setting that a character is in, and probably all of the character's body, this is a wide shot, also known as a long shot. Extreme wide shots can show entire vistas. Medium shots move in closer to the character, so that you usually only see the upper half of their body. Close-ups move in even farther, so all you see is the character's head. An extreme close-up may fill the entire image with the face or even just part of the face. Between the farthest limits of seeing a microscopic part of the scene to an epic landscape, the variety is endless (Figure 14.7).

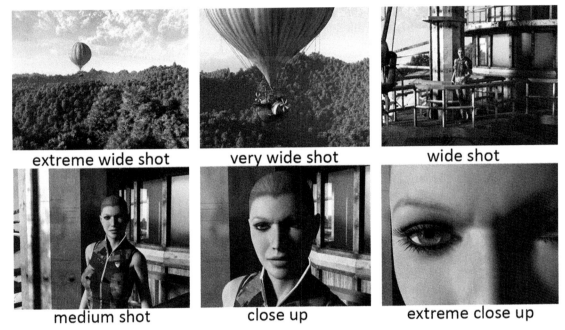

extreme wide shot very wide shot wide shot

medium shot close up extreme close up

Figure 14.7 Distance camera shots.

Generally, you'll want to keep your camera about even with the character or object, but there are other angles you could use (Figure 14.8). When the camera is looking at the character from below, this is called a low-angle shot, whereas if it is looking from the ground this is a worm's-eye view. Low angles usually makes the character look large and imposing. If the camera is above the character looking down, this is a high-angle shot, and if very high above it is a bird's-eye view. The higher the angle of the camera, the more insignificant and powerless the character may appear.

Other things to consider is what things are in the shot, and where the camera is in relation to these (Figure 14.9). For instance, if you have two characters talking to each other, you may have them both in the shot with one character facing the camera, and seeing only the back of the head and the shoulder of the other character. This is called an over the shoulder shot. Over the shoulder shots can also be looking at what the character is doing or looking at, with the back of the character still in view. A two shot has two characters in it, both more or less facing the camera. There are also three shots and group shots.

Figure 14.8 Camera angles.

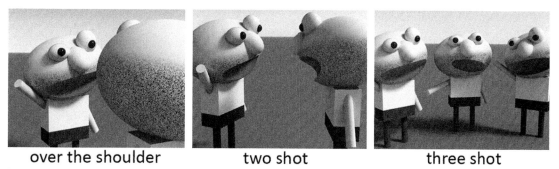

over the shoulder two shot three shot

Figure 14.9 Over the shoulder, two and three shots.

Camera Movements

You also need to get a handle on how you can move the camera, or at least what the terminology is in cinematography (Figures 14.10 and 14.11). Rotating the camera from left to right is called panning the camera. This can be a way of changing what the camera is looking at. Crabbing is when you move the camera left to right while keeping it pointed straight ahead. This lets you scroll a scene from side to side. Tracking in and out, also known as dollying in and out, is when you physically move the camera forward. Zooming in and out is when you use the focal length to

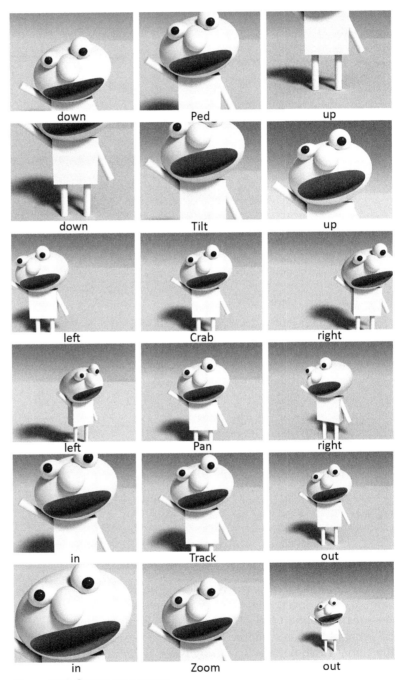

Figure 14.10 Camera movements.

Figure 14.11 You can cant the camera to give an odd angle.

move the view closer to the object. When you ped (coming from the word pedestal) the camera up or down, once again it stays pointed straight ahead while it is moved up or down, so you scroll up the scene. Tilting the camera up or down works much like when you tilt your head up or down to look at something — it's being rotated down or up.

One cool effect you can get with a camera is called the dolly zoom, or Vertigo effect. It was first seen in Alfred Hitchcock's film *Vertigo*. While tracking in a camera, you zoom out at the same time, keeping the object in focus the same size in the view (Figure 14.12). You can also do it in reverse: track out and zoom in. This causes the perspective to change while it appears that the camera is standing still. This disconcerting effect can be a great

Figure 14.12 Dolly zoom.

way to show a sense of fear or a warping of reality, or a sudden realization (usually about looming peril that comes into focus with the dolly zoom).

Using cameras in the virtual studio takes just as much art as using them in real life does. If you really want to excel in this area of 3D art, read some books on photography and/or cinematography. Then, get a real camera and go out there and shoot. One of the advantages of real cameras is that the scene is always set up, everywhere. Even with a cheap digital camera, you will learn a lot and be able to port that knowledge to the virtual world. Plus, looking at the world through the camera's eye can inspire.

Tutorial 12
Animating the Camera

Step 1

This tutorial will demonstrate several common camera movements. Set up a couple of figures facing each other and light them up properly. Move the camera behind one of them at a respectable distance and with the face of the other visible. This is an over the shoulder shot. Render a preview.

Step 2

Move the camera forward and create a preview render.

Step 3

Move the camera back to the original respectable distance, but now zoom in; in other words, narrow the focal length until the face of the character looking into the camera is about the same size as when you moved the camera forward. Notice the difference between the perspective of the tracked-in shot and the zoomed-in shot.

Step 4

To create a simple animation, return the camera to the default focal length. Add a keyframe to the camera at frame 1. Create a curved path for your camera to follow and keyframe it as appropriate. Make the camera keep its focus on the space between the two characters. At the beginning of the shot it will be an over the shoulder shot. As the camera moves, it should pan so that at the end of the animation it will have the side of both characters in view.

ENVIRONMENTS

Sometimes the hero of a scene is the setting. Think of the movie *Avatar*, with those incredible floating mountains on Pandora. With the rocks draped with jungle and nurturing mists, we came to care for the planet and we saw that not only was there power there, but also a natural bounty for those who respected it. This pulled audiences into the movie while at the same time giving important information that moved the story forward. This was where the last stand was going to happen between the evil corporate sappers and Pandora.

Even if your setting is not quite so powerful, it is important to the whole atmosphere of your scene and animation. Nothing ruins a great character design more than having it romp around in a poor setting. A setting grounds the character and gives it the foundation of a story. It provides atmosphere through its appearance and also through its lighting.

Terrain

Most of the 3D modeling packages out there are ill equipped to create terrains with much complexity. However, there are several standalone applications and plugin tools that can generate terrains, and other natural and urban scenery elements, very well.

Terrains are usually polygon or NURBS planes modified to have elevations like land. There are a couple of ways to apply elevation. One is to use a specialized displacement map called a heightfield map (Figure 15.1). This is a grayscale map where black is the lowest elevation and white the highest. Heightfield maps can be created randomly, from geographical data, or by sculpting them yourself. Terrains generated from heightfield maps can also be sculpted, letting you include features such as overhangs and caves, so that the deformation of the plane is along all axes. Other ways to work with a heightfield terrain map include modifying the randomizing equation or using a filter which changes the values (see Chapter 17).

Another method is to use fractal equations. These modify the terrain plane directly, without the use of a map. A fractal is

3D Art Essentials

Figure 15.1 A heightfield terrain generated from a 2D image. Without proper formatting, artifacts may occur. 3D application generated heightfields tend to look better.

a shape created by starting with a geometric shape and adding a smaller version of that shape onto the edges. This can be done over and over again, with smaller and smaller shapes. This type of geometry is common throughout nature. There are some strong advantages to using fractal equations: they can be made to simulate common land formations (Figure 15.2) better than a randomizer of heightfield terrains, there is a larger variety of equations that can be used, they can be recalculated as the camera moves to get smaller detail close to the camera and larger detail farther away, and you can make fractal terrains that go on to infinity.

Water

These same types of equations work just as well for lakes and seas as they do for land (Figure 15.3). Because of the nature of the equations, they are easily animated, so that you can have open water waves. Lakes and oceans have other features as well: foam, and waves breaking on the land. Foam is usually just a feature of the material settings. But waves breaking on land cannot be handled by the same fractal equations as the less dynamic waves in open water. This is sometimes handled by

Figure 15.2 A terrain generated using fractals.

wave objects. It is also a task that can be accomplished in postproduction.

This is why you rarely see rough rivers or waves in 3D animation. Their dynamics are difficult to achieve since they require using fluid dynamics that are very chaotic, meaning they take a lot of calculating. Another common feature well loved by artists is waterfalls. Since they are usually seen from a distance the solution is often to use animated alpha planes. You'll recall that alpha planes can be transparent, allowing the features behind the waterfall to peek through the water as it falls.

Underwater scenes are simulated using lighting and slow wind type movements of such things as water plants or hair. Creating this effect can also include volumetric lights in a god-ray type of effect and, if the water is shallow enough and the bottom can be seen, caustics which follow the rays of light piercing through.

Figure 15.3 As you can see, the water looks fine in the open sea, but without advanced techniques, it lacks realism where it meets land.

Plants

Unless you are creating a moonscape or a wasteland, part of your landscape is going to be plants. How you handle these plants depends on where they are in the background and what your requirements are for the production. For game play, the requirements for low polygon count will rule. For animations meant to be part of live-action footage, realism is paramount.

The most primitive way to show greenery in the scene is to texture your land with materials that have green color variations. Even for higher level requirements, this works well for distant backgrounds. Another option that works for distance is bitmap images of ground-hugging plants.

But for anything that has some height, something more is needed. Plants can be modeled just like any other object (Figure 15.4). Trunks and stems are created in three dimensions, but leaves are usually just alpha planes, since in real life they have little thickness. These alpha planes do not have to remain flat; they can be curved a little bit. Bump maps and normal maps can also be applied to these alpha planes. This combination gives the leaves body and depth. Leaves are attached onto the 3D trunk with hook points. These are in the places where the leaves need to be on the trunk, and on the leaf map,

Figure 15.4 A collection of several plant models.

where it needs to attach to the trunk. Since there can be hundreds of thousands of leaves on a tree, often instead of single leaves, the alpha plane depicts branches of leaves to be hooked on at the point where all the branches converge into a single branch. Sometimes plants like grasses are made up of specially arranged planes with images of grasses on them. Even some ground plants with stems can be shown in this way and often are in games or backgrounds.

While it is perfectly possible to hand model a trunk, it takes time. This makes it difficult to put more than a handful of unique plants in a scene. One solution is to scale and rotate single models. Though it is possible to quickly fill up a forest like this, the repetition is almost always visible to the audience's eye. Another solution is to use a program that specializes in generating plants. Several algorithms are available, including fractal equations and applications that use them to create plants.

Sky

Sky is the natural background to everything outdoors, and it varies a lot. From a placid blue sky to roiling clouds, it's a feature worth spending time on. The earliest skies were simple 2D color maps. Often, they are applied to a sky dome. These still work well for animations that are more cartoonish, and are fast to render.

However, this simple map doesn't solve the problem that the sky is also a light source. The solution to this is to use an HDRI map, which was described in Chapter 13. This image-based lighting not only provides a beautiful, photorealistic sky (after all, it is a photograph of the sky), but also lights the scene. The problem is that it's not as practical to animate and is difficult to modify. This is a good solution for combining live footage with 3D objects but not so much for pure animation.

For animation, it is best to simulate the ambient light that comes from the sky. This can be done separately from the sky, using an ambient light as well as a sky map (Figure 15.5), or it can become part of the sky simulation. Light from the sun is scattered across the sky. Because of the size of air molecules, the light that gets reflected off these is primarily blue. Other particles in the air also change the light color, including water (fog) and particles of pollution. All of these effects, sky color, fog, and pollution, can be simulated using algorithms that will change the sky color, the light color, and how quickly things tend to fade with distance. For instance, in the clear blue sky of a desert, there is little water or pollution. This allows for objects to be seen in the distance. In

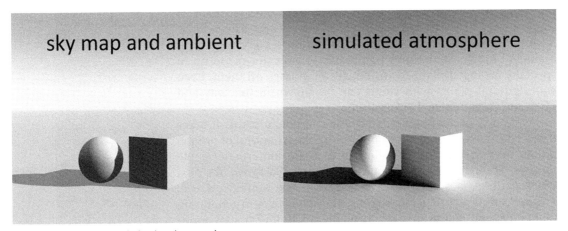

Figure 15.5 Sky map and simulated atmosphere.

Figure 15.6 Fog.

a very thick fog, we might not be able to see just a few feet in front of us (Figure 15.6).

Sun

Another part of the sky is the sun. As a lighting source, the sun is handled as a directional light. But this doesn't give us a visible sun. The solution is to create a sun object, usually just a very bright disk. However, you must also take care with its color. The closer it gets to the horizon, the more light gets scattered because of the air, water, and pollution. This makes its color decay, so that it becomes more orange and red while near the horizon.

Clouds

The way clouds are handled depends in part on what kind of a sky is being used: a mapped sky or a sky being controlled by algorithms. To add clouds to a sky map, one can use a similar alpha map layer with images of clouds on it. These 2D images can be generated using equations and can be animated. But they are just two dimensional and do not affect the light.

A better method is to have 3D clouds. They can be modeled in the typical way, using volumetric materials. Modeling a custom cloud is often done for a hero cloud featured in the scene. However, it is more practical to let the application generate volumetric clouds using 3D algorithms. These can sometimes become very specialized in how they interact with light, letting you

achieve images of clouds impossible to distinguish from real ones (Figure 15.7). Another way to create clouds is to use particles. This allows clouds to be simulated using fluid dynamics, creating very realistic cloud shapes. Both types of clouds can easily be animated.

Figure 15.7 Clouds created in a 3D application.

Indoors

Though modeling indoor scenery is easy enough, it is the lighting that gets complicated. Indirect lighting is a very strong influence on the overall lighting. Light from windows and artificial sources bounce from walls, tables, chairs, and anything else in the room. If you are creating architectural rendering where the indoor setting is paramount, you will want to use global illumination for the best results. But if your indoor setting is part of an animation, you may want to consider something less render intensive. You could use something like ambient occlusion, where the soft shadows of ambient lighting are achieved by casting rays out from the surface of an object and only lighting the surface if they hit the background or sky (Figure 15.8).

ambient occlusion global illumination

Figure 15.8 Ambient occlusion and global illumination of an indoor environment.

Tutorial 13
Raising the Ground

Step 1

In a new scene, create either a polygon plane with at least 50 divisions on each side or a NURBS plane. Make sure it has 50 spans in each direction. The higher the resolution of your surface, the more detail you can add.

Step 2

 You will want to connect the height deformation of the plane to a grayscale image, with black being the lowest elevations and white being the highest. You can even get grayscale images that represent real geographies at several map services. Government mapping sites are a good free resource. You may need to fix them for use as a heightfield map. There are several ways to connect the image to the mesh's shape. These could involve a displacement tool, a specific heightfield capability (though this can act differently in different applications), connecting it through a noise attribute of the mesh, or an attribute tab in the mesh sculpting tool. Once you have the image connected in, you may need to lower its height or alter how much influence it has on the mesh.

Your heightfield map should be of a sufficient resolution to match the size of the mesh you need to make. However, one of the advantages of a NURBS plane is that its curves can smooth out low-resolution artifacts unless they have enough spans to follow the pixelization.

Step 3

You can also use an image map to add some color. For instance, there could be a little snow on the peaks.

RENDERING

Even though it is something to consider with every creative decision you make, pressing the render button may be the last thing you do with your 3D application. (Some 3D applications offer a few postproduction options.) This is how your 3D scene becomes a pixelated 2D image. Of course, your scene is being rendered constantly throughout your 3D work: it's how you see the objects you're handling. This real-time rendering also occurs in games and uses industry programming interfaces such as DirectX and OpenGL which use the faster scanline algorithms and are supported by video graphics cards.

But to get your renders to look their best, you need to bring the more advanced technologies into play. Rendering is a whole field by itself, with studios employing experts in just that. Even though a native renderer comes with your 3D program, chances are you will end up using software that is a devoted renderer — those are often bundled with 3D software as well. There are a lot of rendering programs available and there is no single answer as to which one is best (see Chapter 19 for comparisons). This chapter gives you just a few basic settings. Your renderer will have many more options. During the exploration of shaders and lighting effects, a few landmarks were provided that should help you to navigate those options.

Image Size and Aspect

This is a setting you may have considered while working with your camera, but it is usually controlled in the render settings. You will need to know how big your final output is going to be. This depends a lot on what you want to do with it. To view on the web, keep in mind that the standard quality (as far as resolution goes) for the web is 72 dpi, or dots per inch — which is pixels per inch. For television, the maximum you will need is 1920 × 1080. That is the resolution for full high-definition quality images on television. Film, of course, is much higher. For printing, you will need something quite large if you want it to look good. Printing quality resolutions are usually 300 dpi. This means that if you

3D Art Essentials

want something in A4 format, which is 210×297 mm or 8.27×11.69 inches, at 300 dpi you get 2480×3508 pixels. The only limits to the size of your image are how much computing power and time to render you have.

Something else you want to consider is the aspect ratio (Figure 16.1). This is the ratio of your image's width to its height. A4 is a standard print ratio, used for magazines and books. Other common aspect ratios are the standard PC monitor (4:3) and television (and monitor) widescreen (16:9). While you should keep these in mind for projects, don't be afraid to experiment with other aspect ratios for artistic effect.

Figure 16.1 Common aspect ratios.

Quality and Optimization

Before you render, you'll want to manage settings for quality. One of the easiest things to do right off is to use the presets that are often available in render settings. Many of these presets contain optimizations for special cases, such as motion blur or caustics. Just clicking on the presets and exploring what has been changed can help you to get started.

However, settings that affect the quality of the image do not just reside in render settings. You will find things throughout the

production. With modeling, you need to consider the right polygon count against render time. In shaders and materials you need to choose which shader is optimized for the desired effect, the resolution of your textures, and how light is transmitted and emitted from objects. In lights, you need to choose the type of lighting as well as settings for shadows. With every setting related to quality, you should keep in mind that after a while, higher settings give no noticeable improvement. Always choose the lowest settings possible to get an acceptable result. The audience is not going to be looking at the image zoomed in to 200% of its size.

Antialiasing

One of the problems that can crop up when rendering is seeing artifacts such as sharp, stepped edges, noise, or flickering in animations. This is aliasing, and you can get it even if the image has high resolution (Figure 16.2). Remember that rendering

Figure 16.2 Antialiasing techniques before and after.

algorithms gather data from the scene to give a pixel its color. To get the most accurate color for the pixel, the renderer needs enough samples per pixel. Increasing the samples per pixel will do this for the entire image, so you should use the lowest settings possible to get the result you want. There is also the possibility of adaptive sampling: the renderer sees if there is high contrast or detail and increases the sampling only in that area, while keeping lower sampling in other parts of the image. This will tend to improve things where they are needed most.

Another cause of aliasing can be having texture maps that are of too low a resolution for the object they're applied to. In that case, you will need to edit the texture image in a 2D application and increase its resolution.

File Type and Naming

You can save your image or animation as one of many file types. If you are just saving a still image, you will probably want a JPG for viewing onscreen, such as on the web, and a TIFF for using in print. But, if you intend to do some postproduction work in something like Photoshop, and especially if you're rendering more than one channel, either you need a file type that supports layers such as TIFF or PSD or you will need to render several passes.

For an animation with more than one channel, you need something like RPF, RLS, or EXR (for HDR). If you do not need to use multiple channels you can use JPGs for animations as well.

When making an animation, it is generally better to save it as a series of images, for any postproduction work required. You will need to follow some kind of naming convention, such as name_#.extension, and also specify a output path to save to. It is possible to save it as a composite animation file such as MOV (QuickTime) or AVI, but this has a serious disadvantage. If rendering stops for some reason, like a computer crash, then you will have lost all the rendering that was accomplished for the animation file. If you were rendering to a series of images, you will have only lost a single image and can start the render running again from the point at which it failed.

Bucket Rendering

Now comes the question as to what is rendered when. An image is usually rendered in tiles, piece by piece (Figure 16.3). The advantage of this is to separate the parts of the image that are

Figure 16.3 Bucket rendering.

difficult to render from easier areas. In many applications, you can control the size of your bucket. For complex scenes, smaller bucket sizes will help to break down the tasks and increase the speed of the render. But for simple scenes, smaller bucket sizes can actually slow down the render. This is because every time a bucket tile is finished, the image is updated. This adds to the load on the processor, which slows things down. With modern computers, however, this is less of an issue and in some cases user control has been removed.

Batch Rendering

Let's say you would like to have several non-sequential frames rendered without needing to start the render again each time a new frame is started. This is where batch rendering comes into play. A batch file is a set of commands given to the computer to do, one after another. With batch rendering, the rendering often occurs on a different thread. This means that it is running as if it were a different program. Using batch files, you can queue several rendering tasks at the same time, so that once one is finished, the next starts rendering. Since you only need the render software open to do this, and that software can read a project file,

you can even have it render images from several different projects. It is often handled using command prompts or scripting, though sometimes there will be a user interface to create a batch file and start it. Recent versions of some applications allow you to keep working while the batch is rendering. Batch rendering is not very practical unless you have quite a few images to do or you wish to leave the computer while two or three pictures are rendering.

Network Rendering

If you need more than that, such as with an animation or a large and complicated image to render, you can recruit the help of other computers. With network rendering, each computer involved needs to have a client – a smaller version of the renderer that will communicate with the server. In a home studio, your network will be the computer you have been working on, and any spare computers or the computers of your friends or family. The server application will dole out the tasks to each computer, which will render that portion and send it back to the server, which will then piece it all back together. These could be either tile buckets, in the case of distributed bucket rendering, or whole frames. You really do not want to get a network involved for smaller rendering tasks, since it will just slow things down because of the communication and task organization that must occur. In a medium studio, you may be fighting for access to the render farm (what a network of computers devoted only to rendering is often called); in a larger studio, you would probably just hand over your work to a render technician.

Frame Buffers

All that graphical data bouncing around has to be stored somewhere before it is rendered as an image or to a file. The frame buffer can refer to two things: the actual hardware that is capable of storing that data or the actual store of graphical information. In some cases, this can be viewed.

Spherical and Panoramic Renders

To render a sky map or a reflection map, you will need to have a spherical or panoramic render (Figure 16.4). A few applications do this directly. With others, you will need a special lens shader. For

normal spherical

Figure 16.4 Spherical rendering.

a full spherical image of the scene, one method is to have a reflective sphere, render that, and then unfold it in a 2D editor to get your map.

Stylized Renders

Your goal may not be to get an image as realistic as possible, but to create an artistic or useful effect (Figure 16.5). As an example, the lined illustrations of 3D objects in this book were created using contouring. This required that contours be turned on in the render settings and adjusted in the shader. You can

Figure 16.5 Stylized rendering.

make your renders look more illustrated or painterly, and change their color saturation, exposure, or any number of things. Playing around with lighting, shaders, camera settings, and render settings can enhance the mood of your images and bring another level to what is possible with the computer-aided imagination.

Layers

An image can be rendered with several layers (also called passes, or elements). These layers can contain different information such as lighting maps, shadows, and Z-depth (distance from camera). They can be used for postproduction and compositing (Figure 16.6). This gives you a lot of power to edit your image without having to rerender it. For instance, if you were to render the lighting map for each light and set it to white, you could then change both the brightness and the color of the light in postproduction. Another powerful tool to use in conjunction with this is the ability to hide objects from render. This lets you use very high-quality settings for only some parts of the image, forgoing them where they are not needed. Using this and Z-depth maps, you can recomposite the image back together. You can use it to fake the depth of field by blurring some parts of the image and not others; render bubbles drifting in a scene; or render an object with motion blur moving behind glass – the transparency makes motion blur effects take a long time, but if you render the glass on a different layer that problem is solved. Many special effects such as particles are also more efficient to render separately. Computer-generated effects are incorporated into live footage using layers.

Figure 16.6 Layers.

Postproduction

The work after your render is an important part of getting your image or animation just right. In postproduction, it's a lot easier to do some things such as adjust the lighting and color balance. Various effects can be added as well. For instance, if you didn't render a lens glare effect, but decide you want it, it is fairly simple to do with a 2D editor.

Postproduction is when you do the compositing work. When you render objects that are meant to be combined with other objects or with live footage, part of the information included will be an alpha mask, giving the 2D application the information it needs to add only that object into the scene and not the background surrounding the object. In this way, not only can you tweak color and lighting, you can also nudge the arrangement a bit. This is one reason why shadows need to be rendered in a separate layer. Also, as you are arranging things in the image, you need to make sure the lighting intensity and direction match. So if you rendered these objects in the same scene, you cannot move them too far from where they were originally.

An efficient way to animate is to copy old school methods. If a background will be static, then instead of rendering everything in that background for all your frames, you can make just one render of the background. Then you can render all the moving objects and creatures, and then composite the single background image into every frame. With 2D video editors, this is a simple thing to do.

Tutorial 14
A Batch of Robots

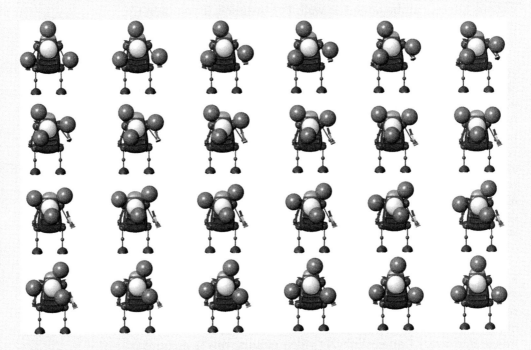

Step 1

Open up the scene with the robot animation in it. In your render options, set your quality so that the minimum sampling is at least 0 and the maximum is at least 2. This is the number of sample rays put out for each pixel. When it is less than zero, this means that there is only one sample ray for more than one pixel. Set your aspect ratio to be a square, and make it at least 1000 × 1000. Set the name convention and file type so that it is something like theJuggler0001.jpg. The numbers at the end of the filename will increase with every frame. Set it to render frames 1—24. Render it as a sequence of images. You may have played with the lighting, but if not and if you want a white background you will probably find it within the environment settings on either the camera or the render options. Start a batch render.

PROCEDURES AND GRAPHS

In order to get some things done, we have to go through specific, step-by-step procedures. Let's say we want to bake a cake. For an easy start, we pick a mix. To this mix (which already has some important ingredients added) we add eggs, oil, and water. We mix it. We put it in a pan, and bake it at a certain temperature. If we change any of these things, what we get will not be a cake. It could be good: it could be cupcakes or cake mix cookies. There are many great things that can be made with a cake mix as the beginning. Or it could be a disaster. Either way, we went through a procedure to get from mix to finished product.

Procedural methods are a way of modeling, animating, texturing, and just about anything else that involves giving step-by-step instructions. What if you want to model the cake in 3D? You could start with a primitive cylinder, give it an interesting, somewhat lopsided shape, and then add a texture to it. Once again, exactly what you do and in what order will affect your cake model for good or bad. As you've done this, your application has set a node for every object you created and everything you did to change that object. One of the great things about storing and viewing objects and actions in nodes is that you can go to a specific node and change it later on. These nodes become part of a node tree which you are able to access in a graph.

The Graph

It is often easier to understand a set of instructions if we can visualize how each step relates to the others. When you access the graph, whatever it is called in your application, you will see nodes as labeled boxes connected to each other by lines or arrows. The lines that link them pass information from node to node. The nodes and the links together make up a function (Figure 17.1). If you watched *Wall-e*, you may recall that Eve asked Wall-e, "What is your function?" In reply, Wall-e demonstrated his function of compacting trash into a neat cube which he then stacked. A function is the task for which something exists. In mathematics, a function is the task that changes one value to a new value.

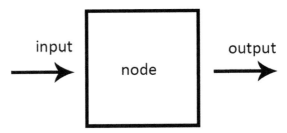

Figure 17.1 A function is made up of nodes and links.

As used in 3D graphics, changing the value will alter the model and the scene it's in. A function is made up of an input (the first value), a node (the modifier), and the output (the new value).

Each of the lines connecting the nodes are the inputs and outputs. One or more links go in: these are the input. And one or more links go out: these are the output. If the lines are not portrayed as arrows, inputs usually run from left to right, or from up to down. When we set up a chain of functions, we can start out with simple inputs and gain a useful output. This whole chain is the workflow or the procedure by which the result is gained. Figure 17.2 is the cake example set up as a graph.

Try opening up the graph for anything that you've created (Figure 17.3). There you can see the different values that are in each node. Sometimes there will be nodes you are not sure of that are part of how your 3D package handles things. You will see

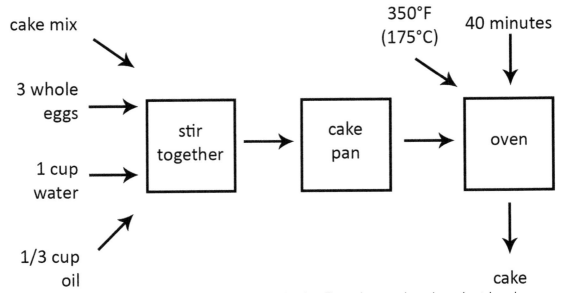

Figure 17.2 Baking a cake shown with inputs, outputs, and nodes. The nodes are where the action takes place.

Figure 17.3 Graph showing the inputs and outputs of the root joint of the robot created in the tutorials. The skinClusters are the groups of vertices which that joint influences. You also see which joints it influences. Since this graph has the root joint, only those objects directly input and output to it are shown. The skinClusters and nodes down line from them show how the joint influences a shape object.

every object, any scaling, transformation, deformation that you applied to it, any edge loops added, or any other modifier of that object. You will also see all images, texture maps, and shaders that you have used in the materials. This gives you an easy way to go back and alter characteristics that you may have given to your object early in the history of its creation. It is also a great way to access the hierarchy of the model, including its rig. The graph can become huge and difficult to navigate, but it is still easier than trying to go back into the also huge list of things.

Types of Values

What kind of information can be passed through nodes? Just about anything you can think of can be reduced down to numbers: speed, time, direction, position, color, height, etc. Even though it is numbers that are passing through these nodes, they often represent things that can be visualized. For instance, color is assigned a certain number value. When a node has that value and is set as a color node, you will see a color. That is why there are often images in the text boxes representing the nodes. It's

kind of a cool thing, really, to be able to see how each function alters the object or animation.

Many times, the values have to be handled in a special way. There needs to be a tag, so to speak, indicating what kind of a thing a number is representing so the node knows how to handle it. In the previous example of color, a number will pass through a node which assigns a color to it. An important thing to understand about this is that not every node can handle every kind of value. An example of this is data representing position. This comes in the form of X, Y, and Z coordinates. A node meant to handle a single number like a color can't work with the coordinates. If you need some value that comes from two incompatible types of data, there are math nodes that can adapt them.

Value Ranges

When you have a minimum and a maximum value, this can often be converted to a simple 0−1 range of values. This is often easier to handle mathematically than something like 31.875−347.314 m, even for a computer. All of the modifications through the functions can be handled; then the range can be given the values in both number and type that it represents. As mentioned in Chapter 11, the 0−1 range can be visualized in grayscale as black to white.

Hierarchy

Any object that is parented to another object will become connected to the parent object. The parent object will output something such as location or rotation, and this will become an input to the child object. There may be a special hierarchal graph making this easy to visualize (Figure 17.4).

Types of Nodes and Functions

Inputs

The first node (or set of nodes) in a graph is the input value node. This can be the main object itself (its geometric values) or a type of attribute such as location or time. For instance, if you created a sphere, then this sphere is shown in the graph with the size and placement you have given it. Sometimes inputs for a certain object refer to outputs from somewhere else in the scene. As an example, a light could turn on once the light from the sun gets below a certain value. This is called an external dependency or input.

Figure 17.4 Graph showing the hierarchy of a joint system from the shoulder down to all of the fingers.

Joints and Rigging

When you create a skeleton and add things such as inverse kinetics these will appear in your graph as nodes. As joints are created, their hierarchy is automatic and will appear in your graph. The same thing happens with any other kind of deformers you put in. Any controls you create for them will also be added into the graph.

Math or Utility Nodes

There are lots of things you can do with nodes that are purely mathematical. You can combine two nodes together. You can add, subtract, divide, or multiply certain numbers to your values. For instance, if you want to give your object a redder tint procedurally, you can add a number to the color values to get it closer to red. You can inverse numbers, quickly turning a mountain into a pit. Another very useful math node is a filter that works with the 0–1 range. This filter will let you control the 0–1 range that comes out of a different node (Figure 17.5). Let's say you used a fractal terrain node, but you want everything above and below certain heights to be flat. We'll say that within the 0–1 range, everything between .25 and .75 should be flat right between those values. Then when any value between .25 and .75 came in, they would be

Figure 17.5 Here, this filter (using a −1 to 1 range) changes the graph so that everything above .6 is turned to a value of 1, also increasing the values below .6 slightly.

changed to .5, giving us a flat plateau with peaks poking up from it. This means that filters can be used to increase the presence of a color, an elevation, a speed: just about anything.

Material and Texture Nodes

These are nodes that contain information about shaders, materials, textures, and the like which help to control how these are fixed on the surface of your object.

Noise

Noise is a very useful type of function that adds randomness. There are several types of equations that can generate it, such as Perlin noise algorithms (Figure 17.6), but the easiest way to understand it is to visualize it. Noise is like the static on an analog television screen. We could use noise for both a color and a bump map for sand. Since this is done mathematically and not with images, there is no limit to the area we can cover with a sand texture created procedurally in this way, which means that we do not have to be concerned with seams.

Noise does not have to be fine in detail like sand. We can increase its scale: just a bit bigger and we've got the gravel of an asphalt road. The scale can get as big as we want, and we can increase the prominence of some values. For instance, let's say we want a few specks appearing in what is otherwise mostly one color, like granite. There can either be a setting in a noise node or a node after the noise node where you can control how much one value is shown more than another, or rather the distribution of features. For our granite example, we would want larger features to be more prominent while keeping the smaller features rather fine. Noise nodes can show grayscale, but when a color node is added to after the noise node, it can also be a jumble of colors.

Figure 17.6 Perlin noise used to control the displacement of a sphere's surface.

Fractals

You have met fractals, before when you learned about terrains generated using them. A fractal is a piece or fraction of geometry that is the same as the whole where it came from. Fractals repeat geometry, following a pattern. Usually every repetition, also called iteration, is smaller than the previous one. You may be familiar with some of the common fractals such as Julia sets (Figure 17.7); other methods such as Voronoi diagrams may also be used to produce fractals (Figure 17.8). They can be very regular in their pattern, but can also include a lot of variability. They are often used in place of noise. For instance, Perlin fractals look a lot like Perlin noise. Both the regularity and the randomness can be well controlled. This makes them very useful for plants and the previously mentioned terrains. A large tree starts with a trunk, then has branches very similar to the trunk forking off in a fairly predictable way. Smaller branches fork off those, and smaller and smaller. Each branching follows a pattern but there are factors that make for some randomness. The more branches there are, the more random it appears. The fewer branches there are, the more obvious their regularity is. Several very regular patterns such as cross-hatching or checkerboard may or may not be generated using fractal equations as well.

Figure 17.7 A Julia set fractal.

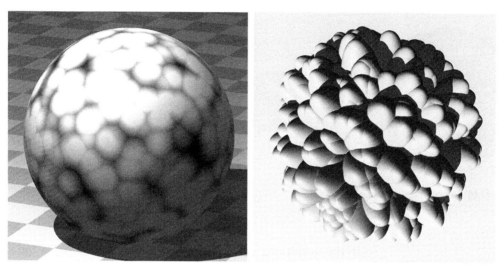

Figure 17.8 A fractal based on Voronoi diagrams then applied to displace the surface of a sphere.

Color Maps

A color map is a collection of colors given number values which can be used in a function graph. A stone, for instance, could have a range of colors from tan to dark rusty orange. These colors can be arranged together in a gradient which has the value range of 0–1. The lightest tan could be at the far left, having a value of 0, and the darkest at the right with the value of 1. In this way, you can use only a limited range of colors for an object, within which any color would be called by a number value. It also lets you convert a grayscale map to colors (Figure 17.9).

Figure 17.9 Color map.

Images

Another type of node is an image (Figure 17.10). These are the bitmaps that you use when creating your textures. Having them

Figure 17.10 The settings in a node which apply an image onto a sphere.

in the graph lets you edit them within the context of the scene you're creating. For instance, a stamp on a box could be an image map. The rest of the box would be a cardboard-looking texture. Both of these could be connected to the same water-damage effect. Anything you can do with the other color nodes, you can do with an image.

Combining Nodes

So one by one, it's easy enough to understand what a node is. How do they work together? Let's say we want to create the same texture as we see on a school bulletin board. It is made out of a rough burlap material which is sometimes painted. We can take a regular cross-hatch or weave pattern as one node. In the next node, we can add randomizing math node, so the interweaving lines are not completely straight or even. Then we add node with a bit of noise, for the little knots and other irregularities which come up in the fibers of burlap. If we want to paint it, that could be one or two more nodes adding on a smooth color over the very rough fabric. Or let's say we have created an animation with a person walking, smiling, and waving to others. Each joint's position and rotation and each morph target will become separate nodes, with all of them combined together (Figure 17.11). This is automatic, but makes it very easy for you to access the animation properties of one joint in order to manipulate it, change its values, or combine it with a different set of nodes; for example, catching a ball. At first, the two sets of nodes will not be connected, but once the ball is caught, the ball's animation will be connected to the hand's.

Figure 17.11 The movements in just the Z direction of the root joint while walking.

Container Nodes

Sometimes, it may be easier to work with your graph if you have grouped several nodes together into one node. It makes the graph cleaner to work with, and it is easy enough to open up the container and work with the nodes inside.

Outputs

An output is the final result of a workflow. It gives the final value of something, and can be connected as an input to something else. You might not see it specifically in your graph.

Though it may seem a bit daunting at first to work artistically using nodes and functions, it can be a very useful tool with very satisfying results once you get the hang of it.

Procedural Methods

When any geometry, texture, or motion is created using mathematics this is a procedural method. There are some good advantages to using procedural methods, one of the most significant of which is memory. A great example is a procedural terrain. Rather than being stored as a model using a gluttonous number of polygons, a procedural terrain is stored as a relatively simple mathematical algorithm which informs the application of its geometry only when it is rendered. Not only is the memory footprint smaller, but it leads to fewer calls to the memory, which improves render time. But render time, of course, is not the only thing that is improved. Since a procedural method requires only choosing a few options and how they work with

each other, it is much faster for you to create a terrain procedurally than to sculpt one yourself. And because nature can be described mathematically so well, it is often more accurate than what the artist can do.

Order

As you learned in the deformation chapter, the order you put things in is important. For instance, let's say you perform a bending deformation and then you twist the object. It will look a lot different than if you twist the object before you bend it. A motion path with a noise pattern will act differently than if that turbulence was applied before the path. If things are not looking quite right, try moving the order in which your nodes are placed. An example is shown in Figure 17.12.

Figure 17.12 From left to right is a checkerboard pattern node, a turbulence node, the turbulence node combined before the checkerboard node, and the turbulence node combined after the checkerboard.

Tutorial 15
Smoothing the Joints

Step 1

Though it is not ideal to fix this after everything else is done, it is not unusual to see something later on in the process that you want to fix. It can be difficult or impossible when there is a parent—child hierarchy to select only the object that is a root, rather than that object and all of the children objects. When trying to do some operations on the hierarchy, it may not work as you would like. However, you can use a graph simply to select individual objects of a model, without selecting any of the children. Start with a shoulder sphere and select it so that only it is selected and not the rest of the arm. Then use a smooth mesh operation with two subdivisions. The sphere should then look fine when rendered. Using the graph, navigate to each sphere that is a joint and smooth their meshes.

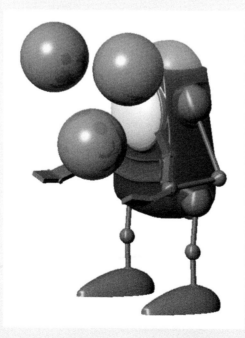

18

SCRIPTING

You can be a great modeler or animator without learning how to script at all, but it is a skill that's very useful. Imagine a scene where we are supposed to see lights come on randomly in a city-scape as the sun goes down. This is not very difficult to do, but it is time consuming and tedious, and your client needs it the next day. This is where a little scripting knowledge can really assist as a time-saving tool for automating repetitive tasks. Another use for it is in controlling animations such as walking cycles.

A scripting language is similar to a programming language. It doesn't need to be compiled (converted to 0s and 1s) into a program, but is read by an interpreter that is usually part of your 3D package. It comprises a set of instructions, a script, that tells the software what to do. Scripts can do a number of things that are difficult or not practical to achieve manually. As well as automating multiple tasks, they are especially useful for an efficient workflow. Because scripting is so flexible it's not possible to list all of its uses. Often your 3D package uses its scripting language internally, so that if you click on a button you set off a command from the scripting language. In these cases, you can even use a script to customize the software itself to fit your needs. You could change the user interface and menus, or you could write something to use the latest developments in computer graphics science.

All the main 3D applications have their own proprietary language, but the most common one is Python. Python is an open-source language developed independently of 3D graphics, though it is used a lot for that purpose. That's because it is well established, well documented, powerful, and most importantly, simple. Even the 3D packages that have their own language usually have a way to integrate Python into it. There are some great resources out there for Python scripting, including http://www.python.org.

One of the easiest ways to get the hang of scripting is to see it in action. Many applications give you access to a command line, or a place where you can write in a command from the scripting language and see it as it is executed in a script editor. To take it to next level, find a script — there are plenty of websites with

them – run it to see what it does, then open the script in a text editor and check out the code.

When you open up a script in a text editor, you will see two things going on in it: comments and the script. Especially in small scripts, the comments may be larger than the script itself. Comments are there for your sake. They tell you the name of the script, give instructions, and sometimes explain what the script is doing in a certain section. You will recognize comments by the hash symbol (#) that comes before every line to tell the 3D application not to read it. In Python you can also put multiple lines of text between triple quotes ("""). Easier to read, this is often used at the beginning, when there is a lot of information.

When you are writing scripts, comments are important. You should add your name to the script, the date on which you wrote it, the version of software that it was written for, the version of the script, and what the script does. Always keep in mind that the user may not know what some little bit does, so you should document every part. At work, it could be a project manager who knows little about coding who is reading your script. If you are putting it out into the great wide world for others to use you will have an audience of every skill level. Even if you are just writing it for yourself, a few years down the line you may want to use it again or you may decide to let a friend use it. Documenting with comments is a good habit to get into.

The script part will contain things such as commands, arguments, functions, and variables. A command will do something and the argument is the value that is being worked on by the command. A function is like a miniprogram that, when "called", will do a combination of things to perform a task. A variable is a value (input or pulled from somewhere else) that is stored somewhere and is later modified. Both functions and variables need to be defined. Definitions must come at the first part of a script, or at least before they are called.

```
#****************************
#
#CREATE A SPHERE EXAMPLE
#This script will create a sphere
#which will be positioned based
#on user input.
#****************************
#
#Defining the function
def CreateSphere (xPos,yPos,zPos):
    #Creating new sphere
    mySphere=AddSphere()
```

```
    #Move sphere to position set by user and passed in to the
    function
    mySphere.Move(xPos,yPos,zPos)
    #Resize sphere by coded values
    mySphere.ResizeAxis(3,3,3)
return
    #Get position values from user
    xPos=Prompt("What is X?")
    yPos=Prompt("What is Y?")
    zPos=Prompt("What is Z?")
#calling the function
CreateSphere (xPos,yPos,zPos)
#Refreshing the 3D views
Refresh()
```

The previous code is an example of a Python script. In the very first part of the script is a paragraph of comments giving a title and telling us what it will do. There are also comments throughout the script. The first thing that this script does is to define a function, which is a set of several commands. The first command is to make a sphere: AddSphere. You will notice that it doesn't just say AddSphere, but mySphere=AddSphere. mySphere becomes a new instance of the object that is being handled within the code. The sphere is created with several default properties. Using mySphere you can change those properties.

Then the code sets up the three coordinate variables that will be used for position. Prompt will cause a window to appear that has the text that is in the quotes and a place to input text. This user input will become the values of the variables. In this case, the input should be a number which specifies the X, Y, or Z coordinates.

The script contains variables between parentheses, including the text which says "What is X?", and xPos. These variables are the arguments. The arguments are the values that the function or command will work with.

This function will not actually run until it is called. Once defined, when it is put in the script again, it will execute its commands. Scripts can be as simple or complex as you need them to be. One of the reasons functions are useful is so that you do not have to repeat large blocks of code – for instance, if you wanted to create twenty spheres. However, the function used in this example is an inefficient way to create lots of spheres.

The last command is a refresh command. Many applications will run a script without renewing the image in the 3D views. If

they did renew throughout the script, lots of flickering and jumping around might occur. So the entire script is run, and if you want the view refreshed at the end of it, you can add that command. If you were creating a function that affected the result of the render, you wouldn't need to use a refresh command.

Things are always evolving with software. Old scripts might not work on newer versions of your 3D software. You will have documentation showing you commands, prebuilt functions, and other fun things that are recognized by the software.

This particular chapter has no tutorial because you may not even be using the same scripting language. However, a good practice problem for you would be to check out your documentation and write a simple script such as creating a cube and resizing it, or creating several cubes with random scale, translate, and rotation values.

19

WHAT TOOLS TO USE

If you've taken even a small look at the number of applications available to you, your head is probably spinning: there are a lot of them. One of the most common questions asked by beginners when they get onto a computer graphics forum is "Which app?" This is often in the form of "Should I choose Really-Good-App 1 or Really-Good-App 2?" Don't do this. While most people will react with patience and give some good advice, others are tired of the question, and most members are frustrated because someone will always start a flame war over why one is better than the other.

With that dire warning, what is the good advice often given? It is that there is no one piece of software that rises above them all. You cannot make a mistake by choosing one over the other. There are, however, mistakes that can be made. One is that, having chosen, we become so loyal to a piece of software that we are the ones responsible for the flame wars. The other, in the same vein, is that we stick by the application no matter what, even if there is a task that some other app can do better, or after development has been stopped for so long that the app has become a redundant dinosaur. A 3D artist and especially a studio must remain flexible. It's the final result that is most important, not the tool used. Pick the right tool for the right job.

A big film production could use Maya, Lightwave, Softimage, ZBrush, Vue, and a few others. Maya, Lightwave, and Softimage are all big packages that do many of the same things, but each one of them excels at certain tasks. Smaller studios or solo artists can still usually do everything with any of the full solution packages and a decent renderer. They just have to work at it.

So, there is the big answer. But what about you, right now, right here?

Well, you might already know that you do not have much of a choice. If you are at school, the school has often chosen which applications it will be teaching 3D with. So go with it. But during break times, try to get experience with other software. Don't think that because a professor or course leader chose an app that means it is the best app, as discussed.

One consideration is money. You may not have a choice because your only choice is free. Don't worry. The free solutions out there are for the most part every bit as powerful as the ones with jaw-dropping prices. The society of 3D artists includes good-hearted and talented folk who want to bring 3D to the masses. User interfaces can have a steep learning curve. But this difficulty is softened by the equally great community support you will receive. There are also applications that are aimed at hobby level. These cost a little, but as they are ideally suited for non-experts they are usually much faster to learn.

Something that can help you afford some of the more expensive packages, especially if you are a beginner intending to become professional, is the educational discount prices offered. Even if you are going the self study route, take a class at the local community college and get a student card (unless you're in high school — you already have one!). Even with tuition rates, the price for one class will probably still give you enough savings to be worth it, as well as give you some projects with deadlines that may stretch your abilities. Always a good thing.

You also need to keep in mind your hardware and your operating system. Most of this stuff is not going to work on an out-of date laptop, or even older desktop for that matter. Are you using a PC with Windows or Linux, or do you have a Mac? If possible, you should have a 64 bit processor and the operating system to support it. You need a good graphics card that supports Open GL. Mac versions of software, unless they were created only for a Mac, tend to be a bit less stable than Windows. If you are intending to purchase a computer for this, and you need to choose between spending the money on computer or software, lean toward getting the best computer you can. If you cheap out on a computer in order to purchase a high-end package, then your software will not run as well on it and will have a tendency to crash. As a result you will have a frustrating experience.

The most important question for you is: what do YOU want to do? Do you want to create models? Is your primary purpose creating art, and you don't care much about modeling? Do you want to make still images or animations? If you are looking to be professional, do you want to go into game development, visual effects, or animation? Maybe you want to create architectural visualization. What is a comfortable type of workflow for you?

With all of this in mind, you still do not have to worry about choosing wrong. Happily, all of these programs offer a limited free trial or, even better, a personal learning edition (PLE). PLEs are extended trials that usually limit the file-saving abilities

and/or add watermarks to renders. Download a few and take them for a test drive. Get a feel for the software.

Below is a list of many applications available, with short descriptions. Hopefully, this will help you get a handle on what is available and help you to narrow down your options.

Full Packages

3DS Max and 3DS Max Design
 Developed by: Autodesk
 Platform: Windows
 Price: $3495; Student Price: Free
 Trial: 30 days
 Main Uses: Animation, Modeling, Video Game Creation, Visual 3D Effects
Blender
 Developed by: Blender Foundation
 Platform: Windows, Macintosh, Linux, and more
 Price: Free
 Main Uses: Animation, Lighting, Modeling, Video Game Creation, Visual 3D Effects
Carrara
 Developed by: Daz 3D
 Platform: Windows, Macintosh
 Price: $89.95–$549
 Trial: 30 days
 Main Uses: Animation, Modeling
Cheetah 3D
 Platform: Macintosh
 Price: $99
 Trial: Unlimited time, cannot save files
 Main Uses: Animation, Modeling
Cinema 4D
 Developed by: Maxon
 Platform: Windows, Macintosh, Linux
 Price: $995–$3695; Student Price: $195–$495 through resellers
 Trial: Unlimited time, limited rendering and saving capabilities
 Main Uses: Modeling, Texturing, Animation
Houdini
 Developed by: Side Effects Software
 Platform: Windows, Macintosh, Linux
 Price: $1995–$6995; Student Price: $99 (limited rendering capabilities), $350 (full)

Trial: Unlimited time, watermark and smaller renders, etc.

Main Uses: Animation, Lighting, Modeling, Visual 3D Effects

Lightwave

Developed by: NewTek

Platform: Windows, Macintosh

Price: $895–$995; Student Price: $195 through resellers

Trial: 30 days fully functional

Main Uses: Modeling, Texturing, Animating

Maya

Developed by: Autodesk

Platform: Windows, Macintosh

Price: $3499; Student Price: Free

Trial: 30 days

Main Uses: Animation, Lighting, Modeling, Video Game Creation, Visual 3D Effects

Softimage

Developed by: Autodesk

Platform: Windows, Linux

Price: $2995; Student Price: Free

Trial: 30 days

Main Uses: Modeling, Animation, Video Game Creation

Smaller Packages

These always offer modeling, but sometimes have one or two other things that they do really well too.

Hexagon

Developed by: Daz 3D

Platform: Windows, Macintosh

Price: Free–$149

Trial: Yes

Main Uses: Modeling, Texturing

Modo

Developed by: Luxology

Platform: Windows, Macintosh

Price: $995–$1195; Student Price: $149

Trial: 15 days limited free, 30 days unlimited $25

Main Uses: Modeling, Animation

Silo

Platform: Windows, Macintosh

Price: $99/$159

Trial: Fully functional 30 days, limited thereafter; Student Price: $69/$109

Main Uses: Modeling

Sculpters

These are often used to add details after the main shaping of a model is complete. However, it is still quite possible to model the entire object in these applications, and many prefer the sculpting technique.

Mudbox
 Developed by: Autodesk
 Platform: Windows, Macintosh
 Price: $745; Student Price: Free
 Trial: 30 days
 Main Uses: Sculpting, Posing, Texturing

Zbrush
 Developed by: Pixelogic
 Platform: Windows, Macintosh
 Price: $595; Student Price: $450
 Trial: None at time of printing
 Main Uses: Lighting, Sculpting

Character Animation

There is usually not much going on in the way of modeling in these applications (though morphing preexisting models is common), but they are very nice for making images of characters that you've created.

Daz Studio
 Developed by: Daz 3D
 Platform: Windows, Macintosh
 Price: Free/$149.49
 Trial: 30 days, some features disabled after this
 Main Uses: Animation and Rendering of Characters

Poser
 Platform: Windows, Macintosh
 Price: $249.99, $499.99; Student Price: $199.95 through resellers
 Trial: 30 days
 Main Uses: Animation and Rendering of Characters

Scenery

Bryce
 Developed by: Daz 3D
 Platform: Windows, Macintosh
 Price: $99.95

Trial: Personal Learning Edition, unlimited, no watermarks, non-commercial use only
Main Uses: Terrain Modeling, Plants, Sky and Atmosphere, Animation

Vue
Developed by: e-on Software
Platform: Windows, Macintosh
Price: Free–$1495. There are several versions with different capabilities
Trial: PLE unlimited time, watermarked
Main Uses: Terrain Modeling, Plants, Sky and Atmosphere, Animation

Terragen
Developed by: Planetside
Platform: Windows, Macintosh
Price: $99–$399
Trial: Unlimited, non-commercial use, limited renders
Main Uses: Terrain Modeling, Sky and Atmosphere, Animation

XFrog
Developed by: Greenworks
Platform: Windows
Price: $299–$499
Trial: 30 days
Main Uses: Plant modeling

Renderers

mental ray
Price: Bundled free with software or $745 standalone
Supports: 3ds Max, AutoCAD, Inventor, Maya, Revit, Softimage

YafaRay
Price: Free
Supports: Blender; Via third party: Sketchup, Maya, Softimage

RenderMan
Price: $995–$3500; Student Price: $250–$875
Trial: Contact sales
Supports: Maya; Via third party: Blender, Cinema 4D, Softimage

V-Ray
Price: $999; Student Price: $149
Trial: 30 days fully functional
Supports: 3ds Max, Maya; Via third party: Blender, Cinema 4D, Rhino, SketchUp

MAKING A CAREER OUT OF 3D

Whatever dream job you're reaching for, your career doesn't start when you graduate from college. It starts the minute you decide. How well and in what direction it moves forward depends on what you do from that moment. This chapter will describe a bit of what it is like to be employed as a 3D artist and will give you an idea of how to get from beginner to professional. Even if you don't want to be professional, the community is always wonderful and you will find some tidbits about that too.

The State of the Industry

It's an exciting time to be an artist. The field of special effects is bigger than ever and includes the creation of fully realized virtual characters in otherwise live-action films. Matte painting is an important part of the ever popular epic movies, but also finds its way into films with smaller scope. Video and computer games are now an important part of our media culture, their appearance relying entirely on 3D and 2D computer graphics. Then there are advertising, simulations, medical and architectural visualization, and the list goes on. All of these require concept art as well.

This is a very international industry, having grown up with the internet and the instant communication that offers. You could easily be working for someone on the other side of the world, and with a team scattered all over. Or you may even be able to travel to another country to work. As projects start and finish, a skilled artist could have the opportunity to work in lots of different countries.

At the same time, the coolness factor of working with games and films has saturated the job market. It's a very competitive field, and unfortunately this does not necessarily translate into big bucks. In the gaming field, to make above US $100,000 you would have to have more than six years of experience and be the art director, which means more politics and less art. The starting salary averages around $45,000 and you can expect growth up to around $80,000 if you are a lead or technical artist. Independent contractors and developers tend to make less, do not have the benefits such as health and retirement, and don't reach the pay

rate of supervisors in the field, though they often have other sources of income (Source: *Game Developer Career Guide*, 2010). To get those jobs, let alone those numbers, you have to be committed and skilled at what you do.

The workplace environment is not always ideal either. Many studios and companies are motivated by profit. Computer graphics artists are often thought of as expendable, which is not entirely untrue. For every person employed, there are others wanting their job. Expect long hours, and then spend more hours keeping your skills fresh and up to date. In the film industry, unlike writers, actors, and technicians, there is no guild to protect computer graphics artists. This has sometimes resulted in artists being taken advantage of.

However, if you love your art, it may not matter. Just creating art can be such a source of satisfaction that you will find happiness in life no matter what other difficulties are going on. And you will find constant appreciation for the magnificence that is this world that we live in. With that in mind, sometimes the artist may prefer a simpler nine-to-five type of job which leaves them the energy to create freelance work at home.

What Specialization?

As you begin your career you'll start out as a generalist, trying a bit of everything. If you become a freelancer or work in a small studio, you may still work with all aspects from concept to post-production. But if you work in a larger studio, chances are you'll be doing only one thing. Among some of the specializations within the field are concept artist, modeler, rigging, texture artist, animator, renderer, and postproduction. Those are sometimes broken down even further. Try taking a look at the credits of a game or a fully animated film. As you explore the art, you'll get an idea as to what part of creation you like the most. You may be more technically minded and enjoy scripting and using procedural graphs. Perhaps your inner engineer will draw you toward rigging. You may enjoy the process of texturing or modeling more. Or you may be more inclined towards matte painting types of activities. You will want to figure this out early, in order to get your skills at a maximum before you go looking for a job.

College

Like many artistic pursuits, it is possible to get a job in computer graphics without a degree. What is most important is

what you can produce, not the letters behind your name. However, education outside your own self-direction can serve you very well. A teacher or mentor can pick up on and correct your mistakes, fill in the gaps in your understanding, and help you to find focus and direction.

With this in mind, you need to find the program that can actually do that for you. Just being an accredited college or technical school does not guarantee such a thing. The sad thing is, price does not necessarily equate to quality when it comes to education, especially in the 3D field. New for-profit colleges are cashing in on the coolness factor, but not necessarily providing the essential job skills, while more established schools may be simply adding 3D modules to their multimedia programs. You will need to do some research to find an institution that is good for you.

You need to find out how many graduates from the program are actually getting jobs. A good school will post this. Otherwise, you need to ask that question. If they do not know, then that is cause to beware, as it is an easy enough statistic to track. The school should also let you see the portfolios and demo reels of previous graduates. Compare these to the ones typical of the industry. Take a look at the ratio of graduates to portfolios. There are always a few talented people who push themselves farther than what the course has given them. If you are only seeing a couple of good portfolios, then that is another cause for concern.

How many instructors are connected to the industry, and how long ago were they working in it? Are there visiting mentors and teachers who are currently working in the industry? Is there the possibility of placement in an intern program? Look at the curriculum. In particular, the earlier classes should be focused more on drawing and 3D basics than on how to use a particular piece of software.

One more indicator for you to pay attention to is the age of the hardware. Old hardware is not as capable of running the up-to-date software, at least in a timely manner. It is also an indication that the program is not getting the resources it needs to be top notch.

This is perhaps the most important money and time you will ever spend, and it could be a lot. Do make sure, not just by asking the recruiter, that your credits will be transferable. Grab the course book of the school in question, call a local accredited university, and then ask if they will take credits from certain classes. They may not take all of them, but if they do not take at least the basics which they have a program for, then beware. Also ask if they will take an associates degree from the school.

Once you've found a college and begun, you need to stay on your feet. Are you learning? Are you being challenged? You cannot necessarily depend on the school to challenge you. Take what you learn in class as a direction and expand on it. Get training materials online. Make good use of your college library, which will have books and magazines and may have subscriptions to online training. During school, you should live, eat, and breathe 3D art. Remember that 10,000 hours to mastery? If all you do is complete your class assignments, it's going to take longer than ten years to reach that number.

If you find that the education you're receiving isn't worth the money you're spending, do not be afraid to stop going to that school. Still, if you do need that degree and you have few options, just keep forging onward and make sure you supplement yourself even more. Write down questions you have during lectures, then go find out what the answers are. Just keep this in mind, no matter what: you are responsible for your education, not your teachers.

Self-Study

Even if your intent is to use only self-study, consider taking an art class at the local community college. This can get you discounts for software, help you meet like-minded people in real life, and give a little structure to your education. As impressed before, self-study is an important part of your growth even if you pursue a college education. Then once you have finished college and have a job, even if you are years into a job, you need to keep on pushing yourself to learn more. You will have to change software at some point. As technology evolves, the things expected of you will change. To stay viable in the job market, you have to keep up.

Your first resource for learning software is to read the manual. It will take you step by step through the interface and everything the software can do. The software developers also often provide start-up tutorials with their software. These tutorials have been designed to take you through each important operation that the software can perform.

There are several great online training resources. In fact, as one of the partners of Geekatplay Studio, developing training materials is what I do. The two big hitters that consistently deliver quality training videos are Gnomon Workshop and Digital Tutors, but there are lots of tutorials scattered all around, both in text and as video. Some of these are quite fantastic, others not so great. Many of those found in community forums are free. Reasons for

using tutorials that do not come from the software developer are repetition and gathering some pearls of wisdom. Having another person explain the basics in a slightly different way will help you to learn them that much better. Having someone very experienced show you a tip to do something specific can help you to expand your knowledge.

Also, there are always good books being published, and reviews to help you know which ones to get.

Go through each main focus (modeling, texturing, rigging, etc.) and learn it well before you try to move on to the next one. Pulling up a tutorial with a cool project is not a good way to master the basics. The hazards of learning by random tutorial are having gaps in your skillset and getting discouraged by attempting something beyond your experience. The results will probably be a file full of unfinished projects. Spend about three or four weeks in each field, starting with the manual and help files. Animating is a later field, so the first things you want to attempt are still images of models you've created and added materials to.

Whether you go down the pure self-study route or are augmenting your college training, one of the most important things you can do is practice. Take it seriously. Schedule a certain number of hours each day to follow training videos or work on self-inspired projects. This number can be smaller if you're going to school, but should be more substantial if you're not. Practice will be frustrating at first. As you watch those videos, where the teacher does everything so quickly it looks easy, don't worry. They can only make it look quick and easy because they've put in thousands of hours of practice beforehand. You will be slow at first. You won't be able to model heads at first. But if you keep at it, then you'll find it easy to navigate the user interface and manipulate your objects. At that point, you will be able to refine your skills until application-based tasks are easy and all you're worrying about is the work of art.

You will need to be finishing projects. To help you move forward with this, give yourself deadlines. This will have to be self-imposed if you're not in school or employed in the field. Once you have set a deadline for a project, tell others about it, especially those who would encourage you. Having supporters and being accountable are proven ways to help you to accomplish your goals.

Most importantly, don't worry about how non-professional your artwork looks at first. This is the reason for your practice. Just do things, and enjoy learning. As you finish project after project, you will have satisfaction in seeing your progression from the first thing you did to the latest.

Communities

The first time I met with a group of people who were writers, I felt like I had found my homeland. We each understood the frustrations and joys of doing what we did. We often had a similar way of viewing the world. We had a common vocabulary. As I've continued meeting with other writers and with my 3D art friends, this mutual understanding and culture of creativity has helped me to grow as an artist and sometimes, as a human.

By going to college, you will gain a group of friends bound to you not only by a love of computer graphics, but also by the experience of the school together. These folks, as well as the many acquaintances you've made, can help you in your career, and you in turn can help them.

Many jobs never get advertised. It's common practice for team leaders to ask their team if they know anyone who can fill a needed position. Networking is one of the best ways to find out about a job, and probably in the process be recommended for it. It could even be your friend who hires you, so it's a good idea to keep in touch with them.

As you go from job to job, former colleagues also make great contacts. The corollary to this is, never burn your bridges, even if it would be cathartic. And don't air your frustations on a social network. Go play your favorite first person shooter instead and don't forget the carton of chocolate ice cream and bag of potato chips. There will be someone in that office whose opinion of you may affect your future.

Other good places for face-to-face meeting are conferences and festivals. Try to attend these and take advantage of the education you can receive from the panels. Make small talk with people and be sure to bring your business cards and exchange them. There are sometimes job fairs at conferences as well.

A good way to keep in touch with all of these people is through the use of online social networks and forums. Groups from your school may have something like a Facebook group, which is a great thing. But online, the real benefit can be had by forums. In forums, you can show your works in progress and receive critiques of them. Many responses are just encouragement like "Beautiful!" "Great Job!" But you need to seek helpful constructive criticism. You won't be the only one showing off; others will be as well, and the galleries in forums and other types of art communities are a good way to compare yourself to others to see how you stack up with the industry. If you're stuck, you can ask

a question and get an answer. But before you ask, try using the forum search on your question, to lessen the chance of repeating something. People enjoy helping others and student–mentor relationships often develop. You will find benefit from this as you participate in communities, and by helping others you often gain by learning something new as well.

Portfolios and Demo Reels

The first impression you will probably make on a prospective employer is what they see on your demo reel, or for visualization artists, a portfolio. This is what you will need to get an interview. You should start one as soon as you start producing any kind of artwork. To get a good idea of what kind of a demo reel or portfolio you need to create for your field of specialization, take a look at the websites of various studios and see what they are asking for. Take a look at the demo reels of professionals that you know are working in the field.

There is a lot more to making a good demo reel than can be mentioned here, but some of the basics are these. They should remain as short as possible, no longer than two minutes. Your audience is recruiters, and they may have to see hundreds of these over the course of finding a good candidate. With that in mind, your demo reel should impress within the first thirty seconds, or else risk being yanked before finishing. Put only your best stuff in a demo reel. These are not static productions. They should evolve and grow as you do. As you improve, take out all old stuff and replace it with newer, better things. The recruiters won't know if your older work is the norm and the better work a fluke.

Even though it's a good idea to always keep a current demo reel, do not invite industry professionals to view your first or early demo reels unless you've already established a mentoring relationship with them. They don't have time to critique and early work probably will not impress them. This is also true of tutorial creators. Viewing their tutorial does not make them your personal teacher. Keep your reel with the idea that as you establish relationships both with people on your level and with those potential mentors, you will have a ready way to show them what you've been doing lately. And speaking of not impressing people, make sure you keep all copies of your demo reel online up to date. You don't want prospective employers to make any judgment on your qualifications based on your early work.

Ways to Attract Attention

Before you have a job, there are a few things you can do to get your name out there as well as to gain experience to put on your résumé. One of them is to involve yourself in independent projects such as films. Some of these are fan-made films based on popular books or movies. Others are films by young filmmakers trying to get their own work recognized by entering them into festivals. Working with these people will also establish good future contacts.

You can take a cue from those filmmakers and create your own animations to enter into festivals and competitions such as CG Society's challenges. There are several that industry professionals pay attention to. Even if you don't win, placing high will do well for your reputation. And no matter what, aiming projects at contests and festivals will have the benefit of stretching yourself and meeting hard deadlines. These are often a group effort, and can help you to learn how to work as a team with a goal.

One other really good thing to do that combines community and portfolios, and is a way to attract attention, is to keep a personal blog. Post your works in progress on the blog. Your blog is also where you can keep your up-to-date reel. This is a good way to keep track of your progress and to show to others that you are actively involved. Always consider a blog, as well as any Facebook or forum activity to be public. What you wouldn't do in public, don't do online.

EXTRA RESOURCES

This is hardly an exhaustive list, but here are a few resources that can help you out as you learn 3D art.

Links

Of course, the first link is this book's website: http://www.3dartessentials.com

Communities often have training and have access to experienced artists who can answer questions:

CG Society: http://www.cgsociety.org

3D Total: http://www.3dtotal.com

Renderosity: http://www.renderosity.com

Several sites are devoted to training, though they often have good communities as well:

Gnomon Workshop: http://www.thegnomonworkshop.com

Digital Tutors: http://www.digitaltutors.com

Geekatplay Studio: http://www.geekatplay.com

Sites Sponsored by Software Developers

These websites have better access to the developer's documentation, including their tutorials designed to take you through their software step by step. Plus the community is often very helpful:

Autodesk: http://area.autodesk.com

Blender: http://www.blender.org

Cinema 4D: http://www.cineversity.com/index.asp

Daz 3D: http://www.daz3d.com

Houdini: http://www.sidefx.com

Lightwave: http://www.newtek.com/lightwave

Vue: http://www.cornucopia3d.com

Magazines

3D Creative: http://www.3dcreativemag.com

3D Artist: http://www.3dartistonline.com/

3D World: http://www.3dworldmag.com

Computer Arts: http://www.computerarts.co.uk/

Computer Graphics World: http://www.cgw.com

Books

Your application's manual

In addition, good guidebooks are often recommended by the application's developer.

The Illusion of Life: Disney Animation, by Ollie Johnston and Frank Thomas, Hyperion Books, (2nd Edition) 1995

Timing for Animation, by Tom Sito, Focal Press, (2nd edition) 2009

Painting with Light, by John Alton, University of California Press, (4th Edition) 1995

Digital Lighting and Rendering, by Jeremy Birn, New Riders Press, (2nd Edition) 2006

Film Directing Shot by Shot: Vizualizing from Concept to Screen, by Steven D Katz, Michael Wiese, 1991

How to Make Animated Films, by Tony White, Focal Press, 2009

Stop Staring: Facial Modeling and Animation Done Right, by Jason Osipa, Sybex, (3rd Edition) 2010

Body Language: Advanced 3D Character Rigging, by Eric Allen and Kelly L. Murdock, Sybex, 2008

INDEX

Printed and bound by CPI Group (UK) Ltd, Croydon, CR0 4YY

23/10/2024

01778247-0002